GOOD GIRLS, GOOD SEX

Women Talk about Church and Sexuality

SONYA SHARMA

Fernwood Publishing • Halifax & Winnipeg

Editing: Tara Seel
Cover design: John van der Woude
Printed and bound in Canada by Hignell Book Printing

Published in Canada by Fernwood Publishing
32 Oceanvista Lane
Black Point, Nova Scotia, B0J 1B0
and 748 Broadway Avenue, Winnipeg, Manitoba, R3G 0X3
www.fernwoodpublishing.ca

Fernwood Publishing Company Limited gratefully acknowledges the financial support of the Government of Canada through the Canada Book Fund, the Canada Council for the Arts, the Nova Scotia Department of Tourism and Culture, the Manitoba Department of Culture, Heritage and Tourism under the Manitoba Publishers Marketing Assistance Program and the Province of Manitoba, through the Book Publishing Tax Credit, for our publishing program.

Library and Archives Canada Cataloguing in Publication

Sharma, Sonya, 1972-
Good girls, good sex : women talk about church and sexuality / Sonya Sharma.

(Basics)
Includes bibliographical references.
ISBN 978-1-55266-438-4

1. Women and religion. 2. Christian women--Sexual behavior. 3. Sex--Religious aspects--Christianity. I. Title. II. Series: Fernwood basics

BT708.S53 2011 241'.66 C2011-903220-1

Contents

Acknowledgements

Writing a book is not a lone effort. I first give sincere thanks to all of the women who took the time to talk to me about their experiences of church life and sexuality. I continue to learn from your stories, wisdom and spirit. The women's stories in this book are based on original research carried out for a doctoral degree at Lancaster University between 2003 and 2007. I am very grateful to Linda Woodhead and Vicky Singleton for their supervision, guidance and faith in this project. Such an endeavour also includes many other people — colleagues, comrades, close friends and mentors — who encouraged this process and/or read parts or full versions of this book. I am very appreciative to Kristin Aune, Ros Borland, Marie Cochrane, Sheila Fodchuck, Kim Goodliffe, Mathew Guest, June Jacklin, Patricia Kelly, Dianne Lawrence, Tara Leach, Shannon Lowe, Emily Mathew, Diane Montgomery, Holly Faith Nelson, Gina Ogden, Sheryl Reimer-Kirkham, Eeva Sointu, Giselle Vincett, Rob Warner, Amy Wilkins, Heather Willes, Andrew K.T. Yip, and the Institute for Women's Studies at Lancaster University. My dear friends who I have grown up with, for your insight, laughter and life experience throughout this project: Priya DeSilva, Shelley Hardy, Kiyomi Kakino, Catherine Racine, Sarah Savoy and Jose and Mike Stockdale. I am also thankful to my family for their affirmation, love and support: Sandra, Amba, Patricia, Emily, Abraham, Abigail, Eli, Jeff and Barbara, and Christopher Harker —from the bottom of my heart, thank you for reading numerous drafts of chapters and for your ease and full heart during this process.

I am deeply grateful to reviewers, scholars and experts in the field who took the time to read and give comments. Your encouragement, insight and feedback has been invaluable and a source of inspiration. I am also thankful to Fernwood Publishing, especially Jessica Antony for editorial guidance, Tara Seel for copy editing, Debbie Mathers for pre-production, Beverley Rach for production and John van der Woude for cover design. Thank you so much for giving this book a home.

Versions of various parts of this book have been published elsewhere as follows: "When Young Women Say 'Yes': Exploring the Sexual Selves of Young Canadian Women in Protestant Churches." *Women and Religion in the West: Challenging Secularization*, eds. Kristin Aune, Sonya Sharma and Giselle Vincett (Aldershot, Hamps., Ashgate, 2008); "Young Women, Sexuality and Protestant Church Community: Oppression or Empowerment?" *European Journal of Women's Studies* 15, no. 4 (2008); "Sexuality and Contemporary Evangelical Christianity." *Negotiating Boundaries? Identities, Sexualities, Diversities*, eds. Clare Beckett, Owen Heathcote and Marie Macey (Cambridge, UK: Cambridge Scholars Press, 2007). With Kristin Aune.

Good Girls, Good Sex

> I cannot say that the good girl died the moment I had sex... being a good Christian girl was so entrenched in my sexual experiences that I could not surrender to the sexual experiences I was having. To express the love that I felt for one guy, it was squashed because of the sins that I was afraid to commit... when I eventually decided to have sex I was embarrassed that I had not [had sex].... (Anita, age 28, Baptist, left church)[1]

What happens when a woman's identities as a Christian and as an embodied sexual woman collide? From the time I answered a call from American evangelist Billy Graham to come down to the stadium floor and give my life to Jesus Christ, my Christian faith took shape amongst a group of Christian female friends with whom I attended church. Through to my mid-twenties the message for sex was clear: all of my youth leaders, both men and women, preached that *sex is only for the context of heterosexual marriage.* Into our early twenties, conversations about sex remained shrouded, even though we knew some of us had done "it." Some friends expressed satisfaction with being sexual, while practising their Christianity. Others expressed conflict and misgivings. Many believed that traditional marriage converted bodily sex into something spiritual and anything outside of that was perceived as sinful or ungodly. From these experiences, my own and those of my Christian female friends, emerged this qualitative study about women's experiences of sexuality and church life.

Being a "good girl," as Anita refers to, is a key theme that runs through the stories of the women in this book. Women gave their definitions and descriptions of what it means to be a "good girl" in relation to their Christianity. Maya, who attended church regularly, said that being a "good Christian girl," someone who "follows the rules," and who remains sexually "abstinent" was difficult (age 34, Baptist, left church). "I was pretty much a good girl," said Barbara. "I followed the teachings of Jesus as I could, but I felt a huge lot of guilt when I didn't, when I thought I was failing... even now" (age 33, Baptist, attends church). For others, being a good girl meant "good behaviour and niceness"; "not getting drunk"; "chaste, pure, womanly, motherly"; "helping out with the nursery, cooking and cleaning." Religious notions of conventional feminine roles and married sexuality are evident in these women's quotes. Underlying these notions of the good girl for many Christian women are long-used Biblical representations. Images of Eve in the Old

Testament, whose actions are often interpreted as having seduced Adam to eat the forbidden fruit in the book of Genesis, are frequently positioned as opposite to the virgin girl Mary, who gave birth to Jesus Christ, described in the New Testament. In other Biblical accounts, a loyal, faithful and dutiful woman is rewarded (e.g., Ruth) compared to, for example, the adulterous woman who is publicly judged (John 8: 1–11). Women's sexuality is thus constructed as in control (interpreted as good) or out of control (interpreted as bad), and only to be conducted within a particular relationship (marriage).

These narratives about women have contributed to good girl/bad girl discourses that are pervasive, often affecting "how sexuality is socially understood, and, in turn, how women understand themselves in relation to those meanings" (Braun and Gavey 1999: 204). Women who are sexually active outside of marital and/or monogamous heterosexual relationships are frequently seen as promiscuous. Jessica said, "Having sex [before marriage] meant that I am not a good girl" (age 34, Baptist, attends church). Good girls are sexually responsible and have one (preferably spousal) sexual partner, while bad girls are sexually irresponsible and have many sexual partners (204–05). Such distinctions are often defined by the absence or presence of sexual desire (Tolman 2002), which can deeply impact on women's sexual experiences, and further generate ideas about what is deemed good sex. As a researcher on young women and sexuality, Deborah Tolman states, "Good girls are not sexual" (Tolman and Higgins 1996: 206). Good girl/bad girl discourses are based in patriarchal constructs that leave many women confronting a dichotomy: on the one hand the expectation to remain chaste and on the other, their personal desire to have sexual experiences. Subsequently, many women can experience a disembodied sexuality, especially when they transgress religious expectations. To submit to the norms of conventional femininity, such as those found within many Christian traditions, women may dissociate from their sense of the self and their sexuality during sexual activity, resulting in "the absence of active embodied desire" (Tolman 2002: 54). Resultantly, a woman may (re)produce a "modest femininity," whereby her body becomes passive, and her sexuality is experienced as detached or disembodied, as needing to be controlled (Holland et al. 1994, 1998: 109). Sexuality defined by terms, such as "good" or "bad," that are used to describe a child's behaviour, can diminish a woman's sexuality as undeveloped or not yet adult, whether she is married or not .

Gina Ogden, who has interviewed numerous women about their sexual experiences, has discovered that many women still confront sexual norms that are "male-defined." Yet, many women are also complicit with men, giving away their sexual capital and control (Ogden 2007). Ogden perceives women in a "triple bind": if women keep silent they are in the same place; if they speak up they risk attack; and if they claim ownership of their sexual energy, they disrupt the way things are and are categorized as "dangerous" (193). Such a bind is similar to what women have described in this book. Many remain silent for fear of losing their

place in their churches, which means their communities sustain age-old teachings of sexuality that are repressive. If Christian women assert their sexuality outside the context of heterosexual marriage, they risk being demonized, seen as loose, as bad. Notions that non-marital sex will make a woman feel lousy are a myth that can be very misleading for Christian women and detrimental to their sexual development. There is a sense that good sex within many Christian denominations is marital-confined. As Ogden (2007: 193) observes in her work with women, the concept that women can love and appreciate good sex (in and out of marriage) along with being spiritual may be unusual because many "have learned to associate sex-loving women not with spiritual growth or societal changes, but with the same old stereotypes — bad girls, manipulators." However, the course of everyday life is messy, constantly shifting the boundaries of the categories of "good" and "bad." The women I interviewed reflected this and found ways to experience both their religiosity *and* their sexuality, contributing to a novel analysis of Christianity and sexual experience.

In this book, I define good sex as that in which Christian women — single and partnered, heterosexual and homosexual — engage in satisfying sexual experiences. This includes women who have heard their church's message, but choose to practise their religiosity *and* to enjoy their sexuality outside of a marriage relationship. One woman who continued to attend church said, "To wait until marriage is not realistic and not for me" (Susan, age 20, Methodist, attends church). She decided to have sex with the man she eventually married. Others in the book continued to practise their Christianity, but were intent on finding a church that would recognize, for example, their lesbian sexuality. Finding churches that honoured their sexual decisions meant being able to participate in sexual relationships with partners they loved and cared for and have sexual experiences that felt good to them. There are also women in this book who chose to wait until marriage to have sex or whose first experiences of sex were in marriage, which they described as good and enjoyable because this was in line with their Christian beliefs and values. Some women talked about finally experiencing sexual freedom in marriage. The decisions Christian women make about their sexuality are not always easy and are often wrought with tensions — struggling whether to wait to have sex in marriage, feeling shame and guilt for engaging in non-marital or non-heterosexual sexual experiences, or reconciling how to experience both their religiosity and sexual desires given their church's teachings.

Heeding the dilemma that Anita poses above and central to this book are the questions: How do women satisfy their sexual desires as they simultaneously negotiate their Christianity amid secular contexts (e.g., university, work and other everyday non-church contexts) that often promote other, more liberal forms of femininity and sexuality? What are the implications for women's sexuality when they are involved and committed to the beliefs and values of a Christian community? How do they handle the conflict caused by the collision of their

sexual desires and the demands of their faith? How are these tensions between religion and sexuality negotiated at the junctures of class and race? To begin to answer these questions, in the next section I briefly describe the group of women who participated in this study. Then it is necessary to explore some key concepts that thread through the stories of the women in this book and that often structure their sexuality.

Structuring Christian Women's Sexuality

In this book, I focus on a qualitative study that explored women's sexuality and Christian experience. Thirty-six women aged between 18-65 and mainly living in Britain or Canada were interviewed between 2004 and 2005. The women who participated in the study were almost all White, middle class and heterosexual, with three identifying as lesbian. Although efforts were made, the small number of lesbian women is due to those who made themselves available for the study. It must be acknowledged at the outset that due to this small number, my analysis tends to focus on the women who identified as heterosexual. However, in the interviews with heterosexual and lesbian women, sexual orientation was not always a factor in the issues women identified as arising from religious-sexual tensions (e.g., masturbation). The women attended churches across Protestant denominations: Anglican (12), Baptist (9), Interdenominational (7), Methodist (4), and other (4). The churches termed as "other" were Alliance, Free Evangelical, Pentecostal and the United Church of Canada.[2] Twenty-one of the participants were faithful churchgoers, six were irregular church attendees or between churches, and nine had left church life.

Protestant Christianity

The women's churches are located within Protestant Christianity, which originates from the reformer, Martin Luther, who protested during the sixteenth century against the beliefs and practices of the Catholic Church. Unlike the Catholic Church, where a believer's relationship with God is mediated by a priest or pope, he believed that "no-one and nothing stood between him and God" (Woodhead 2004: 159). Cultivating a personal relationship with God is a central practice of Protestantism. Since then, the term Protestant has come to generally signify those Christians who do not belong to Roman Catholic or Orthodox traditions. Protestant Christianity or Protestant churches are terms I utilize to represent the array of Christian affiliations that the women had formerly belonged to or were attending.[3] I chose women from Protestant churches because they volunteered to participate and time constraints did not allow for an in-depth comparison of other women from other religious backgrounds (i.e., Catholic, Buddhist, Hindu, etc.).[4]

The churches the women attended are diverse in their histories. They are also diverse in how they approach issues of gender and sexuality and their practice of the Christian faith. Approaches to gender and sexuality range from liberal to

conservative perspectives. Some of the churches the women attended are accepting of women in leadership and same-sex marriages, while others are not. Others endorse traditional representations of family and marital relationships between men and women. A few churches have made more progressive moves by ordaining homosexuals and transgendered ministers (Turnball 2011), while others mainly believe church leaders should be heterosexual and married with a family (Eckholm 2011). There are also various groups that their churches minister to, such as students or engaged couples, which may mean matters of sexuality are addressed differently. Among the women's churches, debates on theology and liturgy occur, as well as debates on social issues, such as abortion, euthanasia and the economy. Even issues of gender and sexuality are considered because of social and historical changes, such as birth control, family fragmentation and recent trends of co-habitation before or instead of marriage.

Religious practices are also varied. Some of the women's churches carry out contemporary evangelical approaches, while others, such as the Anglican tradition, are closer to a high Catholic tradition. Churches, such as Anglican congregations, may celebrate the Eucharist more than once a week, while congregations in the Baptist tradition may serve Holy Communion, the symbolic bread and wine, once a month. Some women's churches sing traditional hymns and have choirs; others have worship bands and sing contemporary songs or a combination of both. Theology, orders of service and election of leaders are diverse, as well as how accessible clergy and church ministers are to their members. Community outreach can vary, too. There are churches within Protestantism that have ministries to feed the homeless and address wider social justice issues related to the environment and human rights. Other churches provide more immediately to their members, such as counselling services, preschool provision and youth groups. Protestant Christianity holds a variation of traditions and practices, which was evident among the women. Moreover, the women, by being from a range of Protestant denominations, allowed me to draw wider conclusions about the commonalities and complexities of women's sexuality and religiosity.

Norms and Negotiations

Despite this diversity, a common finding among the women interviewed was that their churches observed a conventional teaching of sexuality, which had affected them, as we shall see in the following chapters. Significantly, in interviewing women about their experiences of church life and sexuality, my aim was not to compare their denominational affiliations or their experiences by age, even though their social, historical and geographical contexts differed. Central to my study was to understand how their religious communities' teachings on sexuality impacted their sexual lives during the ages of 18 to 25, a formative time when women are becoming more independent and negotiating their way through relationships, new situations and various social contexts (Arnett 2004; Lefkowitz 2005; Smith

and Snell 2009). Women older than these age periods were interviewed, and they offered an additional dimension. Many of the women talked about the age periods of 18 to 25 and more recent experiences of sexuality and church life. They helped me to see that their religious teachings and the social discourses (e.g., good girl/ bad girl) often associated continued to have an affect, even into marriage.

Because women's sexuality transforms across their lifespan (Daniluk 2003), it was more useful to perceive the women's experiences as not framed by their church affiliations, but by dominant constructions (Thapan 1997) found in and outside of their churches that can inform how their sexuality is lived and interacts with other aspects of their identities, such as gender, class and race, that vary according to locality. From this stance, it is understood that "a woman experiences her body, sexuality and femininity as a social being located in cultural settings with its dominant values and norms" (5). A woman embodies and lives out these norms in everyday life. However, these dominant constructions that are lived and expressed through the body are always mediated by individual actions, decisions, experiences and perceptions that vary according to time and place. The women in this book lived out a series of tensions and positions that both accommodated and resisted the dominant structures they were embedded in. Some of the women attempted to separate their sexuality from their Christianity, compartmentalizing their experiences in order to live out both. Others had sexual experiences, but struggled with how these fit with their faith, and some found ways to honour both their religiosity and their sexuality. These stances were continually in flux, depending on age, relationship, cultural context and so forth. Some of the women were abstaining from sexual activity until marriage, some were having sex in a committed relationship, some had abstained until marriage and were now having satisfying sex, some found the sex in their marriages less fulfilling than sexual experiences before marriage, and some were single, but not waiting to have sex in a marriage relationship. Often, the women had more than one of these experiences, highlighting the complexity of sexuality. Furthermore, sexuality cannot be easily understood as existing with regards to church doctrine alone, but is influenced by other discourses, situations and aspects of the women's identities. The ways in which the women lived and negotiated their sexuality within ecclesial and secular contexts is at the heart of this book.

Analysis for this book considers data obtained from women across the sample. Within the sample of women, I include myself. I attended a Baptist church and then an Interdenominational church and, like many of the women, I was taught and encouraged to confine my sexual activity to marriage in both of these contexts. It was not until attending a liberal Anglican church that I found a church more inclusive of various sexual relationships, and in which I was able to find my own way on matters of faith and sexuality. In my own experience, my sexuality has transformed depending on such aspects as my age or relationship. Talking to the women in this book and hearing their stories has contributed to my own reflections on sexuality

and personal formation. Excerpts from my interview, which was conducted by a colleague I trust, are part of the book. I decided to include myself toward the end of my research because I felt I had something important to say about the questions asked. I wanted the experience of being interviewed and the chance to reflect upon the questions I was asking the women. I also wanted to analyze my experiences alongside the other women's narratives. I remain anonymous because I still find it difficult to discuss religious and sexual experiences openly, even though my own experience of sexuality is more integrated with who I am since embarking on this study. My interview, like the others, was recorded and transcribed, and in order to help myself critically analyze my interview, I gave myself a different name throughout the course of the research. On the one hand, I am the researcher, locating myself on the same critical pane as the researched, and on the other, I am also the researched. Being able to locate myself on both sides of the study is a stance that could not have been done without feminist scholarship that emphasizes the importance of situated and responsible research (Maynard and Purvis 1994; Slee 2004).

Social Changes: Secularization and Feminism

Experiences of sexuality "are inextricably linked to the historically and culturally specific belief systems in which we are embedded, and therefore there is no such thing as 'culture-free' or 'context-free' experiences of sexual desire" (Tolman and Diamond 2002: 39). Women's (and men's) sexualities are inevitably impacted by the different belief systems, histories and socio-cultural contexts in which they are situated (Daniluk 2003). Keeping in mind the different contexts that women came from, it is also the case that different geographical, social, cultural and economic histories have inevitably shaped the religious beliefs and practices of many churches. I do not have adequate space to address in depth how Protestant churches within Britain and Canada have been affected by and have reacted to broader social and cultural changes. Yet, I can say a few words about some of the social and cultural transformations that have affected both countries' churches and people's approaches to issues of gender and sexuality. The social processes I briefly discuss are secularization and feminism, and the mainstreaming of sexuality.

The process of *secularization* is defined by sociologists of religion as the decline of the importance of religion, not only in "the operation of non-religious institutions like the state and the economy," but also in "the social standing of religious roles and institutions and the extent to which people engage in religious practices and beliefs" (Bruce 2002: 3). With the fragmentation of family life and the rise of individualism, as well as the sexual revolution and civil rights movement of the 1960s, churches that once had much power and cultural sway over women's and men's gender roles and sexual lives began to decline (Brown 2001). Birth control pills were available for purchase, and women were entering university and the workforce at increased rates, which meant churches began to lose their place as the social centres of communities

(Simpson 2006). In Canada, "the state no longer needed the churches as partners and took over their erstwhile functions in such areas as education, social welfare and the like" (Beyer 2006: 86). Britain confronted similar circumstances, and as a result, churches were unable to overcome how these social and cultural changes affected their members (Brown 2001). Secularism seeped into the public sphere, affecting areas such as education, government and healthcare.

Although churchgoing has declined, many people identify as being spiritual (Casanova 1994; Davie 1994; Bibby 2002). Sociologist of religion Reginald Bibby (2002: 4) argues that his statistical findings "point to a religious and spiritual renaissance in Canada — new life being added to old life, sometimes within religious groups but often outside them." In a survey conducted by Bibby, "81 percent of respondents attested to a belief in God, including 55 percent of those who never attend religious services" (Bibby 2000 in Bergman 2002: 2). The processes of secularization may have significantly reduced the influences of Catholic and Protestant groups in Canada (Bibby 2000: 239), but "Canadians continue to be deeply spiritual." Sociologists of religion Paul Heelas and Linda Woodhead (2005), found in their research in Kendal, England, a "subjective turn," whereby spirituality is experienced through the personal. God is located within oneself, and through the subjective life, spiritual practices are honed and generated. Religious and spiritual rituals and activities are not restricted to institutional settings, but are integrated into people's everyday lives (Orsi 2003).

Despite scholars' predictions of religion's eventual irrelevance, recent social and cultural changes have not meant the disappearance of religion, but its redefinition and reorganization (Gökarıksel 2009; Warner 2010). Particularly since 9/11, there has been resurgent interest and examination of the study of religion and its relationship to society. Western societies have observed an effervescent input of Christian theologies from people of Indian, African and Latin American origins (Cox 2009). Due to migration, Pentecostal groups have grown (Martin 2005). There has also been a rise in the number of conservative evangelical groups that emphasize community and spiritual well-being, which can be appealing during times of hardship and uncertainty. With the decline of the welfare state in many western societies, the demand on churches to provide social services has grown (Davie 2006, 2011). It is also the case that cathedrals are becoming popular places to visit and appealing spaces in which to exhibit art and hear musical concerts. Churches that once questioned their role in public life are re-evaluating how to provide for their congregations and local communities. Also of note is the rise of atheist and humanist groups generating their own discussions and debates alongside the religious and the spiritual, and the interest in other forms of belief and practice, such as Buddhism and First Nations spirituality. As a result of these social and cultural changes to religiosity and spirituality, there has been a shift for many from the "outer authority," such as that found in the church, to "more inward forms of authority rooted in the inner life of the individual" (Woodhead 2007a:

116). This has led to many women and men attributing more value to one's own needs, attitudes, emotions and sexual desires, treating them as more authoritative in the living of one's own life than the voice of external, often patriarchal, authorities, such as the Church (Woodhead 2007b).

Feminism, broadly defined as the belief in and importance of gender equity (Cott 1987: 4–5), has also contributed to the changing nature of religion in western societies. Numerous first-wave feminists (e.g., Elizabeth Cady Stanton) critiqued religion for its discounting of women's contributions. Second-wave feminists and theologians (e.g., Simone de Beauvoir, Mary Daly and Rosemary Radford Ruether) more ardently critiqued Christianity's patriarchal and traditional gendered constructions. As a result, many women, from the 1960s onwards, left the traditional church, adapted their religious beliefs and practices or formed new spiritual collectives and thealogies that affirmed their voices and roles (Walker 1983; Plaskow and Christ 1989; Isasi-Diaz 1996; Anderson and Young 2004).[5] Most significantly, religious change in western societies has been "strongly influenced by long-term and largely unexamined changes in women's lives" (Marler 2008: 23). The shift in social patterns, such as women's employment outside of the home, the demand for gender equality and the right to make decisions about their own lives, altered women's patterns of religiosity (Bendroth 1993; Brown 2001; Marler 2008; Woodhead, 2008). Sociologists of religion, Penny Marler and Linda Woodhead show that changing familial, social and work contexts have affected women's involvement and participation in traditional church. For some, church has become more important, offering relational support and resources for women who are married, partnered, single, working or at home (Woodhead 2003; Warner 2010). At the same time, Marler perceives women's roles as moving "from home-making to self-making," which have impacted women's affiliation to churches — they are attending less. For many women, their religious identities are no longer synonymous with their relationship with a husband or children (Webster 1996). Because of feminism, a woman is no longer confined to marriage and motherhood; she can be a mother without marriage or be married without children and still have a spiritual and/or religious life.

Sexualization of Contemporary Culture

Social and cultural transformations to religious beliefs, as well as to practices, gender roles and activities have contributed to a variety of expressions and approaches to sexuality. In today's world, sexuality and the erotic as subjects are more discussed, more on display, more tolerated, and more common than they were ten to fifteen years ago (Levy 2005). Being gay, bisexual or lesbian is more accepted, singleness has increased, and heterosexual relationships are more varied and less defined by the institution of marriage. Sexual identities are multiple and complex. Sociologist Anthony Giddens (1992: 30) argues that now, more than ever, the self, and therefore sexuality, is a reflexive project.

> Sexuality has become a property of the self, one that we develop, and renegotiate throughout our lives. Today our sexuality is an open-ended personal project; it is part of who we are, an identity, no longer merely something we do. It has become a central feature of intimate relationships, and sexual satisfaction, we believe, is our due. (Perel 2007: 8)

Within contemporary societies, western cultures have become increasingly sexualized with the "pervasive, ironic normalisation of 'soft-core' pornography" (McRobbie 2004: 14). In her book *Female Chauvinist Pigs* (2005), American journalist Ariel Levy notes the increase in the number of "lad mags" that titillate the reader with images of women, mirroring widely available pornography. She also notes that women can attend a striptease/pole-dancing class for exercise instead of a regular aerobics class and that beauty is defined as a fake tan, with augmented breasts, midriff and thong underwear on show. Attending sexual exploration parties or strip clubs is viewed as female sexual power and sexual equality with men (Levy 2005). Feminist scholar Angela McRobbie (2007: 718) argues that "the emergence of the 'phallic girl' appears to have gained access to sexual freedoms previously the preserve of men, the terms and conditions of which require control of fertility and carefully planned parenthood." McRobbie (2007: 733) contends that young women can now seemingly indulge in the same sexual freedoms as men. However, conventional notions of femininity and masculinity are pervasive, affecting how women and men relate to each other. A woman may have the ability to experience more sexual freedoms, but her sexuality is often still structured by good girl/bad girl discourses.

Sexual merchandise is available on the high street, and technology has led to new forms of sexual encounters: "Phone sex, email affairs and cybersex are now part of the late modern repertoire of sexual practices and are becoming part of people's everyday lives" (Attwood 2009: xiv). The sexualization of culture has altered the boundaries between public and private. Confessions about sexual practices, relationships and affairs are now more part of daily life and daily news. Sex and sexuality is everywhere and is "a commodity in itself" (Perel 2007: 90). Sexuality and sociality now blur into one another in complex ways. Swedish sociologist Thomas Johansson asks, "To what degree can one differentiate between the sexual moments of everyday life and the discourses and images that shape human sexuality in today's society?" (Johansson 2007: 8).

Statistics indicate that people are having sex at a younger age, which means that saving first-time sex for a marriage relationship is, for many, a thing of the past, particularly for women. In the U.S., where religion is often perceived as more prominent in daily life than in Canada or Britain,[6] the national census reported, "In 2000 75 percent of American women have sex before marriage" (Winner 2005b). In the UK, the survey BareAll06, an online poll supported by the Department of Health and answered by nearly 20,000 young people, showed that "60 percent of

young people aged 22 to 24 had had more than five sexual partners, compared with 23 percent of 16 to 18-year-olds" (*The Guardian* August 15, 2006: 11). The poll also revealed that only "4 percent of those aged 24 or under were virgins with 7 out of 10 waiting until at least 16 to lose their virginity" (*The Guardian* August 15, 2006: 11). In Canada, data from "the 2003 Canadian Community Health Survey (CCHS) found that an estimated 28 percent of 15 to 17-year-olds reported having had sexual intercourse at least once in their lives." By ages "20 to 24, the proportion was 80 percent," with "one-third of sexually active 15 to 24-year-olds report[ing] that they had had more than one sexual partner in the previous year" (Statistics Canada 2005). As this data shows, in today's social climate, it is more common to have had sex before or around the age of 18 while in a serious or casual relationship than it is to wait for marriage.

Chastity and Marriage

At the same time, and within secular contexts, there has been a move towards chastity — a position taken by some to guard against sexual pressures, unwanted pregnancy and sexually transmitted infections (Carpenter 2005).[7] Young people are exploring new ways to experience first-time sex, where "virginity and oral sex can co-exist" (Bernstein 2004 in Carpenter 2005). Journalist Zoe Williams recently wrote an article entitled, "The Outdated Idea of Chastity as a Feminine Virtue is Making a Most Unwelcome Comeback," (*The Guardian* January 24, 2007: 31), noting the publication of such titles as *Not Tonight, Mr Right: Why Good Men Come to Girls Who Wait* by Kate Taylor and *The Thrill of the Chaste: Finding Fulfilment While Keeping Your Clothes On* by Dawn Eden. Feminist writer Jessica Valenti (2009: 9) argues that recent promotions of "virginity" and "sexual purity" means "that young women's perceptions of themselves is inextricable from their bodies, and that their abilities to be moral actors is absolutely dependent on their sexuality." These books endorse a deeply moral message and conservative values and norms that are challenged by an increasingly sexualized mainstream culture. Choosing a chaste lifestyle may also be a reaction to the perceived over-sexualization of mainstream culture (Attwood 2009). Because sex seems to permeate countless aspects of daily life, for many its meaning is less significant. Journalist Jenny Taylor argues that in a context of increasing sexualization and promiscuity, chastity is a radical lifestyle choice that can offer women (and men) a community and sense of hope and renewed meaning for their sexual lives.

The variation in behaviour and perspectives on sexuality coincides with practices in which Protestant churches are engaging, particularly in relation to homosexuality and chastity. On the one hand, marriage, as that which takes place between one man and one woman, has been debated in several Protestant denominations. The Anglican Church in Canada and England and the Episcopal Church in the U.S. have experienced conflicts within their dioceses on the issue of blessing same-sex unions, an example of the church's attempt to regulate what

they perceive as proper sexual relationships.[8] Some dioceses have supported same-sex unions, while others have rejected them. On the other hand, various Protestant denominations are endorsing their own messages for chastity. One example is Pentecostal churches that espouse chastity for their young people along with other conservative values for appropriate social and sexual conduct (*The New York Times* January 16, 2007). Another example is "purity balls," an event in which (mostly) young women in formal dress make pledges with the support of their families to save their virginity until marriage (Robb 2007). Evangelical Christian churches have primarily hosted these events. They are an outgrowth of the purity movement that began in the 1980s in the U.S., a campaign that was largely a Christian grassroots response to the increasingly sexualized mainstream culture (Robb 2007). Other Christian movements in recent years that advocate sex only in the context of heterosexual marriage have been evangelical initiatives like Alpha for new Christians founded by an Anglican Church in London, England, or abstinence youth movements like True Love Waits (1993) and The Silver Ring Thing (1995) that both originated in the U.S., but have endorsed their messages in Canada and Britain (*The Observer* June 27, 2004: 12). Many Christian churches and organizations utilize current media forms to make their conventional sexual message hip and cool to young people. For example, The Silver Ring Thing has its own facebook page, as does True Love Waits.[9] Emphasis on abstinence is also seen in popular Christian literature, as well as in popular Christian magazines and music (Schaefer 2010). While Christianity's moral clout on sexual matters has generally declined in western societies due to secularism, feminism and increased individualism, numerous Protestant churches continue to encourage and teach a marital-confined sexuality to their members.

Marriage, however, is certainly something many women and men are committing to later in life, which means this traditional Protestant sexual ethic is not always relevant or easy to uphold. For example, in Canada in 2001, 52 percent of women between the ages of 20-24 lived at home with their parents, while the proportion of women in this age group who married dropped from 46 percent in 1996 to 26 percent in 2001 (Canadian Census 2001). For others, not getting married is related to economic and housing opportunities. In Britain, a recent YouGov survey found that "seven percent of people aged between 18 and 30 said they had put off marriage because they could not afford to buy a property or were saving up for one" (*The Guardian* March 14, 2010: 14). It was also reported by the Office of National Statistics that, "In 2008, marriage rates in England and Wales fell to the lowest level since they were first calculated in 1862. There were 232,990 marriages in 2008, 35,000 fewer than a decade earlier" (*The Guardian* March 4, 2010: 4). In the U.S., marriage has also declined, with cohabitation on the rise. A study conducted by the National Center for Statistics, using data from The National Survey of Family Growth, found "the proportion of women in their late 30s who had ever cohabited had doubled in 15 years, to 61 percent" (*The New York*

Times March 3, 2010: A13). Thus, confining sex to heterosexual marriage is not an ideal that many people easily live out, especially when the tradition of marriage is decreasing due to various social and economic factors.

Moreover, when sex is all around in popular music, films, fashion magazines, shopping outlets and television, and flows into everyday contexts like work, university and home life, it can be a difficult issue for women to navigate when they are involved in a Protestant church community that teaches a different message. Given societal changes, I was curious about how the women were responding and interacting with the social and cultural contexts around them. When I asked women what message they would give to Christian women about sex today, Susan said,

> Both people should really love each other. Each person should feel comfortable in exploring different sexual activities and should not if you don't feel comfortable. The church cannot be so black or white on this issue because there is so much grey in between. The church's message is not so relevant for today (age 20, Methodist, attends church).

Jane answered, "I would say that it is up to you as to when and who with, but the Bible says that sex is within marriage" (age 20, Anglican, attends church), while Linda said, "Anything from God is good if you use it in the right way" (age 22, Anglican, attends church). Grace told me, "I would say that it is something loving and that shouldn't have to happen after marriage, in my opinion" (age 20, Methodist, attends church). The women share a range of responses. On the one hand, they show Christian attitudes regarding sexuality, while on the other, a fusion of Christian and secular stances.

In considering the impact of these social and cultural shifts on sexuality, gender and religion, Protestant churches face pressures to adapt or cope with a changing world. This can, therefore, result in varied stances with regard to sexuality among congregational members as they negotiate long-established doctrines in the face of ever-changing modern societies. As such, denominations within Protestantism can be seen to advocate liberal and conservative positions. This, however, does not indicate the demise of Protestant churches and their traditions, but is an acknowledgement of the richness and complexity of Christian experience. The slipperiness of the boundaries between official church teachings and ministers' and members' individual interpretations and practices amid cultural transformations thus provide a greater contextual understanding for the women's varied sexual experiences and behaviours.[10]

Heterosexuality and Femininity

For many Christian (and non-Christian) women, dilemmas with regard to gender and sexuality remain, even though there have been numerous social and religious changes affecting how femininity and sexuality are viewed and lived. Many of the

women I interviewed experienced a continued observance of the gendered and sexual tradition that female sexuality is only to be expressed within heterosexual marriage blessed by their churches. Thus, Protestant Christianity's gendered and sexual tradition has the effect of influencing, even possibly controlling, women's sexual behaviours and also other aspects of female life, such as relationships, family and career aspirations. Central to this tradition are *heterosexuality* and *conventional femininity*. Heterosexuality is defined here as an institutionalized, organizing and normative structure of everyday life, accentuating relationships and hierarchal divisions between men and women (Rich 1980; Richardson 1996). Conventional femininity is defined as an adaptation by women to hegemonic masculinity of which other forms of masculinity and femininity are perceived as subordinate (Connell 1987). Helping to shape the lives of many women, including those involved in this book, these discourses have affected women's sexual subjectivities. For example, Holland et al.'s study (1998) revealed that young men and women jointly engage in constituting a single standard of heterosexuality that regulates their sexual and relational behaviour. Their study described the femininity of young women as being constructed so as to allow them "to appear sexually unknowing, to aspire to a relationship, to let sex 'happen,' to trust to love, and to make men happy" (Holland et al. 1998: 6). Deborah Tolman's study, *Dilemmas of Desire*, helped us to see that, from an early age, women managed their sexual desires within and through the lens of compulsory heterosexuality. This view of heterosexuality that tends to emphasize traditional gendered roles can result in many women feeling pressure to "perform" femininity correctly (Skeggs 1997). According to Judith Butler, performing gender is not a singular deliberate act. Rather, it is the "reiterative practice by which discourse produces the effects it names" (Butler 1993: 2). Despite today's various observable forms of femininity, many women continue to re-iterate conventional feminine discourses. And while there are conflicting standards of femininity that demand women to be sexually desirable and chaste at the same time (Gilmartin 2006), women continue to reproduce these discourses, even though they simultaneously resist them.

These constructions of heterosexuality and femininity are evident in Protestant churches and helped to shape the lives of the numerous women I interviewed. Protestant Christianity typically affirms "femininity as the ideal spiritual and moral state for women," and marriage as the goal to aspire to (Grant 1989: 129).[11] In my interviews with women, emphases on remaining chaste until marriage, appropriate body presentation and conduct, as well as married heterosexuality were key aspects of what I term a *Christian femininity*. Women "become feminine not in their behaviour but also in their bodies, in response to particular expectations about what is appropriate, normal, and acceptable female comportment, appearance, and sexuality" (Tolman 2002: 54). A Christian femininity was, for most women, a social, religious and personal commitment. Many women in this book espoused this, since it provided them with helpful boundaries or a reference point for their

sexuality. Several spoke of preserving sexual intimacy for their (future) husbands, a decision supported by their churches, while others resisted or struggled with this teaching. Those that spoke of sexual experiences outside of marriage felt a mixture of resolution and freedom in their decisions along with shame and guilt about their transgressions. For some, a Christian femininity was something they disrupted through modes of dress (e.g., skirts over trousers, Doc Marten boots and baggy jeans) and bodily comportment (e.g., slouching) or through lesbian or non-marital relationships. Importantly, while a Christian femininity influenced Christian women's experiences of sexuality, this is only one aspect of their sexual identities. As we shall see in the next chapter, femininity intersects with race and class, affecting how sexuality is lived and experienced.

Sexuality and Agency

Just as Protestant churches are not static to the social changes to sexuality happening around them, nor are the women within their communities. Upon listening to women's stories, *sexuality*, as I came to understand it in light of their experiences in today's world, is not confined to traditional notions of sexual intercourse, genital masturbation or heterosexuality; rather, it also includes sexual desire and a range of sexual experiences, expressions and constructions of sexual identity, such as lesbian, bisexual or gay experience (Martin 1996). Such variation is lived within systems of power that often control how sexuality is defined and enacted, as seen, for example, in recent church debates about same-sex marriage and ordination. Many individuals are forced to fit within societal prescriptions of what is presumed sexual normality (Fausto-Sterling 2000).

Women and men, however, are not without *agency*; they have the ability to disrupt how these sexual discourses affect their daily lives. Where there is power, there is resistance (Foucault 1978). Jana Sawicki (1991: 103–04), who provides a feminist reading of sociologist Michel Foucault's work on discourse and resistance, explains agency,

> [The] subject does not control the overall direction of history, but it is able to choose among the discourses and practices available to it and use them creatively. It is also able to reflect upon the implications of its choices as they are taken up and transformed in a hierarchical network of power relations.

Although sexuality is shaped by gendered discourses across Christian and secular cultures, women bring awareness, insight and alternative actions to their sexuality. Women in this book lived out their sexual selves in multiple ways that included choosing abstinence until marriage, leaving their churches to experience their sexuality or being sexually active while maintaining their religious commitments. "The agency of an individual reflects how she performs within often competing regimes of discourse and practice" (Quach 2008: S153). Agency enables

women to exercise control in decisions about their sexuality, to experience sex as safe and pleasurable, and to live out their Christianity and sexuality in ways that fosters a sense of confidence. It also enables women to achieve gender equality in sexual matters with men and women, and resist their churches' constructions of feminine sexuality. Their agency helps them to facilitate how they deal with the conflicting demands of accommodating and/or resisting church and non-church teachings on sexuality. In my interviews with women, they reflected on the ways they negotiated the tensions apparent between official church teachings and secular mainstream behaviours and understandings of sexuality.

Outline of the Book

This book considers the extent to which women negotiating their Christianity and sexuality move society towards gender equality and/or simultaneously both threaten and reinforce patriarchy. In order to do this, in Chapter 2 I focus on women's intersecting social differences (i.e., race and gender) that can impact on women's experiences of church and sexuality. I also focus on women's experiences of power and community within church life. Many women described experiencing a sense of joy and gratification within their churches, but they were also aware of power relations between women and between women and men that affected them. In this chapter, I explore women's experiences of church that are complicated by race, class and respectability, as well as relations of power, community and belonging, demonstrating that women's experiences of Protestant churches are not homogenous.

Chapter 3 highlights the notion of accountability, which, in many churches, is the emphasis on one's commitment and responsibility toward the community's beliefs and values. In this chapter, I discuss women's sense of accountability to the community for carrying out a marital-confined sexuality, which, for many women, resulted in self-policing and the policing of one another in their churches. Alternatively, accountability among Christian women can produce a sense of community that was a source of encouragement and support. In this chapter, I focus on aspects of the nature of accountability that were tied to women's religious commitments.

Because many women embodied the social and cultural expectations of their churches, they subsequently found it difficult to separate their sexuality from their investment in the feminine norms of these religious contexts. In Chapter 4 good girl/bad girl discourses and the emotions that accompany them and discipline women's sexuality are addressed. Many women experienced shame and guilt and disembodied sexual experiences when they transgressed their church's sexual ideal (Holland et al. 1998). Women's descriptions of sexuality as good (married sexuality) or bad (unmarried sexuality) often gave the illusion that an embodied sexuality could be experienced only in heterosexual marriage. Although women participated in sexual activity, which confronted a Christian femininity, such

actions did not necessarily free them from the sense of feeling responsible to the expectations of their churches. Because of this, many women described feeling ashamed and guilt-ridden about sexual experiences, which contributed to the separating and silencing of their sexual selves (Daniluk and Browne 2008).

The emotions and commitments women experienced as a result of their involvement in church life were at times oppressive. This leads me to discuss in Chapter 5 the various ways Christian women expressed their agency in order to satisfy their sexual desires. This chapter will examine women leaving church life to experience their sexual selves, choosing abstinence and/or becoming sexually active while maintaining their religious commitments. This chapter examines how faith and sexuality can work hand-in-hand to shape women's sexual experiences. While their churches often promote narrow conceptualizations of sexuality, these women demonstrate their agency in living out their sexuality reflexively in various ways. I conclude the book by looking at how feminism, which has under-examined religious women's lives, can at the same time contribute to congregational practices in order that women may experience more equity within their ecclesial contexts. I also heed theologians and sociologists to offer an alternative way to consider sexuality within church community.

The religious and sexual experiences of women in this book are heterogeneous and challenge the seemingly fixed sexual interpretation that Protestant churches can espouse. Notably, a feminist thread weaves throughout the book, showing how interactions between feminism and Christianity can complicate traditional gendered constructions and expectations for women. Central to this book is the idea that while women recognize the ways in which church cultures can often limit their roles and experiences, it is through their sexuality and insights about church community that they challenge systems of patriarchy that often persist in these spaces. Hence this book also criticizes an oft-assumed secularist politics, arguing for a need to not just dismiss Christianity as irrelevant, but to understand how secularism and religion work together, transforming and impacting on women's experiences of religion and sexuality.

Notes

1. All participants' names are pseudonyms (name, age, church affiliation between 18 and 25, current church status).
2. See the appendix for more discussion on research methods and the Protestant denominations women attended.
3. See Linda Woodhead's (2004) *Introduction to Christianity* for a detailed historical account of how Christianity and its churches have developed, reacted and addressed cultural and social changes up to present day.
4. Please see *Good Sex: Feminist Perspectives from the World Religions*, eds. Patricia Beattie Jung, Mary E. Hunt and Radhika Balakrishnan (London: Rutgers University Press, 2001) and *Sexuality and the World's Religions*, eds. David W. Machacek and Melissa M. Wilcox (Santa Barbara California: ABC-CLIO, Inc., 2003) for analysis and comparison

of approaches to sexuality across different religious traditions.

5. 'Thealogy' was a term that came about during the second wave of feminism to reflect the meaning of Goddess in Neopagan communities. Women, in order to describe the feminine aspects of God, applied the term in feminist writings and literature, and in other monotheistic religions.

6. See Robert Bellah's 1967 article for an explanation of civil religion in America.

7. Chastity is "the abstention of sexual intercourse between one person and another" (Cline 1994: 143). Sexual intercourse in patriarchal Christianity is defined as a man penetrating a woman. Once a woman has been penetrated in this way, she is said to lose her virginity. According to Feminist scholar Svetlana Slapšak (2004) "Virginity is a patriarchal construct."

8. The state also has a powerful say in regard to sexuality, as seen for example in American legislation against homosexual unions and the outcries of its citizens when religious and political leaders commit adultery (Perel 2007).

9. The Silver Ring Thing is a Christian abstinence-focused organization/movement for youth and young people. It incorporates a faith-based abstinence message and contemporary forms of media with a traditional Biblical message. True Love Waits, founded in 1993, asks young people to make a commitment of abstinence until marriage by pledging, "Believing that true love waits, I make a commitment to God, myself, my family, those I date, and my future mate to be sexually pure until the day I enter marriage." The Youth Alpha programme, a world wide Christian evangelizing initiative that has its origin in London, teaches that sex and marriage ideally go hand in hand, as does the main Alpha programme (Hunt 2005). *Christianity, Youthwork, Christianity Today* and *Relevant* are examples of current Christian magazine titles.

10. See N. Jay Demerath, 1995, "Cultural Victory and Organizational Defeat in the Paradoxical Decline of Liberal Protestantism," *Journal for the Scientific Study of Religion* 34, 4: 458–69. This article discusses the influence of "liberal Protestantism's values of individualism, pluralism, emancipation, critical inquiry and tolerance" as having permeated into western society, especially in America, so much so that it has influenced it's own decline. Also see Smith and Snell's (2009) concluding chapter for their discussion of this social and cultural phenomenon and its impact on emerging adult Christians.

11. A woman, as a gendered Christian, is perhaps obliged to make life choices that differ from a woman who is a gendered non-Christian because of her religious commitments that intertwine with a Christian femininity.

Women and Church Life

"I go to church to worship God and meet with Christian friends."
(Brenda, age 22, Anglican, attends church)

"I have been going to a very White church, and if there were other
Indians, church would probably feel different." (Mina, age 24, Alliance,
attends church)

"Within our church community, women were much more put in their
place and assigned a role of passivity." (Olivia, age 45, Anglican, left
church)

Jessica (age 34, Baptist, attends church), like Brenda quoted above, also loved
to worship. The chance for her to go to church once a week to tell God that, "He
is awesome" was really important to her. She said she got "a lot of strength out
of fellowship." Meeting other young moms who were also having "a hard time
brushing their toddler's teeth," gave her the sense that she was "not the only one
in the struggles" of her life. She enjoyed worship, fellowship and loved to hear
about the Bible. Many women in this book discussed the joy and the contentment
they experienced in their churches. They found a sense of community with other
women. Opportunities to discuss everyday circumstances, and receive emotional
and spiritual encouragement were significant to them.

This chapter focuses on women's relationships with their church communities.
I explore themes that emerged when I interviewed women about being involved in
church during the ages of 18 to 25, as well as more recent experiences. Throughout
their lives, women are moving in and out of various social and cultural contexts,
including church. They are negotiating their churchs' constructions of gender
and sexuality that are complicated by other social differences, such as race and
class. While many women receive much from their churches, they are also aware
of power relations that marginalize them from leadership and more prominent
serving roles, something Olivia's quote refers to. Like Mina explains above, social
structures within their churches marked their difference. In this chapter, I discuss
women's experiences of church life and their reflections on these issues.

Identity Formation

> When we were growing up, we primarily went to the Anglican Church, the Church of England. But since I have made my own decisions about where I attend church, that hasn't been such a big thing for me. I think when I went to university, I was in the same town as my parents. The whole family had moved to town, and I ended up going to university in the new town. And since we were all new in the town, and I was 18, I chose my own church to go to. It was a Church of England church, but different, a different one to my parents'; it was a university church. (Hannah, age 27, Baptist, attends church)

Between the ages of 18 to 25, women (and men) are typically moving into adulthood and independence (Arnett 2004; Smith and Snell 2009). "Relationships with parents, religious views, and sexuality" are all areas in which women are developing and exploring (Lefkowitz 2005: 41). For many, these years are a time when one's peer group becomes a key influence in their self-development. In moving away from home, many young people gain more autonomy in making decisions. It can be a time of sexual discovery, and as Hannah explains above, changing environments can allow for more religious exploration (Lefkowitz 2005). Although many young people today continue to live at home due to social and economic factors, for those that live away from home, family is less central to their personal formation compared to wider social influences. However, long-time family effects based on Christian values can remain, even in the background, making this time of transition a complex one to navigate.

Writing on women's self-development, feminist and psychologist Jean Baker Miller (1976: 83) states, "women's sense of self becomes very much organized around being able to make and then to maintain affiliations and relationships." A woman's identity formation is very much tied to relational growth and movement with others. It is shaped through social processes, practices and relationships. Hence, the community and friendships that many women experience in church can impact how they live out different areas of their lives. Anita told me, "I think the church played a huge role [in my life] in terms of living for the values that were in the church" (age 28, Baptist, left church). In my conversation with Victoria, she expressed similar themes:

> I suppose [church] completely influenced my life in terms of the choices I made. Well, not in terms of did I go to university and what I studied, it didn't really. Well, I prayed about where I should go to university and believed that God wanted me to go where I went. But yeah, the kind of people who I'd be friends with. I was quite involved in the Christian Union at university, and when I started, well, I went to university when I was 19, and I had had a year where I had not lived the good Christian girl kind of life. Then when I did go to university, I

was determined that I was going to be, you know, a really enthusiastic Christian — join the Christian Union and make Christian friends, that sort of thing. From the start, it influenced, even fresher's week, what I did during that. I won't get drunk, and sex, I decided I wasn't going to have sex until I got married.

Sonya: Were you dating anyone at the time?

Victoria: When I went to university?

Sonya: Yeah.

Victoria: No. I had a boyfriend and some flings before, when I was 18, but that had finished before I went to university, so it was a new slate. My faith influenced everything.

Sonya: So, it gave your life structure during that time, it gave you friendships...

Victoria: Yeah, support, community, moral codes to plan my life by, and the codes I chose were very selective, like I don't have sex and don't get drunk. (age 29, Anglican, between churches)

When women find a strong community and support in church, the values and standards that are encouraged there can contribute greatly to their emerging identities. Janet Surrey, who writes about women's identity development, emphasizes that the direction of personal development is not towards "greater degrees of autonomy or individuation," even though moves towards independence are happening, but toward processes of growth in relationship. From Victoria, we learn about her investment in the relationships she found in her Christian community. Growing through relationship becomes an important aspect of women's experiences, where "developing all of one's self is in increasingly complex ways, in increasingly complex relationships" (Miller 1991: 21). Alongside relationships with family, many women find close relationships in their churches, where they feel heard and validated. The risk, however, is that women become oriented to relationships — including in their churches — that may be harmful or disempowering, where they cannot or do not fully participate or are without a voice. Women's growth in connection is throughout the life course, and life experiences can become more complicated as women navigate through familial situations, careers, education and so forth (Miller 1991). Even the negotiation of a woman's sexuality in relationships becomes more complex. While Victoria states, "I don't have sex," her sexuality is lived and negotiated among dominant values and norms and within relations of power both structural (i.e., religious teachings) and material (i.e., with another man or woman).

Relationships can also be significant to the development of one's Christian

faith. Theologian and feminist writer Nicola Slee (2000: 6), who draws from the work of feminist psychologists, found that patterns of women's faith development proceed within the context of connections and relationships. This finding by Slee is what many of the women in this book would confirm. Community, friendships, and a sense of belonging and connectedness were essential to their experiences of church and to the formation of their Christian identities. Jane said, "You may have a building, but without a community, there is nothing there, really" (Anglican, age 20, attends church). Church involvement can subsequently be crucial to women's sexual formation. Social, religious and personal development, including sexual, can be strongly informed by regular church participation and church peer relationships.

This transitional time of 18–25, and life transitions more broadly, are complex and continually contested. The nature and experience of these are likely to vary according to various markers of social difference (Hopkins 2006). Whether women move into employment, higher education, find a new church, go travelling, start a relationship, make new friends, get married, have children or a combination of all of these, their ability to move through these life changes will likely be influenced by their gender, class, race, sexuality or religion. Women's religiosity is central to this book, but it is only one characteristic of their identities. Religion intersects and is lived in relation to other aspects, such as race, class and gender. Focusing on how such intersections can work is what I now turn to.

Intersecting Differences

> My church, apart from being a ministry, was also White, kind of middle to upper class, so what you wear was something, going to university was something…. Whenever my Dad would come to church on the odd occasion, I could sense his difference when he was there, and hence my own difference, and at times, this was difficult. He is Indian. (Maria, age 30, Baptist, left church)

Although Maria discussed church as an enjoyable experience in our interview, it was also one in which she experienced her race and class that caused her to feel different, at times out of place. During the course of women's everyday lives, they not only experience pleasure, satisfaction and fulfilment, but also lived realities of intersectional oppressions and marginalization (Crenshaw 1989; Yuval-Davis 2006). Feminist scholars Avtar Brah and Ann Phoenix, who write about intersectionality, remind us that this dynamic is historical and can be seen in the life of Sojourner Truth. She was an African woman who had suffered enslavement. In 1851, at an abolitionist convention, she stood up and said, "I have borne children and seen most of them sold into slavery, and when I cried out with a mother's grief, none but Jesus heard me. And ain't I a woman?" Race, gender, social position and religion were all given heed in Sojourner Truth's speech, highlighting that her experience was not just lived through one aspect of her self, but through many facets

of identity (Brah and Phoenix 2004). Thus, one is not simply a White woman, but a White, middle class, Christian woman. Race, class, religion and gender are not static categories of identity, but are always in flux depending on culture, geography, history and sociality. Sociologist Amy Wilkins (2008: 6) writes that race, class and gender are not merely "things that we *have*," but they are "things the we *do*," and that are performed (Butler 1990) in accordance with the contexts in which one is embedded, the social structures that one is conditioned by. They can operate on many levels and seem invisible, all the while affecting people's lived experiences and circumstances. Sojourner Truth's speech encompasses gender, race, social position and religion, which are social structures, and embodied and enacted experiences that affected her life.

Through the women's movement, feminist scholars have helped us to see how religion and race can aggravate women's experiences of gender and sexuality (Ruether 1983; Daly 1985; Lorde 1984; hooks 1990). Kimberlé Crenshaw, a legal scholar, considered how gender and race *both* worked to affect a woman's life. She was the first to speak about intersectionality. She "argued that theorists needed to take both gender and race on board and show how they interact to shape the multiple dimensions of Black women's experiences" (Davis 2008: 68). Following Crenshaw, early intersectional analyses focused on overlapping categories of identity with more recent developments conceptualizing, for example, gender, race and class as systemic forces that shape societies rather than as individual traits (Vakulenko 2007). The intersectional approach I apply is that the relationship between the self and the social are inseparable — "structural influences are always subsumed and internalized in the individual" (Vakulenko 2007: 186). Applying this kind of analysis to the women's lives allows for a consideration of some of the complexities and contradictions that they experienced, particularly in relation to religion. Sojourner Truth's speech reminds us of this. Religion, used by the slave masters during her time, was a structural force that was oppressive, but her religion was also embodied and gave her a form through which to resist types of subordination. As such, within intersectional theorizing, religion, unlike gender, race and class, has been less considered. Feminist scholars and academic theorists have been wary of religion because of its history of colonization and patriarchy (Klassen 2003). While this is evident, it is also clear that religion is important to many women's lives and can complicate how gender, race and class are lived. Religion cannot be regarded as a distinct category of difference or choice, but is, in reality, intertwined into people's everyday lived experiences (Reimer-Kirkham and Sharma 2011). This is certainly the case for the women in this book. In the following sections, through the women's experiences, my aim is to show how instances of religion are lived when race, class and gender intersect. Many of the women carry out similar religious beliefs and practices, but they are diverse in their backgrounds, ethnicities and personal histories. Some of the women talked about underlying issues of race and class that affected their church experiences. Others spoke about

the correlation of beauty and race in their congregations. They also revealed how Christianity and notions of respectability work hand-in-hand in their churches and families in order to be accepted and to maintain their reputations as good.

Religion and Race

I now turn to an excerpt from Mina. In our interview, she told me about her experience of being a Brown Christian woman in the church her family attended. She said,

> My church is part of a denomination that is based on missions; there are a lot of White people involved and a lot of White Christian values in the church, very White Anglo-Saxon. We were always Othered in the church. I was the only Indian person at Bible school. I still think I have that feeling of not being good enough because of my culture and my parents not always being Christian. There was always this glamorization of my family in my church. They converted from Hinduism to Christianity. We happened to be converted and Brown as well. It's an interesting story, especially for those people who are White. 'Oh those Punjabi people that converted.' There is no intention of being mean by them, it's just that the church emphasizes missions and evangelizing, and our family did have a conversion experience.... My family has always been different, and I have always been different.... I never really was fully accepted in the church group because I was the converted Indian girl. It was never said out loud, but I knew that I was different. (age 24, Alliance, attends church)

Mina's religion is a point of social connection for her and her family. By converting to Christianity, they assimilate into the "host society," which gives them a community in which to belong. Yet, as Mina indicates, Christianity is racialized as White, "a phenomenon wherein the fact of an individual's *race* creates a presumption as to her *religious* identity" (Joshi 2006a: 211). In North America and Western Europe, Christianity and Whiteness are intimately linked, generating social norms and forms of power (Joshi 2006a).[1] Even though Mina's conversion to Christianity generates a sense of acceptance, her race creates a feeling of marginalization. Sociologist Ruth Frankenberg (1993: 1) articulates that, "whiteness is a location of structural advantage, of race privilege... a place from which white people look at themselves, others and society." In Mina's account, the conflation of race and religion results in her not feeling "good enough" in her church and peripheral to forms of privilege created by Whiteness and Christianity.

Khyati Joshi's work on Indian Americans shows how racializing religions, such as Hinduism or Christianity, "results in essentialism; it reduces people to one aspect of their identity and thereby presents a homogeneous, undifferentiated, and static view of an ethnoreligious community" (Joshi 2006a: 212). Such acts, conscious and unconscious, result in or exacerbate differences of minority groups,

which Mina reveals in having been a Brown Hindu in a mainly White Christian community. She and her family represent the evangelized "Other." Edward Said has discussed how White Europeans and Americans have historically constructed an image of East and South Asians, creating discourses on and about the Other. Mina refers to this dynamic above when she says, "There was always this glamorization of my family in my church." Joshi (2006a: 217) explains that Hinduism in current western sociopolitical and cultural contexts is often "exoticized," while "Islam is demonized, and Sikhism is vilified." When axes of marginalization, such as race, are layered onto religion, there can be a compounding and demoralizing effect. This results in Mina's peripheral position in her church, even though she and her family's difference and eventual religious conversion accords them a place in the congregation.

Inclusion and Exclusion

Religion can be a powerful social force for inclusion and exclusion, especially when it overlaps onto race and class (Reimer-Kirkham and Sharma forthcoming). As Mina describes above, her Christianity afforded her acceptance at church, but her race marginalized her. Inclusion and exclusion are not binaries, but overlap because social differences create tensions between fitting in one way (i.e., religion) but not in another (i.e., race). A Black Nigerian woman named Miriam who had lived in Britain for a number of years spoke about an experience she had at her church:

> My husband was a leader in the church, as a deacon. Once my middle son did a Bible reading, and two people came up to me and said, "Oh, isn't wonderful how he reads! We don't understand [your husband] when he preaches," and I said, "Why not? My husband is a university lecturer. He doesn't lecture in our dialect; he lectures in English. Why don't you understand him and how come you understand his child?" And they said, "Oh, Miriam, you're too sensitive." And I said, "No, you understand the child because the child is raised with an English accent. He was born here, but when they call on my husband, the iron barrier is raised. When you hear my husband, you hear Africa and your heart is closed; you are not open." And they said, "Miriam, you are such a difficult person." If I am going to be sincere, I hate to be in a situation where I criticize my church. (age 43, Baptist, attends church)

Apparent is how religion can become identified with "real or imagined ethnic/racial characteristics" (Joshi 2006a: 217). Miriam explains that they understood her child's reading of the Bible because he was raised with an English accent. When they heard her husband read, they heard "Africa"; they heard his difference. Part of being accepted into the Christian community, as Miriam conveys, is being able to speak and sound like the White majority. However, the way Miriam's husband and son speak is racialized. Her husband's race presumes a certain intellectual and

linguistic identity that is perceived as inferior. While Miriam's son's reading surprises them because they made an assumption about his language skills based on his race.

Class, in relation to race, is also given social meaning that results in people being identified or identifying themselves in certain ways (Joshi 2006a). In Miriam's account, her husband's education and job indicates a certain social standing. However, his position as a university lecturer and a deacon at their church, a mark of esteem and social status, did not alter her fellow parishioners' view of him. Because of his difference, this intersected with how they viewed his social and personal achievements.

Miriam's story reminds us that race and class are not distinct. They are always lived in relation to power and other social differences, including religion. Miriam remarks that she disliked being critical of her church because it was a place of belonging and she had close friends there. Her religiosity gave her a place where she experienced a sense of inclusion. However, when religion is overlapped onto race and class, it can invoke colonial images of the racialized Other, positioning those who are not White western Christians on the margins, and re-inscribes longstanding patterns of exclusion and inclusion (Reimer-Kirkham and Sharma 2011). Miriam and Mina's stories demonstrate the contradictions that abound in their church communities — Christianity seeks universal fellowship, but can enforce partial norms — and the underlying relationship between race, religion and class.

Beauty and Whiteness

Christianity and Whiteness are historically perceived together, and sustain pervasive cultural sway (Joshi 2006a). Instances of race and religion as demarcations of identity can be quite clear, as seen in Mina and Miriam's stories. At other times, race and religion can seem invisible or normative (Frankenberg 1993), especially in relation to ideas about beauty. When I interviewed Maya, who comes from a Chinese background, she discussed some of her observations about the other "girls" at church. She said,

> I always think of the pretty White, middle- to upper-class good girl, happy, smiley, pretty, wanting to help, going through a little pain in her life to earn the pity of the rest of the congregation or the affections, not the pity. Don't you see that the pretty girls got more attention than the Brown girls, the, not-so-good-looking girls, ones without the wardrobe from Banana Republic, or the butchy girls? They just didn't get that kind of [attention]. (age 34, Baptist, left church)

Maya captures what other women described — being White, pretty, emotionally affirmative, dressed in designer brands and of a certain class background provides a source of social currency in their church communities. Whiteness also "refers to a set of cultural practices that are usually unmarked and unnamed" and that can be privileged (Frankenberg 1993: 1). Maya names the

unnameable by describing "what a Christian woman should look like." While being Brown, unfeminine, unattractive and dressed in non-designer brands is the opposite. "Appearance operates as the mechanism for authorization, legitimation and de-legitimation" (Skeggs 2004: 100). Maya points to the prominence given to Christian women who are White and of proper attire, which the middle and upper classes have historically been associated with (Skeggs 2004). R. Marie Griffith also brings notions of beauty and race, class and bodily physique within Protestant Christianity to the forefront in her book *Born Again Bodies: Flesh and Spirit in American Christianity*. Although her focus is within the American context, her findings are pertinent to the women in this book. She finds that slim, physically fit bodies represent the spiritually authentic, while the obese are considered lazy, sinful and undisciplined in their faith. A disciplined lifestyle in areas such as diet, fitness and sexual conduct mean a closer relationship with God. Griffith thus contends that Protestant ideals of thin, beautiful bodies are frequently racialized as White, generating forms of power and privilege within Christian cultures. Another woman described the particular beauty that was given reverence at a church she attended,

> Blonde and thin very important…. The best women in the ministry are blonde trophy wives: talons, could play the flute, will sing, must sing, woman's place is to sing and have their beauty heard through voice. You're beauty is important in a way. You have to be White, nouveau riche… (Rhonda, age 26, Pentecostal, left church).

These observations, made by Maya and Rhonda, point to normative representations of beauty and femininity in their churches, which are widely accepted as "Anglo-Saxon and heterosexual" (Bordo 1995: 25). However, sociologist Amy Wilkins (2008: 10), in her ethnographic research on a subculture of mainly White evangelical Christians on an American university campus, describes Whiteness as less easy to define. "Whiteness, once taken for granted, is now a more problematic identity… once used to define 'normal' behaviour or 'normal' people" is not the case, for Whiteness also intersects with various markers of difference, such as gender, religion and class that complicate assumed norms of what it is to be White. Sociologist Katerina Deliovsky found in her work on compulsory White heterosexuality in European women that they face pressures of their own to perform "White" feminine sexuality that is consistent with gender, ethnic and race expectations. Those that step outside of these expectations, for example to experience an interracial relationship, are seen as breaking their loyalty to Whiteness and the patriarchy within their families and communities. Because of an invisibility of Whiteness in mainstream cultures (Bordo 1995), these pressures for White women are often perceived as absent or are unacknowledged by those around them. Several of the women interviewed were aware of their social differences and privilege, and how these could marginalize or accord them status in their congregations.

Respectability

Underscoring many women's experiences of religiosity and sexuality is the notion of respectability that is tied to being a "good girl." Intertwined with Maya's description of race and beauty is the idea of being respectable through feminine comportment and presentation, which can mean social acceptance. Another way of being accepted and respectable is through sexual morality. Evelyn Brooks Higginbotham, who focuses on the history of African American Pentecostal women, discusses the intersection of race and religion with respectability. She addresses how Black women emulated the sexual behaviour and etiquette of White women so as to receive respectable treatment (Higginbotham 1993). This strategy taken up by Black Pentecostal women worked to resist images of Black sexuality that were perceived as deviant, but also worked to control and limit the range of acceptable sexual expressions (Higginbotham 1993; White 2001).

Upholding certain behaviours can symbolize morality, self-esteem and self-respect. Some women talked about what it means to be a respectable Christian woman. Rose was the oldest woman I interviewed. She understood the pressures that young people can confront today with regard to sexuality, but this did not stop her from expressing her concern and observations of one young woman she knew in her church:

> There's a young woman in our church who will give [sex] freely to anyone who asks…. She always comes and gives me a hug and introduces me to the next bloke, and about a year ago, I said to her, "I do not want to give you another hug until you start behaving yourself because I do not like what you are doing." It wouldn't bother me if she was in a proper relationship with one guy, but it's a different one every Sunday. She sits in church snogging nearly every Sunday; I think she likes showing off her conquests. She's 21. I can't cope with her. If you want to do that, leave church and get on with it, but don't come to church, pretend you are a Christian and live like that because that's not the way Christians live. (age 65, Baptist, attends church)

Rose's religious and feminine values inform her opinions of this young woman's behaviour. She is not acting as a Christian woman should, her sexuality is out of control. Rose would prefer this young woman to be in a proper monogamous relationship where her sexuality is contained and therefore more respectable and respected. Rose, while concerned for this young woman's well-being, perceives this display of sexuality "as a practice of the uncivilised, the one without respectability" (Skeggs 1997: 121). Also apparent in Rose's statement is how women can reinforce conventional norms, reproducing feminine ideals and expectations that are rooted in systems of patriarchy.

While race and class are not explicit in Rose's excerpt, sexual purity is often gendered, classed and racialized (Wilkins 2008). On sexual purity being racialized, Wilkins (2008: 15) explains, "Because interpretations of gendered sexual behaviour

are shaped by racial meanings, White women are able to remake themselves in a way that Black women are not." In Rose's example, the young woman was White, and hence, all she had to do was find a committed relationship to turn herself and the perceptions of others around. Brown and Black women can engage in a range of sexual behaviours, but White women do so with fewer costs (Wilkins 2008). This phenomenon is also described as "sexualized racism" (Collins 2000), whereby stereotypes cast Black women as promiscuous and/or, for example, Latina women as sexually available and desirable (Valdivia 2000).

As Rose alludes to, for many women, religion can be used as a strategy to avoid being perceived as sexually immoral. If the young woman were to have acted more Christian, she may have been perceived as a good Christian woman. Religious practices and feminine practices are intertwined and mutually constituted. For this reason, they can work to counter the consequences that the racialization of women's sexuality can bring. In a study of immigrant Filipina women in America, sociologist Yen Le Espiritu found that sexual restraint, often related to their religion, was endorsed and practised in order to position themselves above "loose" White women (Espiritu 2001). The Filipinas in Espiritu's study perceived White American women as sexually liberal, and thus employed their religion and other forms of cultural reconstruction "to reaffirm to themselves their self-worth in the face of colonial, racial, class, and gendered subordination" (415). For women across different ethnicities, sexual morality is linked to femininity, race and class, but also religiosity, whereby Christianity can merge to restrain sexuality, thereby maintaining women's respectability.

Family Honour and Acceptance

Respectability is also linked to familial and cultural expectations. Miriam, who comes from a Nigerian background, discussed how sexuality was approached in her family growing up:

> I knew whatever I did, I never had myself in a situation where I would have to consider whether to indulge in sexual activity or not, so that was not a problem for me. It would bring shame to my family if I [didn't] get married a virgin, and I would feel ashamed, and the man might disrespect me, thinking, 'Oh, how many more have [there] been'? So, it was important for my future; it was important that I didn't go there.... It was my faith and my culture. The two together have had a great influence.

Miriam enacts her femininity in order not to be seen as a promiscuous woman, which is tied to her family's honour and her Christianity. A woman's perceived out-of-control sexuality is a threat to her family's reputation and standing in the community. Notions of respectability are determined by patriarchal discourses that "look at honour and shame from the point of view of men, while women are the sites or the symbols" (Viswanath 1997: 316). The woman and family's honour

are placed on the behaviour of the woman. She is held responsible. "Thus, women's sexuality is only allowed to be expressed within legitimate spaces," such as marriage (316). Within familial spaces such as Miriam's, relations of power are entrenched in constructions of masculinity and femininity (Lees 1993: 18). Miriam, therefore, states about her sexuality, "I didn't go there" because her future involved a man, "the masculine 'other'" that holds "power and control" (Mann 1996: 82).

The women also discussed perceiving father figures and church leaders as God-like or God as a patriarchal man-like figure, affecting the expressions of their sexuality whether alone (e.g., masturbation) or with another. One woman named Olivia told me about how her father was a vicar and how she used to think of him:

> I put my father on a pedestal next to Jesus, and I think as a child, I had a difficulty with the identity that this is my Dad like anyone else's Dad, but actually he's not like anyone else's Dad; he has contact with God. (age 45, Anglican, left church)

As a young woman, she then married a vicar and equated him as God-like, too, but realized,

> You can't have sex with somebody who is supposed to be a divine being. To have sex, it is a bit earthy, and you have to both be human. And now, we've got a nice levelled human relationship because I'm an atheist, and he is nothing but a human to me! And our relationship is much improved.

For many women, notions of femininity and respectability are constructed at home in relation to family men (i.e., husbands, brothers) (Mann 1996). These constructions found at home can be mutually constituted by church life and religious experience, whereby women equate ministers as God, and God as a patriarchal figure to whom they feel compliant and restricted in their femininity and sexuality. This contributed to Olivia's experiences of her sexuality. Through a process in which she gave up her faith, she became more sexually fulfilled.

Respectability, as it relates to sexuality, is further intertwined with reputation and social acceptance. "Sexuality creates moral boundaries," which can create separations and hierarchies between people (Wilkins 2008: 13). Angela, who identified as lesbian, talked about her experience of being homosexual amongst her Christian friends:

> I couldn't talk to any of my Christian friends about [being gay]. The Christian friends [who] I did tell, [had] an attitude of, 'That's nice, but we won't really talk about it.' So, I had a large group of Christian friends [who] were quite evangelical — that the Bible is literal and being gay is wrong — and big groups of gay friends who say that the church doesn't like us, and me stuck in the middle by myself. (age 23, Anglican, between churches)

Angela feared telling her peers about her sexuality in case they rejected her. Where sexuality intersects with traditional religion, privileging heterosexuality contributes to the silencing of women's diverse realities, as seen in Angela's experience among her Christian friends. This can mean the exclusion of a range of experiences had by lesbian, bisexual and transgendered women (Daniluk and Browne 2008: 135). These sexualities become deemed without respectability because they do not fit within the expectations of a Christian femininity that endorses compulsory heterosexuality (Rich 1980). Many Protestant churches thus sustain constructions of "women's sexuality in accordance with the values and power of patriarchy" (Daniluk and Browne 2008: 131). Conventional religious teachings can therefore result in people judging the sexual relationships of others and/or themselves with consequences for sexual pleasure and enjoyment. Despite contemporary liberal messages about sexuality and femininity, traditional religious teachings have historically been part of western society's cultural beliefs and values about sexuality. Angela highlights this fact in how her gay friends perceive the church, which has contributed to their marginalization within wider society. Traditional religious teachings have shaped and impacted "the sexual experiences, identities and sexual self-perceptions of girls and women regardless of religious affiliation" (Daniluk and Browne 2008: 135).

Christianity is lived at the junctures of class, race, gender and sexuality, and varies across time and place (Reimer-Kirkham and Sharma 2011). In the women's experiences, religion intersects with gender, race and class to encourage appropriate behaviour. The risk of employing religion as a moral and social strategy of resistance (i.e., to resist being seen as promiscuous) is that it perpetuates patriarchal Christian constructs. Historically, churches have been places where women are affirmed theologically and socially for right behaviour. Yet, this can mean acquiescence to hegemonic norms and values. Enacting notions of respectability and femininity that are tied to patriarchy may afford access into social and cultural spaces, but can also result in the sexual oppression of Christian women. These women's experiences shed light on sexuality as where religion, class, race and gender collide (Wilkins 2008). I now turn to Christian women's experiences of negotiating power within their churches.

Negotiating Power

Women's experiences of their sexuality are complicated by intersecting social differences and relations of power. Highlighted in this section is how women negotiate power within their ecclesial communities, even though many experience their churches as encouraging and supportive networks. Responding to societal changes, many women have been leaving church life in large numbers since the 1960s. However, compared to men, they still constitute the majority of churchgoers (Davie 1994; Walter and Davie 1998; Brown 2001; Vincett et al. 2008). Also, in contrast to men, women's experiences of their churches are different. Studies,

beginning in the 1980s, emerged to record and bring attention, through empirical work, to women's religious lives, particularly in Protestant Christian communities (Ammerman 1987; Ozorak 1996; Griffith 1997; Brasher 1998; Beaman 1999; Wraight 2001 Heyer-Grey 2001; Porter 2002). The challenges and joys of women's involvement in Christian communities began to be captured. What follows are some key themes that emerge from these studies, which help to highlight the experiences many of the women discussed in their interviews. I begin with a quote from Jessica:

> I would say two major influences in my life and church who are men: my pastor who totally respects women, and actually who I think prefers women and thinks men are losers, and my father-in-law, who stood up on Boxing Day at church when it was time to share about the spirit of Stephen, who was one of the first deacons in the church in the book of Acts. He stood up and said, 'I need to mention women, especially at this time at Christmas, who, when you really look at the spirit of Christmas, are the ones who make it happen, are the ones who shop and wrap the gifts and distribute them, who cook and make the dinner, who clean up. Like let's be honest here, it's women,' and I respected him so much for that. So, I do think men have influenced the experience of women in the church. (age 34, Baptist, attends church)

Jessica highlights the gendered power relations that exist within her church, but also the awareness of them by both women and men. Although some have argued that there has been a feminization of churches because countless men have left and women remain, it does not replace the fact that patriarchy is still alive and well in countless congregations, where men hold positions of power and leadership that affect a congregation's perceptions of gendered roles, and thus how women (and men) negotiate patriarchal structures embedded in church life. Sociologist Brenda Brasher found this in her ethnographic study of two fundamentalist church congregations in California. She describes the Christian women in her study as being very involved in women's ministries that have a prominent presence in each church. Yet, in order to have a voice in decision-making, the women "bargain with patriarchy to get what they want.... To have any chance of realizing their religious goals, they must work with male believers, not against them" (Brasher 1998: 68). Similarly, Nancy T. Ammerman (1987: 146), a sociologist of religion and researcher on American church congregations, found that fundamentalist women "learn how to influence family decision-making while still deferring to their husbands' authority." It is also the case that Pentecostal women "exercise a considerable degree of influence over domestic and family matters, find important arenas of religious expression and even achieve a surprising measure of individual autonomy," even though the oppressive reputation of their churches "masks a very different substantive reality" (Martin 2001: 53). It cannot be simply put that men have all of the power and exercise it over women. Rather, power is a relational conceptualization, and women make moves to negotiate their roles and positions

(Beaman 1999). Women in the United Church of Canada are transforming age-old perceptions of gender and systems of power that exist within that community by earning and working their way into more prominent roles in leadership (Airhart 2006). Disallowed to preach in the pulpit, African-American women have also forged paths to equity and interdependence with men in the Sanctified Church (Gilkes 1985). They have, through collective action, established traditions that have sustained the life of their community and the strength of their presence. Through their roles in the community as educators and economic providers, they transferred these skills and roles to their churches, making a prominent place for themselves alongside the men.

However, some women are not fortunate enough to have the support of the women in their communities. Resistance to women's changing roles can be perpetuated not only by men who hold positions of power in their churches, but also by women who can perform patriarchal practices that attempt to keep women in their place. Olivia, a vicar's wife, who had just begun to go to university and reduced the frequency of her church attendance, told me about her experience. For years she had been a vicar's wife and a mother, but when she decided to make some changes in her life, women in her church expressed their disapproval. Olivia said,

> A lady came to the door one day and said, "Oh, you've got wild parsley in your garden." I said, "Oh, have we? How lovely!" And she said, "They say it grows in houses where the woman wears the trousers." Now, she said that about the time I was going to university and starting to have my own life, and clearly the message was one of disapproval from the congregation.

Evident in Olivia's excerpt are the traditional and patriarchal ideals of femininity, such as marriage and motherhood, that frequently define a Christian woman's identity, and one in which women can play a role re-enforcing. These ideals can subsequently limit women's capabilities and aspirations.

Forging Spaces and Serving Roles

Women whom I interviewed found ways to negotiate and exercise power, ways to have their voices heard in church life. Many found congregations after moving away from home that were more egalitarian, allowing them to have a say in the decision-making. Often, these churches were student-populated and encouraged parishioner involvement at various levels. They were different to the churches the women attended while living at home with their parents. Cynthia, who attended church at her university chaplaincy, said, "Back home, I don't have a voice, but here, yes. Here [at the chaplaincy], I am so well looked after, but at home, I am out of things because I am not 60" (age 22, Anglican, attends church). In contrast, some women described their voices as only being heard in their congregations if they were mothers or wives or were discussing domestic-related church activities. Abigail

explained, "If [a woman's voice] is in a permanent role, it is heard and listened to. I think sometimes it gets put into a minority voice, if it is about a domestic issue like a weekend away" (age 33, Methodist, attends church). Women nonetheless confronted gender partiality in the running of their churches.

However, many women make attempts to carve out spaces where they can feel a sense of power like the men do in their churches. Veronica told me about her experience:

> I looked up to the men. I wanted to join the club, and I actually did join the club. I became an alter girl. I was the first alter girl in [Canadian province]. They were all boys, and there was a little change to the agreement saying that girls could do it. I heard about that and went right for it. I wanted to be in the leadership. Women were not doing that. They weren't role models for me. I didn't look up to any of them — they polished the brasses. That's what they did.

> Sonya: What struck you about women polishing the brasses?

> Veronica: From the time I was a kid, I could see how the power thing worked out. A man was at the front doing the important stuff. No women were at the front, and the women [who] were there were with the shammies on a Saturday. I had to go with my mother on a Saturday to do the alter guild, and it was awful to go in there to polish the brasses and clean it up. I never saw anyone acknowledge that labour as important. It's not as if it got any credit; it was just a duty. I never looked up to any of that. I was inspired to give sermons and to have all my hands on the important stuff like the bread and the wine, the serious stuff where the men could only go, and so I became an alter girl so I could go into that holy place. I felt that it was power, a feeling of leadership. I didn't want to be with the other women making tea at the end of the service. It didn't attract me at all. (age 48, Anglican, left church)

Veronica figured that if she was doing what the men were doing, she was therefore involved in the power structure of the church. If she did the things the women were doing, she saw herself as being denied power. Despite the moves Veronica made at a young age and the bargains women make with the patriarchy in their churches, researchers have found, "women [who] comprise at least 60% of most religious congregations have not been allowed to function in as many or as essential roles as have men" (Rayburn and Richmond 2002: 180). Women continue to be delegated conventional serving roles in Protestant churches. In a small study on women in Baptist Church communities in the U.S., Zoey Heyer-Grey (2001: 111-12) found that women are "more likely to perform supporting rather than leading roles... less visible in their serving roles at church services despite outnumbering the men in attendance, and are much more involved in the

everyday jobs key to sustaining church life." Such is the case for many evangelical women from Northern Irish denominations who consistently negotiate their roles and offerings in a context that does not often recognize the contributions women make to their congregations (Porter 2002).

Community and Conforming

The sense of connection and community many women find in their churches can far outweigh the "patriarchal systems of belief and practice" they confront (Ozorak 1996). Several women interviewed for this study remain churchgoers because of the support they find in these communities. Christian women can be "empowered through their beliefs and through their connectedness to their faith communities" (Beaman 1999: 142). Women in this book talked about attending church because of the friendships and community they found there:

> Friendship is what helps make the community, the culture and the shared experiences. Friendship means that you don't feel isolated. You are not just one Christian; there is a group of you. You don't feel alone. (Linda, age 22, Anglican, attends church)

> And I think also the community because I know most of the people there, a lot of them have known me since I was a baby, and so it's sort of a real church family. (Jane, age 20, Anglican, attends church)

> I go there to worship God and meet with other Christians who are in that same position of wanting to know Him better and to understand what He asks of us, to give Him glory and to have time in the week that is specifically focused on God. (Brenda, age 22, Anglican, attends church)

Many of the women interviewed described their churches as a sense of community; a place where friendships abound, where interests, values, beliefs and a "like-mindedness" are in common. For some women, however, the expectation to "conform" to their church's values and standards can be one reason why women leave church (Wraight 2001). The sense of community that women find so important to their experience of church can simultaneously act as a source of pressure to conform to standards that do not fit with how they want to live their lives. Numerous women have therefore left their churches because the pressures to conform to traditional gender roles and a marital-confined sexuality were too great. These ideals did not allow them to embody their sexuality in ways that fit with their desires. Simone discussed her experience of church after she identified as lesbian:

> I was actually thinking of becoming a minister. I was really into it, but then when I became a lesbian, I thought I don't feel comfortable with that. I had heard people from my own church saying that homosexuality was bad, and I was personally hurt to hear things like

that, so that made me take a distance from the church. (age 38, United Church, left church)

Although her former church currently performs marriages for same-sex couples in Canada, at that time, she felt she could not act on her desire while remaining in her church community. Her reason to leave, however, was not based on feelings of shame about her sexuality, but rather a presumption of future exclusion. Sociologist of religion and sexuality Andrew K.T. Yip found in his research on gay, lesbian and bisexual Christians in the UK that their decision to leave their churches was not "precipitated by shame and guilt," but was "precipitated by their counter-rejection of the Churches, having felt that they were rejected in the first place…. Respondents preferred leaving to exclusion." He found that these former members "had arrived at a stage in their faith where they were assured of God's acceptance of them, and that their Christian faith need not be undermined" (Yip 2000: 141). They countered the power structures within their churches that said their sexuality was wrong by leaving the institution, not their Christian faith.

Although a quarter of the women I interviewed no longer attend church, leaving church is not necessarily the result of no longer having a faith or not being spiritual. Rather, the reason for leaving lies in what their churches could not offer, such as safe spaces to explore issues of gender and sexuality. There is often "a gap between conservative church teachings and norms surrounding sexuality and gender, and the lived experiences of those who negotiate them" (Aune and Sharma 2007: 168). Numerous women face marginalization because of church values that endorse marital and familial roles as normative, which can cause single women to disaffiliate (Aune 2008a; see also Wraight 2001). Single Christian men may also be questioned if they have not married because of a dominant male heterosexuality. Across Canada, the U.S. and Britain, unmarried people have lower church participation rates (Clark 1998, 2000; Aune 2008a), while church attendance is significantly higher for those who are married and have children (Clark 2000: 23).

Belonging Found in Church

Many women do not consider leaving their churches to be an option because of the fellowship and communion they find there. Rose, who had attended church all of her life with her husband and children, explained her reasoning for not leaving church: "Because I love God, and I want to worship Him, and I've got a lot of friends there" (age 65, Baptist, attends church). The support, affirmation and fellowship found in church may mean that women negotiate their church's existing structures, a strategy that results in them staying. For many women, remaining in church means they can receive support in two key areas of their lives: in their domestic roles and in the tensions raised by living within secular contexts. Encouragement in these two areas by their churches can lead to a sense of belonging that the women interviewed did not necessarily experience elsewhere.

Support for Women's Roles

The women in this study found the sense of community in church assisted them in the complexities of everyday life. The support women can receive in Christian cultures can help them to gain some control over difficult domestic roles and situations (Griffith 1997). One woman who had taken a break from church talked about her reasons for returning. Barbara said,

> After I had my son, I ended up going back to church. Why do I keep going? I actually go more for my children because I think… the teachings of Jesus are actually a really good way to live your life. It has lots of good, strong moral code for living life, and you are surrounded by a lot of people with like minds. And it is a network of people that support your Christian life and care if it works well. And there are some people there with similar ideas that I have, and it's a good way to raise my kids. (age 33, Baptist, attends church)

Although Christianity has been criticized by many for endorsing a notion of femininity that includes becoming a wife and mother, which is, for some, viewed as subordinating women, there are many women who choose to become wives and mothers, and for some, their churches are where they find support for these roles. They also find opportunities for connection and guidance in these day-to-day roles and relationships at church. From a young mom's group to marital counselling to children's holiday camps and church family picnics, parents, children and families are nurtured. Since the 1960s, numerous churches "have become carriers of communitarian and relational values in a society that they criticise as unhealthily 'individualistic' and 'materialistic'" (Woodhead 2004: 405). Churches can offer caring communities with "clear moral values based around church, family and local society" (405). In numerous contexts, they have little competition in this area. Against the backdrop of increased individualism, changes to family composition "and the collapse of externally authoritative moral orders, many churches feel they are now in a unique position to offer social and moral capital" (405). Religion cannot be simply dismissed as patriarchal oppression, even though patriarchy signifies many churches. Likewise, feminism cannot be considered a completely secularizing experience for women. Numerous women continue to be avid members of churches, seen in the growing Evangelical and Pentecostal movements in Canada, Britain and the U.S. (Martin 2005; Miller and Yamamori 2007; Burgess 2009; Wilkinson 2009). Churches in many communities may provide what the secular social state cannot or does not. For instance, nursery-care for mothers, mentoring for youth and therapeutic services. It is not uncommon to see that churches providing a number of personal, relational and social services are thriving (Bibby 2002), and thus, functioning as part of "the shadow state" due to the decline of direct welfare-state governance (Mitchell 2001). As such, not all women perceive or feel one another to be oppressed in religious communities. A

large number of women consider their gendered roles as wives and mothers as more valued in church communities and therefore feel more empowered in these environments than in secular spaces. Some might argue, however, that women relying on their churches for affirmation, where systems of patriarchy remain, perpetuate systems that oppress women.

Support in Secular Contexts

It can also be the case that during times of hardship, relocation and rapid change that religiosity and churchgoing persists, providing a sense of belonging and refuge (Inglehart and Norris 2004). This was the case for women who had moved country or city or were confronting life transitions to unfamiliar settings. Finding a church where they could feel a part of their local community and neighbourhood and be supported in new work, family and university ventures was significant to them. Lisa summed up what going to church meant for her:

> It's very much about relationships not just your relationship with God, but your relationship with other people, and the church is supposed to be like the body of Christ, and it is supposed to support every member who is in it. I think church is supposed to be where everyone can support each other through good and bad times. That has been my experience of it, especially the chaplaincy centre.... I think the church, for me, is about that community aspect. I find it really important to have other Christian friends who can support me and know where I am coming from and talk to about shared things. (age 22, Baptist, attends church)

Many women go to church "for a sense of belonging, and to experience spirituality in a structured, often female environment" (Stuckey 1998: 12). Churches can provide instant friendships and a network of people who share similar goals and values. They can also provide a place of refuge from the tensions that occur for them within secular contexts, such as university. Women in this book discussed the permissive culture associated with being a student. They talked about their secularized peers and popular media that frequently insist that women should be sexually active. For many of them, their Christianity provided a structure by which to base their behaviour. Jane said, "I think [being a good Christian] is just being responsible and not doing stupid things ... , like getting drunk and injuring yourself or getting involved with a lad" (age 20, Anglican, attends church). Anna also said, "My friends sleep around, take drugs, get drunk. My life is different. The view to stay sexually pure until marriage, alcohol in moderation ... my faith influences my life and how it's different from maybe the majority of university students" (age 20, Interdenominational, attends church). Jane and Anna's Christianity provides them a way to navigate through the challenges of student life. Paul Bramadat found in his study of evangelical students at McMaster University in Canada that women who were involved in Intervarsity Christian Fellowship often felt disparaged and

alienated by the secular and permissive university for their religious beliefs and values. In the face of this, their on-campus Christian community provided "a safe place to reflect on the issues raised by challenging academic or social experiences at university" (Bramadat 2000: 99). Many of the women in this book attended church services and Christian groups at their universities, which served as spaces where they could safely explore their faith and the challenges to it. Relying on one's faith that has been nurtured through their families and churches can give many women a foundation to negotiate new situations and relationships. Living out a Christian identity helped many of the women to confront life's dilemmas and transitions.

Renegotiating a Sense of Belonging in Church

Women who remain in institutional religion assert their agency in their choice to stay, and some are actively re-shaping their Christianity and churches in order to belong on their own terms (Vincett et al. 2008). When I talked with Angela, "a lesbian, feminist Christian," about her experience of sexuality in church life, she discussed her theology:

> I think in the Bible, where it is about sex being procreative, is right. It doesn't have to be a physical procreation. If it is fostering your relationship and creating new things in your relationship, then that form of sex is just as procreative.

Angela brings an alternative interpretation to her church's theology to fit her lesbian sexuality. She resists the traditional Christian view of reproductive sex in heterosexual marriage and adopts an interpretation that views sex as a resource that can generate and affirm a relationship. Angela went on to say about her church experience:

> I think, my church at home, I don't get much from it, but if I leave, then there won't be any way that I can help them toward a more inclusive service. A lot of the congregation are quite homophobic, and if I just, they don't know I'm gay, but if I did come out at church, they might then be able to say she's gay, but she's okay really. Maybe there is nothing wrong with being gay; it doesn't negatively affect someone's personality, or the gifts that you can bring to the church aren't negatively affected by being gay. (age 23, Anglican, between churches)

Angela desires to transform her church so that she can worship among people she knows. Such change would mean that she can belong and be accepted for who she is. Transforming church life to be inclusive of gay, lesbian and bisexuals has been a difficult and slow process in numerous denominations. Her desires, however, show her agency and longing to experience her church differently. Several Christian women, such as those mentioned in other studies and those interviewed here, are making agential moves to re-shape their Christianity and

church communities, to disrupt conventional norms that may cause them to feel excluded. By doing this, they "defect in place," countering patriarchal structures that constrict women's roles and sexuality (Winter et al.1994). Such is the case that women have not emancipated themselves from traditional religion because of feminism and secularism. Rather, women are incorporating feminism into their religiosity (Brereton and Bendroth 2001). This was the case for Abigail, who also identified as a feminist. Her aspiration for equality contributed to her desire to instigate change in her church. Through their feminism, women she knew were negotiating new spaces of belonging in their churches. Abigail told me about her mother and a former minister's wife as women who inspired her feminism:

> My Mum was someone who kind of allowed people to not fit in and fought a lot of battles for us, like what you should wear to church, especially when we were 14-16. It was a huge issue, and other people I spoke to said that she gave them permission to not follow what the church expected.... And [name of minister's wife] definitely. When I first met her, she was a minister's wife with children, but was completely against the role model that she should be, and was very much into the equality of women in the church. It was the first time, it was one of those things that was in me, but nobody had ever allowed me to explore, and I had been through these two years, a year that I didn't go [to church] and a year that I did, and to suddenly meet this person and have conversations about where I fit in as a female, suddenly all of those things that I had suppressed I was allowed to say. And I think a lot of women I have met along the way who look like on paper, like your traditional woman, have actually redefined themselves in that [church] context. (age 33, Methodist, attends church)

The minister's wife, whom Abigail said was doing a PhD in Feminist Theology and committed to gender equity, was significant to her church experience. She could see from the minister's wife and her own mother that self-transformation was possible, even in church life, which could benefit other Christian women like her. Abigail was inspired by her mother's actions and the minister's wife's agency. Subsequently, when the new church leadership took over, Abigail was confronted by having to renegotiate feminist moves that had been enacted and accepted. She explained:

> I do get irritated when God is always described in a male gender. And this is another issue that happened when there was the change of ministers. The previous leadership had pushed for inclusive language in everything that we did, and it was great. But when the new leadership came along, they didn't see the point in it. I remember vividly our first Christmas, calling up and asking, "Would you like me to type up the carol sheet and to change the language?" He said, "Oh, we'll use the printed ones." "Yeah, but the language is all wrong and we need

to change things." And he said, "Oh that's not an issue." I remember being on the phone and being floored, and then a friend of mine, who was a lay worker at the time, said, "You need to raise this because there are a lot of women who, for them, it is an issue." I think there a lot of people who don't see the issue in language.

Abigail took action to reclaim a space that honoured gender inclusivity (i.e., the song sheets). Many women in church life, clergy and laity, are in favour of gender-inclusive language (Robbins 2001). Yet, they are also aware that such changes may be alienating to members, just as non-inclusive language can cause members to feel excluded (Winter et al. 1994). Women who have taken steps toward more gender-inclusive language within their churches have had to do so with great sensitivity. Abigail's emotional response reveals both the care and insensitivity her former and present church leadership had to these issues. Her experience also shows that attempts to transform conventional standards within her church are difficult because of institutional histories and norms. Apparent in this book are women's varied responses to long-held conventions within their religious traditions, some of which could not necessarily be enacted without the legacy of feminism and women's sense of agency. Some women make moves to sustain, reclaim and/or renegotiate traditional religion in order to facilitate a sense of belonging, while others choose to leave their churches, finding belonging elsewhere.

In the next chapter, I continue my examination on women in church life, but with a specific focus on how they negotiate the notion of accountability found in many Protestant churches. I will look more closely at women's embodiment of a Christian femininity that is very much tied to being accountable to their church communities for appropriate sexual behaviour. The paradox, however, is that, while women are grateful for the sense of community they find in their churches, which can function as a source of empowerment, the same community and the sense of accountability that one feels toward its ideal for female sexuality can result in sexual oppression. Evident is how women continue to make complex negotiations between accommodation and resistance in relation to their religiosity and sexuality.

Note

1. While Christianity and Whiteness are intimately linked, Christianity is also important to African-American and African-Canadian communities. Thus Christianity can be racialized as Black, depending on how and where a person is situated.

Accountability and Policing

> I think the church culture says that you need to take dating very seriously. You can't mess each other around. Respect each other. In the experience of my friends, it is your close friends keeping you accountable and who have every right to be talking to you and keeping you accountable... it's like a fish bowl. (Hannah, age 27, Baptist, attends church)

Accountability in church life is the emphasis not on the self, but on the worship of God and on communal bonds (Miller 1997). It means a commitment of faith and a commitment to the beliefs and values of the church community. British theologian Martyn Percy, who writes and researches contemporary Christian culture, and British researcher Tony Watling, who has studied people's experience of the Alpha program, a Christian evangelizing ministry, have found that when people make a new commitment to believe in Jesus Christ, believers new and old come together to form a community. "They learn to interpret events 'in common,' using communal meanings to engage in the world. It is also where they can be monitored and 'guided' by being encouraged to interpret events, articulate feelings, act the 'correct' way and be held accountable" (Percy 1996 in Watling 2005: 103).

Hannah, in the opening quotation discusses the kind of accountability to which Percy and Watling refer. Her peers surround her. She is always within their reach and under their gaze. The accountability experienced by church members is a disciplining force that can shape one's behaviour through frequent observation and assessment. This church-based accountability can be understood through Michel Foucault's notion of the *Panopticon*, an apparatus that leads subjects to perform mutual and self-surveillance.[1] Feminist philosopher Sandra Bartky, who critiques and applies Foucault's work, argues that while women are subject to many of the same disciplinary practices as men, the disciplines embodied by women are markedly feminine. For example, through modes of dress in order to present oneself appropriately at work or at a parent-teacher meeting, or through sculpting the body in order to be considered acceptably thin and/or physically fit. Men also face similar pressures, but not to the same extent women do through popular cultural discourses and media. Protestant churches can be places where women reproduce a conventional femininity in their behaviour in response to particular expectations about what is appropriate female comportment and sexuality (Bartky 1990; Bordo 1995; Tolman 2002). Indeed, monitoring women's behaviour in

church life, particularly related to anything sexual, can be seen as an attempt to keep separate women's identities as Christians on the one hand and as embodied sexual women on the other hand. Such practices can generate good girl/bad girl discourses that encourage a passive and limited sexuality, and possibly deny a rich diversity of sexual experiences and relationships. Drawing from women's accounts, I now turn to their experiences of accountability and policing, exploring how the women negotiated their sexual experiences in relation to their church community and its construction of sexuality.

Accountability and Community

My analysis in this chapter is informed by the theories of feminist psychologists who have studied women's identity development (Miller 1976; Gilligan 1982; Surrey 1991; Jordan 1997). As discussed, central to their work is the notion that women develop through connection and relationship, not through independence and autonomy, which are male-centred (Wastell 1996). Feminist psychologists mainly agree that the process of identity formation takes much longer than is allowed for in traditional stages of identity development as theorized by Erik Erikson and Daniel Levinson. Instead, they believe deep connection and relationships are the basis for self-experience and development, with other aspects of the self (e.g., creativity, autonomy and assertion) developing within the primary context of "self-in-relation" (Surrey 1991: 53).

The period of 18 to 25 is often a time when women are developing alongside their peers, with their growth of the self "continuously being formed in connection with others and inextricably tied to relational movement" (Jordan 1997: 15). Close-knit church communities can be relational systems that give women a structure and support for confronting the various life and identity issues that may arise during this age period. When I asked women how important their church experiences had been to their personal development, Patricia replied, "Oh, fundamentally, absolutely, no question" (age 28, Baptist, between churches). Susan said, "It's like a mixture between family and the church... church has made me a better person...", and I'd still look to my Mom and Dad, but what they've said they have got from the Bible" (age 20, Methodist, attends church). Not only is "community created in relation to identities, identities are molded through community involvement" (Abrahams 1996: 786). In churches, it can be quite likely that religious teachings are shared and reinforced amongst one's peers (Edwards et al. 2008). Religious behaviours can therefore be a powerful predictor of sexual behaviour (Lefkowitz et al. 2004: 157; Regnerus 2007; Freitas 2008). Some researchers have found that young people who perceived social support from their spiritual friends were more likely to be virgins (Holder et al., 2000). It is also the case for the women in this book that they were quite influenced by the perspectives of their peers when it came to sexual matters.

The sense of community and safety perceived and experienced in Christian

circles and that helps to shape women's identity formation can also inhibit self-growth in areas such as sexuality. In my analysis, I also rely on the work of Foucault and feminist theorists (Kelly 1988; Bartky 1990; Lees 1997; Holland et al. 1998) to help illuminate how the accountability to a church community and its gendered construction of sexuality can possibly limit behaviours and experiences. Among members, a conventional construction of sexuality can be what many women believe they have to adhere to, which can result in self-scrutiny and the monitoring of one another. Church communities that foster connection can, through the very same relationships, hinder sexual development and exploration because of the policing nature that can be associated with keeping each other accountable. Thus, many churches may benefit from this kind of behaviour because it can reinforce and maintain feminine ideals. What follows is an analysis of Christian women's experiences of accountability to a marital-confined sexuality.

Sex as a Community Decision

Women's sexual and relational selves that are informed by regular church participation and peer relationships can frequently mask conditions of oppression of which women may not be aware. Because many women believe they are accountable to their churches and the sexual tradition that their churches uphold, sexual decisions are not considered their own; rather, there is a sense that their sexual self belongs to the community. Patricia, who had attended church for most of her adolescence and early twenties, told me about her experience of church and sexuality:

> The personal decision to have sex is an oxymoron in the church. You don't have a personal decision about sex, so you don't think about it in that way. You don't think that it's yours; you think that it is a society decision. (age 28, Baptist, between churches)

Christian author Lauren F. Winner writes about the importance of Christian community to sexual decisions: "The place where the church confers the privilege of sex is the wedding; weddings grant us license to have sex with one person … sex beyond the boundaries of marriage — the boundaries of communally granted sanction of sex — is simply off limits" (Winner 2005a: 123–24). She further states, "Sex is communal and Christians have an obligation to talk to each other about sexual sin" (Winner 2005b: 59). Many women found this aspect in their churches particularly hard to deal with. Patricia eloquently explains the conflict that is presented between sexual desire and the sense of responsibility that one has to their church community. Her decision to have sex is consequently not about her or the responsibility she has to her *own* desires; it is a community decision. Many might argue that Patricia's desires are not necessarily her own, but produced in relation to and in reaction to social and cultural processes and contexts both within and out of her church community. Because Patricia admits to having her own desires, I argue

that Patricia has a capacity for agency that, if acted upon within these contexts, would mean different sexual decisions to what her church community wanted and expected of her. However, as Patricia explains, these decisions were difficult to enact because of her pull to be accountable to her church. During the course of my interviews, I talked to Rhonda, who had attended a Pentecostal church that she described as having a conservative stance on sexuality. I asked her about what this had been like for her, and she said,

> There are many rules, but the most important thing is to be master of your self.
>
> Sonya: Is that something that your church would say?
>
> Rhonda: That's something the church wants you to be able to do, through the teachings, to be able to do. The church's job is to instil in you all the sanctions that you can then instil in yourself. You learn from that, and it works and it is pervasive. (age 26, Pentecostal, left church)

Rhonda indicates that her religion had a powerful influence over herself and her decisions. Michel Foucault, who has written about the power of religion, has theorized that Christianity has two kinds of "obligation": firstly, the obligation to hold true the faith and the book (the Bible), "which constitute dogma," and secondly, to the self, the soul and the heart. Both are linked together, but the second requires one to "explore who he is, what is happening within himself, the faults he may have committed, the temptations to which he is exposed… everyone is obliged to tell these things to other people, and hence bear witness against himself" (Foucault 1999: 182–83). Just like Foucault's abstract male subject, there can be an obligation for women to reveal themselves to another in order to free themselves of sin. In order to protect oneself, one needs to confess to others, submit to their advice and accord obedience to one's superiors (Foucault 1999). This results in little distinction between private and public affairs within religious communities. The nature of surveillance, of oneself and another, contributes to dynamics of being accountable. It was clear from many of the women I spoke to that women can learn and carry out the rules of moral and sexual behaviour, scrutinizing their selves and one another in order to keep their obligations to the faith and community.

Policing Sexuality

In Community

Such obligations, however, can have implications for women, especially when their religiosity is entangled with the community's often-gendered expectations (e.g., chastity, appropriate dress and behaviour), which can have a disciplinary affect (Bartky 1990). Victoria said, "I think what my friends and I were doing [was]

policing each other's behaviour and helping each other to be Christian women, as we thought we ought to be" (age 29, Anglican, between churches). Women discussed the sense of being monitored that they sometimes experienced, as well as the act of self-scrutiny and not disclosing sexual events for fear of being judged.

Some women took steps to scrutinize their own behaviour before others did. Maria told me, "A Christian leader said that she could tell if a girl had had sex, just by the way she carried herself. Whether or not this was true, it caused me to monitor my behaviour lest it be questioned otherwise" (age 30, Baptist, left church). Women in church communities can police each other's behaviour according to the feminine ideals often found in their communities. When I talked with Linda, she told me about an experience of being out with her Christian friends one night:

> There is a sense in the Christian community, a kind of pressure to remain accountable, like being at a nightclub with Christian friends and wanting to talk to a guy and stuff, and feeling a sense of not being able to do so without getting called on it…. You are being held back by the force of the community. (age 22, Anglican, attends church)

Linda's involvement in her Christian community — and her resulting sense of accountability — means that she thinks not only about herself when negotiating sexual behaviour, but the watchful eyes, words and actions of her Christian peers. Her narrative is not unlike what sociologist Trevor Welland (2001: 79) found in his study of students training for ordination in a residential setting, where "students and staff watched and judged each other." As Thapan (1997: 15) explains, this might be thought of as "the panopticist gaze of the community," by which a woman's body is controlled, allowing her little space to act beyond the bounds of community-sanctioned behaviour or with a sense of agency. Linda internalizes her peers' gaze, self-scrutinizing her behaviour to uphold her community's values and her place within the group.

Feminist researchers (Kelly 1988; Lees 1989, 1997; Holland et al. 1998) have examined the policing behaviour that happens amongst young women and men in relation to hegemonic masculinity and traditional femininity. Holland et al. reveal the ways that young women internalize the power of masculinity in relation to normative heterosexuality, calling it the "male-in-the-head," the internalization of male-instituted heterosexuality. Young women carry the idea of male dominance within them and enact this idea with each other, carrying out policing behaviour. As it is understood from this body of research, policing is to watch, monitor, supervise, scrutinize and oversee one's own and another's behaviour (Radford 1987 in Kelly 1988: 33). It is both behaviour and discourse that keeps normative heterosexuality and conventional modes of masculinity and femininity in place. Such behaviour can maintain "the existing structures of patriarchal sex-gender relationships" (Lees 1989: 21). Many Christian women can police each other according to their church's construction of gender and sexuality.

Because of the "force" of the community, some women did not share sexual events with church peers, but kept them hidden. When I asked about Grace's experience of sexuality and church life, she said,

> People who seemed knowledgeable about everything religious, who then tell you that something is wrong, definitely made me feel guilty, but the problem was in feeling guilty meant that I felt I couldn't talk to anyone about it. So, I kept quiet and pretended it hadn't happened.... I definitely felt that you couldn't go and tell people what you were doing, if you were having sex while in the church or tell somebody who you went to church with because they would look down on you and judge you. (age 20, Methodist, attends church)

Grace explains how the close relationships and sense of belonging forged through church communities can perpetuate and enforce feelings of guilt in relation to one's identity as a sexual being. In not telling her friends, Grace gives the impression of being accountable. She, like other women, kept "large parts of her experiences and responses out of connection in order to try to find or maintain connections" with others (Miller and Stiver 1997: 82). Grace pretends her sexual experiences do not happen in order to be acceptable and accepted, as "a woman's sexuality is central to the way she is judged and seen" (Lees 1997: 11).

Linda and Grace's accounts speak to the disciplinary power of a conventional femininity often found in Protestant churches, which can make women feel like "the inmate in the Panoptican ... self committed to a relentless self-surveillance ... a form of obedience to patriarchy" (Bartky 1990: 80). Linda and Grace thus wear the mantle of responsibility for sexual episodes demonstrated in the way they police their bodies and voices, not acting on sexual desire and staying silent about sexual activity. Co-opted by the patriarchal sex agenda, they risk becoming complicit in their own oppression, which can be supported by their church communities, thus repressing their sexual subjectivity. Implications of staying committed to one's church community in this way can mean that it is difficult to enact change or directly challenge patriarchal structures.

In Relationships with Men

Accountability to church community was further demonstrated in the role women can play in setting the boundaries for sexual behaviour between themselves and their male partners. Kathleen reflected on her experiences about her relationship with one man and said, "I was the one holding the cards for how sexual we were (age 33, Anglican, between churches). Jessica discussed similar behaviour with her boyfriend:

> Always being the one in the relationship to try to not do it and, yeah, it was kind of like a struggle. I would've been responsible; I kind of had to teach him that we needed to not [have sex]. My faith was also

probably stronger than his, older than his, more mature than his. Sad, really, when I think about it. (age 34, Baptist, attends church)

Both women believed that being responsible for sexual behaviour was theirs. This presents them with a double bind in that they acquiesce to their Christian beliefs, while giving enough to satisfy their male partners' sexual desires. This bind highlights the limits and constraints that being a "good Christian girl" can put on women's sexual subjectivities. "Women, who wish to avoid the consequences of being labelled 'bad,' are expected to define the boundaries of sexual behaviour outlined by men's desire" (Tolman and Higgins 1996: 205–06). Some women wanted to resist such responsibility. Barbara discussed her experience:

My husband and I had a very long courtship. [My sexuality] was a very strong part of who I was because I was in this relationship at that point, and we had this deep passion for each other that had to be stifled, and that's really difficult when you are 18, 19 years old.… It was a very hard balancing act, which meant the ability to enjoy being able to be yourself was not good.… It's okay to say no sex before marriage, but it's very hard when you can't get married for a very long period of time, and then to live within that is very frustrating. (age 33, Baptist, attends church)

After the interview, Barbara said how she desired to have sexual intercourse with her husband during their early courtship. Yet, sexual intercourse, as she understood it from him, was genital penetration, which meant that they could do everything else as long as they remained virgins in this sense. Questions about what constitutes sexuality and sexual behaviour were issues Barbara struggled with before her marriage. Consequently, she was caught between honouring her desires, his desires and her religious tradition that were inevitably intertwined with constructions of good and bad sexuality.

One way women disciplined their sexual longings was by imagining the potential outcomes of sexual behaviour between themselves and men. Maria (age 30, Baptist, left church) said she would imagine how she would feel the next day or what others would think if they found out she was sexual with a young man. Anticipating feelings of betrayal, being used, letting herself down, disappointing God and others served to maintain a marital-confined sexuality. Harriet expressed her thoughts:

It is a very kind of big step, and if you take that step [have sex] with somebody that you are not really sure about or you break up with a week later, then you are going to feel a bit used and betrayed and stuff.… I, personally, think that it is because God does not want us to get hurt unless He can help it, and I think if we were having sex with people and not carrying on seeing them, we would get hurt because it is such a big thing for a woman to [have sex]; that it is going to

have a lot of emotional impact on her.... And also, if the guy didn't want to see you anymore, you would feel let down by him because you would have given yourself to him, basically, and he would have turned you down. (age 19, Anglican, attends church)

Predicting a hurtful and damaging conclusion helps to preserve not only Harriet's reputation as "good," but also her Christian values and her relationship with God, whom she portrays as a protective father figure whom she does not want to let down. Psychologist Dorothy Rowe, who writes about the fear of failure and the annihilation of the self, has stated, "To rest secure in God's love ... we have to live our lives following certain rules and if we fail to follow those rules then we are in great danger" (Rowe 1987: 33). Such behaviour can prevent potentially harmful situations and give women boundaries for sexual behaviour they may not be ready to experience. However, the assertion that if women have premarital sex, they will be laden with guilt and feel abandoned does not allow women to be responsible for their own sexual subjectivity. Harriet alludes to the possibility of being taken advantage of by a young man, which leads her to objectify her sexual self. This, however, disallows an opportunity for her to experience sexual pleasure, which may have been seen as promiscuous. Feminist writer Jessica Valenti (2009: 10) argues, "A woman's worth lies in her ability — or refusal — to be sexual." Christian and non-Christian women can thus make concessions for their male partners or religious values, not for themselves. Lillie S. Ransom, a Christian and university professor who has written autobiographically about her Christian faith and sexuality, said her sexual desires and experiences came last or not at all.

Community accountability and sexual respectability work hand-in-hand. Christian cultural expectations for women to remain sexually pure for their future husbands and to be strong in their faith so as to guard against sexual sin is often a patriarchal value that, in many instances, can lead women to discount or disallow their own sexual requests, desires and experiences. Whether in church or non-church contexts, countless Christian and non-Christian women do not question this position that is tied to a conventional femininity, nor see how unfair it is that they must be solely accountable or vulnerable to social sanctions (Tolman 2002: 99). Moreover, compared to their male partners, many Christian and non-Christian women are often left holding a disproportionate amount of responsibility for appropriate sexual behaviour, diminishing goals for sexual equity.

Body Presentation

In addition to women policing their behaviour with men during sexual encounters, they also monitored their body presentation. This was particularly through dress. Reina Lewis, a scholar of cultural studies, observes that there has been a rapid development of a diverse market for modest fashion, arising initially from and serving the needs of Islamic, Christian and Jewish women who are motivated to dress modestly for religious reasons. When I was talking to Anna, she told me

about a conversation she recently had with a male friend:

> Me and my housemate, Walt, we often have one-to-one chats — the difference between guys and girls, what we find difficult, just getting another opinion, as well from the point of view from the opposite sex, so that I don't cause a stumbling block, or like Christian males, say if I dress a certain way, it might cause them to feel tempted, whereas if I know what those are, then you can take precautions not to hinder other Christian guys. (age 20, Interdenominational, attends church)

Dressing modestly is related to femininity and can act to monitor sexuality. Sandra Bartky in her work on femininity and the body argues that women embody the male gaze in order to manage and present their bodies appropriately. Art critic and author John Berger has also written on the subject:

> Men look at women. Women watch themselves being looked at. This determines not only most relations between men and women but also the relation of women to themselves. The surveyor of women in herself is male: the surveyed female. Thus she turns herself into an object — and most particularly an object of vision — a sight. (Berger 1972: 14)

Anna describes taking responsibility for what the male gaze views and how the male gaze will respond. As she manages her appearance for her Christian male peers, she manages the presentation of her femininity and sexuality. Theologian Elaine Storkey (1988: 59) remarks, "Woman is both the essence of sexuality and the object of men's sexual desires. She must therefore do something about it." Researchers Holland et al. (2000: 222) found that "young women's primary mental audience during sexual encounters was male, and could, in fact, find no evidence of this audience being female." As a result of internalizing the panopticist gaze of the community and of men, it can cause many women to survey each other through this particular lens. Some of the women spoke about presenting their bodies in acceptably attractive ways, but not overly sexual (Holland et al. 1998). When talking with Cynthia about her views on what it was like to be a young woman in her church, she said,

> Cynthia: I think we have more pressure on us than guys do, but that might be because I am a woman and how I relate to that.
>
> Sonya: What kind of pressure?
>
> Cynthia: Pressures to find a relationship, the way you dress is a huge sort of communication to the outside world of who you are. We have so much more we can do with our dress-sense and seeing your Christian brothers and sisters as your real brothers and sisters and not as people you will lure into a trap, so you do have to dress appropriately. Yeah, I own a short skirt. I wore it the other night, but

you've got to be appropriate with your dress. There are a couple of girls in church who have these loose tops with their bra straps showing and things. And well, that's okay, but it could get so much worse. You need to know how much power you have over guys because you can be manipulative — the way you dress and the way you behave does sort of shape their attitude and communication with you. I think as a woman, you need to take responsibility for that. (age 22, Anglican, attends church)

In this excerpt from Cynthia, she expresses her desire to do right by her Christian faith, peers and community through the way that she dresses. However, she not only takes responsibility for the male gaze, she *becomes* the male gaze evaluating how other women dress when they attend church. She can be seen as internalizing the male gaze to the extent that she exercises its judgement and criticism. By embodying and occupying this gazing position, she enacts patriarchal practices that can objectify women's bodies (Young 1990). From this position, as body presentation was about keeping up an image that was respectable, good, conventionally feminine and sexually in control, she polices not only herself, but also her Christian female peers. For fear of what might be perceived if she does not manage and present her body respectably and decently, she embodies and enacts her community's judgements.[2] Forms of dress can be tied to measures of social control, overtly and covertly, which aim to insure conformity to social norms (Arthur 1999). Highlighted in Cynthia's excerpt is how the body is governed by the social and political systems of which one is embedded (Foucault 1974).[3] Moreover, when women are led to believe that they are to be responsible for both their own and their male partner's sexuality, even through dress, equality cannot be achieved within Christian contexts.

Sex in Marriage Is "Special"; "I Feel Free within that Context"

Despite the sexual responsibility that women are perceived as holding, a marital-confined sexuality and the boundaries it provides that are kept by its members are, for many women, welcomed. If one looks on the shelves of Christian bookstores, they will see titles by Christian women that address sexuality and accountability. For example, Elizabeth Elliot's *Passion and Purity: Learning to Bring Your Love Life under God's Control* has been around for years and has moved into later editions. Current titles include *And the Bride Wore White: Seven Secrets to Sexual Purity* by Dannah Gresh, and *Gift-Wrapped by God, Secret Answers to the Question "Why Wait?"* by Linda Dillow and Lorraine Pintus. In particular, Lauren F. Winner's book, *Real Sex: The Naked Truth about Chastity* (2005a), calls on church communities to assist in a return to chastity. She defines chastity not only as the absence of sex, but also as a spiritual discipline and practise that is carried out individually and communally. Winner argues that sex *is* a church community choice and issue. She offers this as

an encouragement to Christians, relying on the heart of the community and their faith in God as sources of love and support for godly expressions of their sexuality.

For many Christian women, there is a freedom in being accountable, even though they are aware of the patriarchy in organized religion. During interviews, some of the women told me about converting to Christianity between the ages of 18 and 25, a time when they were attending university, an environment that offers options and opportunities for sexual expression, which can be a pressure. For these women, choosing to have sex in marriage was tied to the confidence they have in the boundaries set by their Christian faith, to their belief in the plan God has for their lives and to the support they received from their church peers. Lisa told me:

> When I first became a Christian, I struggled with it a bit because I had had sex, and I thought, "Oh, they're not going to have anything to do with me," but I think, realistically, it's not like that, and although some of the church teachings about it are wrong, like I am not sure that God needs to necessarily forgive the fact that you have already had sex, I can totally see now the teachings make sense, and I think ideally, it should be kept until marriage, and I think the church is a bit wrong in condemning people that don't fit in with its ideal. But I do agree with the teaching.... Um, well I haven't had sex since I have become a Christian, and that is the main thing, really. I guess I have much more respect for it now because beforehand, it was more just, really, more just part of culture or life, really. But I think being a Christian, you put much higher values on it, so it has become something much more important, and it's become something much more necessary, like before I viewed sex as something just kind of physical. I think now, it's much more important, necessary; it's more special. (age 22, Baptist, attends church)

Lisa discovers her faith for herself and shows boldness in accepting a counter-secular view on sex. Harriet concurs: "I see sex as something that should be saved for marriage, and is very special and for marriage. I have never really thought that I want to do it before" (age 19, Anglican, attends church). Adhering to their churches' construction of sexuality provides them with a sexual identity to hold fast to in popular culture. It gives them a form of femininity that can offer a structure they desire in the face of mainstream femininity that endorses sex and sexiness as the way to be feminine. A conventional femininity gives many a recognizable place within heterosexual relations and a public identity in relation to other women (Holland et al. 1998: 133). Journalist Jenny Taylor, a celibate Christian woman, states, "The relief for me was to discover there was such a thing as a Christian sexual ethic, and on converting to Christianity, to discover that for the first time in my life I had a source of strength not my own, with which to say 'no'" (Taylor 2004: 12, 2008). Mina expressed similar sentiments: "My Christian beliefs and values dictate how my sexuality is used.... I don't feel oppressed; I actually feel free within that context"

(age 24, Alliance, attends church). Women today face competing representations of femininity because of women's changing identities since the 1960s, leaving many women wondering what it means to be feminine (Woodhead 2008). Today's society, allowing for multiple perspectives and identities to exist, means women can possess a Christian feminine identity that supports a conservative stance on sexuality. The pressure found in sexualized mainstream cultures is, for many Christian women, something they are able to avoid, negotiate or deal with because of their supportive religious communities and belief systems.

A Church Community that Fits Her Sexuality

Sustaining such accountability, however, can be a huge constraint for some women, resulting in their disaffiliation. Some found that they could not conform to a conventional femininity and sexuality and therefore left in order to embody their sexuality in a way that fit with how they knew themselves to be growing as sexual and relational women. Victoria, a lesbian woman, told me about her experience of church and sexuality:

> At one point, I did aspire to [marriage] and [felt] that was what God wanted for my life. I desperately wanted a husband from age 20 till about 22 or 23, but not that it suddenly stopped, maybe 24, and carrying on after that probably for sometime.... Definitely my Christianity defined my sexuality, and also defined it as heterosexual. I didn't have an issue with it. It was fine, and I didn't fancy women. It was only when I was about 22 when I questioned that aspect, when I [finished university]..., so the break when I left church; that's interesting. The two breaks I had from church have been really significant in terms of my sexuality because leaving the fundamentalist church is when I started to feel attracted to women and then later, when I had the year out from church, was when I actually finally decided I was going to have a relationship with a woman; that was the way I was going to go, and I couldn't have done that in the church because the church community was too close-knit for me to have been able to create a new life for myself and go to gay groups or whatever. So, I had to come out of [church] to make that decision. I think not going to church is probably very important for Christian women's discovery of their sexuality.... Now I probably go about once a fortnight.... I think I need to go somewhere where there is a female vicar so then I won't have these issues about sexism.... I go to quite an unusual church because it is quite liberal and gay-friendly, and it's not easy to find that. (age 29, Anglican, between churches)

Victoria's decision to be in a relationship with a woman is not something she could have openly done while involved in a conservative Protestant church. Thapan (1997) contends that conflict, not passivity, is central to whether a woman

will give expression to her desires and views. Victoria pursued the conflict within her, deciding to leave and enter into a lesbian relationship. This goes against the normative heterosexuality embedded in church communities and subverts conventional modes of femininity. When she did return to church, she attended a congregation that was open to her sexual identity. Victoria no longer shaped her sexuality to suit traditional church life, but found a church that accommodated her.

This was also the case for other lesbian and heterosexual women who found churches that fit with their sexual development and experience. Angela, for instance, found it difficult to agree with her church's conservative stance on homosexuality and was, as a result, exploring an interdenominational church that was "not homophobic," but rather established in lesbian, gay, bisexual and transgendered communities to supplement her church at home (age 23, Anglican, between churches). Abigail faced struggles of her own, but had a group of Christian friends and an evening church service within the Methodist tradition that enabled her to explore issues of sexuality:

> It's quite interesting as a group how we have dealt with it. We go from one extreme, because there is one girl in the group who said the only person she will sleep with is the person she marries, and she did, and I don't even think she kissed him before she got married, and then the other extreme, where people have sex. But somehow we have all managed to respect each other's views on that, and I have looked at [this] model and thought, "How does the church take on this model?" I don't see it attempting to, a model of accepting people where they're at. There are two approaches, one is a really hard-line — no sex before marriage, a really strong teaching on that, or there is this kind, and they tend to ignore it. There doesn't seem to be a middle ground that offers some support.... When my minister started doing the evening services, he was very hard-line, but also felt that you had to find your own way within that. I think for me, the strongest influence was having a group of friends who all had different experiences and were willing to discuss them, and that I could find my own way within that. (age 33, Methodist, attends church)

Because of her acknowledgment and validation from her Christian peers, Abigail experienced a deepening and expansion of herself as a young, embodied sexual woman. Although she was presented with a binary, it was from the tension found between a "hard-line" and an open approach that her and other women, like Victoria and Angela, have been able to negotiate different stances. This did not cause them to lose their faith, but provided them with other ways to explore their sexuality while being a part of a faith community.

The accountability to live out the morals and values of a Protestant faith is expected of copious women (and men). There is an expectation that they will be responsible to one another, revealing to community members the true realities

of the self. Foucault (1999: 183) argued, "The more we discover the truth about ourselves, the more we have to renounce ourselves; and the more we want to renounce ourselves the more we need to bring to light the reality of who we are." There is an obligation to confess one's thoughts and desires in relation to sexuality — to scrutinize oneself against sexual transgression. Such accountability is a personal, social and religious commitment. For many women, this commitment is entangled with gendered expectations — a Christian femininity — that can further limit sexual knowledge and experiences. While church community offers women a refuge and a distinct position amid sexualized mainstream cultures, some women find it too restrictive. It can also be said that non-church cultures hold similar patriarchal ideals of female sexuality with regard to heteronormativity, modes of dress and appropriate behaviour.

Many churches continue to insist on a chaste sexuality until a heterosexual marriage that may be woefully inadequate, remaining closed to the fruits that just, caring, respectful non-marital heterosexual and non-heterosexual sexual relationships can bring (Ellison 1994). Feminist theologian Rosemary Radford Ruether (2000: 219) argues that many Protestant churches' espousal of heterosexual marriage or "virginity to marriage" does not always mean sexual maturity or sexual well-being. Victoria, Angela and Abigail, who felt their sexual experiences were not recognized in their churches, eventually found loving and accommodating friends and communities in which their sexual identities were accepted. Other women were also a part of loving communities, but amid cultures of accountability, where they were continuing to make negotiations between their sexual selves and their church's dominant constructions. These tensions can be difficult to negotiate and can, moreover, result in powerful feelings of shame and guilt when women feel they have sexually transgressed their religious beliefs and commitments. The next chapter will look at how women deal with these emotions in relation to their Christianity and sexuality.

Notes

1. The Panopticon was a prison that was invented by social theorist Jeremy Bentham ([1787] 1995). The building was designed in 1785 for the purpose of being able to observe those who were imprisoned without them being able to tell whether they were being watched. The result is an invisible omniscience that causes inmates to police themselves and one another. Michel Foucault applied Bentham's idea in his book *Discipline and Punish* to explain how modern societies effect behavioural norms and disciplines.
2. I have also represented the gaze here as women's body presented as the object of male desire and perhaps as always before the male gaze. This position is limited in the sense that it ignores other important ways of looking that do not derive from normative heterosexual desire, such as homoeroticism, sensual pleasure and fantasy.
3. Pierre Bourdieu (1973) argues similarly that the body is constantly affected by social and cultural processes.

Sexual Transgressions[1]

> I remember when I came back to God after being sexually involved
> with a guy.... I felt terribly guilty. (Victoria, age 29, Anglican, between
> churches)

The notion of accountability in church communities can have a powerful influence
on a woman's sexuality, which was certainly the case for some of the women with
whom I spoke. As discussed in the previous chapter, accountability to a group
of church peers offered encouragement and support amidst other non-church
environments in which the pressure to have sex can feel demanding. Others talked
about how such accountability was constraining, preventing them from exploring
their sexuality in ways that felt free from shame and guilt.

In this chapter, I discuss the emotions of shame and guilt that arose in
relation to the women's non-marital sexual experiences. Due to these powerful
feelings, women can live in states of dis/connection (Miller and Stiver 1997):
in other words, both connected and disconnected to their church communities
and sexuality. Several of the women were emotionally connected to the ideal of a
marital-confined sexuality. Yet, when they transgressed this ideal, they felt shame
and guilt and disconnected from their church peers.[2] In efforts to maintain their
connections to the group, they implemented strategies such as keeping sexual
activities secret. In their desires to connect to their sexuality, they also felt shame
and guilt, which caused them to feel disconnected to their sexual selves. These
states of dis/connection that women experienced in relation to their Christianity
and sexuality are tied to good girl/bad girl discourses, which are at the heart of
this chapter.

Shame and Guilt, and Being "a Good Christian Girl"

Emotions like shame and guilt contribute to how women in church communities
conduct their sexual selves. Jessica explained how shame affected her experiences
of her sexuality and church life:

> Sex was just mixed with so much shame and guilt that it meant that I
> was a bad Christian.... I think because my early sexual learning was
> so shrouded with shame, my sexual self didn't get to grow. It was
> kind of like a plant that was put in a closet and kept in the dark..., so
> I didn't talk about [having sex] with anybody for a long time. It took

me a long time to confess what I was doing. When there is shame surrounding sex, you are not likely to come forward, and therefore, the shame surrounding it creates distance. (age 34, Baptist, attends church)

As Jessica described, departure from religious scripts that contain the standards of holiness and righteous behaviour, including how to dress and behave, can cause feelings of great shame and guilt (Bradshaw 1988: 66). It is important to understand, however, these feelings as shaped by social and cultural norms and values, and the expectations of others. Significantly, the close relationships forged through church communities can *also* perpetuate and enforce feelings of guilt and shame in relation to one's identity as a sexual being.[3] The messages women receive can be conflicting, to say the least. Some of the women quoted in this book were torn between the imperative of remaining sexually abstinent and non-church peer groups and contexts that often insinuate sexual experimentation. As such, the aspects frequently most valued about church membership — community and belonging — can induce the most painful feelings in relation to sexuality.

Women who discussed shame and guilt made no distinction between these feelings, even though shame and guilt can be seen to have different meanings. Shame emerges from the negative evaluation of the self, while guilt is associated with the evaluation of wrongful behaviour (Lewis 1971; Bradshaw 1988; Crawford et al. 1992; Dryden 1994; Helm Jr., Berecz and Nelson 2001). These emotions that women experience in contexts such as church communities are socially shaped. "Emotion is viewed as an intersubjective rather than an individual phenomenon, constituted in the relations between people" (Lupton 1998: 16). Emotions communicate commitment to one another and to one's cultural values (Crawford et al. 1992: 36). Shame and guilt expressed by women in this chapter are also gendered, in that they relate to not living up to a conventional femininity, particularly a Christian femininity that emphasizes remaining chaste until marriage. Women experienced shame and guilt when they did not perceive themselves as being a "good Christian girl," said Anita (age 28, Baptist, left church), an identity that was described by Patricia as being one who "participates in social work, does not drink and does not have sex" (age 28, Baptist, between churches). Conforming to gendered ideals is a theme that runs through the stories of these women. Here, good or bad often acted as powerful normative values that deeply impact on women's growing identities. Good girl/bad girl discourses are entwined with shame and guilt that discipline women's sexuality, keeping it under patriarchal control.

Teachings about Sex in Church

To begin to understand the women's experiences of sex while in the church community, I asked them what their churches had taught them about sex. The main teaching they received about sex from their churches was that sex is to be

confined to heterosexual marriage. Most of the women discussed being taught that sex is only for marriage while in youth and young adult groups during adolescence and their early twenties. It was rare that they heard a sermon on sex preached at a Sunday morning service. I asked women to reflect on what they had been taught. Maya told me,

> Sex is okay at the right time, in the right context...; you're taught abstinence, and then you think, "Well, is oral sex okay?" But other than marriage, 'No!' 'No!' 'No!' (age 34, Baptist, left church)

Harriet gave a similar response:

> I would say that [church] has basically taught me that sex before marriage isn't a good idea, that it is a thing sacred to marriage, really. (age 19, Anglican, attends church)

Lisa said,

> When I did the Alpha course, that was how I became a Christian. I was taught that it is wrong to have sex before marriage, so when I first became a Christian, there was that guilt there. (age 22, Baptist, attends church)

Patricia was told,

> 'When you get that ring on your finger, babe, you can have sex.' (age 28, Baptist, between churches)

And Abigail said, "Not a right lot" (age 33, Methodist, attends church). Barbara (age 33, Baptist, attends church) told me about her experience. She said that early on, she was taught that sex was a very precious thing — it was to be for a marriage relationship between a man and a woman, a beautiful act that "glued a couple together." In her teenage years, she attended evangelical church camps where she learned about "contraception, female and male anatomy, masturbation, and about the body being the temple of the Holy Spirit." Other women were "annoyed" at the "austerity" of the message and felt their churches' stringent message was unhelpful to sexual development. Some thought it "oppressive" and "unrealistic" to save sex for marriage.

Women also thought that the message could be "improved" in terms of how it is discussed in churches and to whom it is addressed. They questioned the age one has to be before she is considered "responsible" enough to have sex. Churches might argue, however, that having sex is not an issue of responsibility, but of religious belief and practice. Maria, who got tired of upholding the message, said,

> I made a choice as a responsible woman. I don't need to wait until I am married...; when is that going to happen, another five years from

now? I just thought, "What the hell?" and that "it's about time." I mean, how does the church answer that? (age 30, Baptist, left church)

The women expressed their opinions that there is a difference between teaching "no sex until marriage" to a young woman who is 15 years old versus a 30-year-old woman, especially given women's changing identities and the variability of personal relationships in the twenty-first century. Many of the women said they were given little to no practical advice on sexual matters in their churches, nor were they told whether sexual practices, such as masturbation, were acceptable. Despite their churches' message, several of the women said they had sexual experiences, which, for some, included sexual intercourse before marriage.

The women, from a range of denominations, such as Baptist, Anglican and Methodist, heard similar teachings about sexuality. A woman from the United Church discussed a youth group experience that was more open to talking about sex:

> When I was growing up… not much [was said] about sex, nothing about lesbians at all…, but when I was around 18, I was part of the youth group there, and there was a discussion about sexuality, and the guy [who] was leading that group was really progressive, and he brought books about sexuality and wanted us to talk about it. I thought it was an openness. (Simone, age 38, United Church, left church)

The differences between women's church contexts and community attitudes to sex and sexuality raises an important point that feminist theorist Stevi Jackson (1996: 33) identifies:

> How we make sense of sexual experience depends on the discourses, narratives, scripts available to us, and it is through these interpretative processes that we link our experience and practice. The way we narratively construct our experience will depend on our location within our society and culture.

The discourses that women hear and internalize as a result of their location within different church (and non-church) communities contribute to how they interpret and experience sexual activity. "The discourse about sex that we hear or do not hear has a direct impact on the way we register, interpret and respond to our bodily feelings" (Knapp 2003: 126). While most of the women in this book have not lived out the ideal their church has for sex, they have lived with this ideal in mind, seen in the expression of their guilt and shame about sexual events. The grip of the values around good and bad femininity reaches deep into the embodied identities of the women interviewed in this book.

Embodiment of Shame and Guilt

Embodiment means "the experiential sense of living in and through our bodies" (Tolman 2002: 50). Social and cultural expectations and contexts, including emotions, are lived through the body. Shame and guilt are socially produced and are experienced powerfully at the site of women's bodies. A well-managed body within many churches is in control of sexual desires and experiences, and presents itself as feminine through, for example, appropriate dress. Shame and guilt combine to function as an internal compass for how many Christian women present their selves and live out sexual experiences. Maya shared her account of sexual events at the time she was involved in a conservative Protestant church. She described the shame and guilt that she felt and enacted:

> At church it was "no sex before marriage," and I was having sex at that time. I was in a relationship, but there was this guilt — you didn't talk about it; you didn't really talk about it with your closest friends because you weren't supposed to do it. So, where is the joy in that? It was like living a secret!…. I never really thought that I'm going to go to hell for doing this. I just thought, "I am not a good Christian girl," but in the back of my mind, this is ridiculous. Who's imposing these rules? Who?…. Where do you draw the line? But definitely that sense of "bad dog, what have you done?!" Sometimes a sense of shame, but never a sense of true peace with it…, and I hurt myself over that. I remember with my boyfriend, we were having sex and knowing that we shouldn't be having sex, and I physically hurt myself over that. I became a cutter. I cut my own skin with knives, slashed a few places. I think that says a lot…; the cutting didn't last for long, you know, a few isolated incidents, but… I was a failure. I had failed God in His eyes, you know, bad girl. I was a failure — no will power, not strong enough faith, God wasn't enough in my life. I had to repent. All those big words: sin, repent, you know. It was horrible…. I remember going through turmoil, horrible turmoil, and praying for forgiveness. I felt I had to do that, to pray and repent to save my soul. It's oppressive. I don't think I had anyone to talk to…; somehow I think that my friends knew, but we never really talked about it. (age 34, Baptist, left church)

Two ways Maya lives out her embodiment of shame and guilt are keeping sexual activity a secret and cutting her body. Secrecy lived out in the church community is one way Maya manages her reputation: "A girl's reputation is always under threat, not merely if she is known to have had sex…, but for a whole range of other behaviour that has little to do with actual sex" (Lees 1989: 20). Maya maintains her reputation as a "good Christian girl" by keeping her sexual experiences secret and separate from her Christian identity, which in the end helps her to maintain the connections that are important to her in her church community. Feminist psychologists Jean Baker Miller and Irene Stiver, who

examine women's experiences of connection and disconnection, give a helpful explanation of this process of keeping sexual events "secret," "hidden" or "in the dark." Women often do not express or give voice to their experiences in order to sustain their relationships. They will enact these approaches that cause feelings of disconnection in order to keep connections (Miller and Stiver 1997: 82). In order to maintain their connection to church peers and leaders, which can be integral to their lives, many women choose to keep their sexual events secret for fear that it may alienate them from the group. Maya later said, "I remember the first time I had sex. It was a beautiful experience, but it was this huge dark secret.... I lost my virginity when I was 17, so from 17, seven years of having guilt-ridden sex." These kinds of actions can have consequences for women's selves and their relationships. The sexual selves that are kept in the dark, combined with the debilitating silence on issues of sex can lead to a potential loss of worth in one's sexual and social selves because of the shame and guilt tied to maintaining Christian standards, beliefs and values. Miller and Stiver's description, moreover, helps to make sense of women shutting away their sexual selves in order to be acceptable; shutting away the bad girl in order to be seen as the good girl.

Maya's self-monitoring behaviour that emerges from feelings of shame and guilt is tied to the ways in which patriarchal societies can reward the performance of conventional femininity, whereas going against these confines can be penalized. "Shame involves a recognition of the judgements of others and awareness of social norms: one measures oneself against the standards established by others" (Skeggs 1997: 123). Maya punishes herself for going against the standard her church had for sex by self-harming after sexual events. By cutting herself, Maya disciplines her unruly body and soul. This act helps her to negotiate her conflicting emotions, the belief that she is being a "bad girl," and the powerful feelings of failure before God. Secrecy is how Maya manages her shame and guilt amongst her church peers, while cutting is a way through which she manages her shame and guilt before God.

Similar to Maya, some women preferred not to discuss sexual events within their communities. Instead, they preferred to talk with non-Christians in order to keep their connections with church peers. The Internet and friends can be perceived as more safe and supportive to discuss issues of sex (Yip et al. 2011). Cynthia said, "Everyone feels they have free rein to judge you and what you've done.... I feel okay talking about it to a non-Christian, not so much a Christian because it's looked down upon, the whole out of control thing" (age 22, Anglican, attends church). This account conveys non-Christians as being more open-minded when, in fact, they may face similar pressures among peers around issues of sexuality. At the heart of Cynthia's statement, however, is her underlying fear of what her Christian peers would think of her if she were to behave in ways that were not perceived as appropriate and good. "When you see yourself as failing to meet the standards and rules..., you feel great fear" (Rowe 1987: 32). Emotions like fear can "confirm societal values" (Crawford et al. 1992: 123). Victoria told me about the gossip that

would ensue between her and her Christian female friends. For example, "Jane has a non-Christian boyfriend or Sophie's slept with her boyfriend, isn't that *awful?*" There was a sense that this kind of talk caused Victoria and her friends to think sex was "*really* bad" and that they should not engage in it. They held each other "accountable," and as a result, they "wouldn't generally confess to each other" (age 29, Anglican, between churches). Victoria and other Christian women like her remained silent about such experiences in order to maintain (or at least maintain the appearance of) the standards and values of their communities. Sexual desires in women can thus become the "feelings that no one names" (Tolman 1991: 59). When sexual desire is not discussed in church culture, it can leave Christian women without a vocabulary for their sexual desires (Aune 2002). However, "sexual hunger that is undiscussed, at worst presented as a bubbling cauldron of danger and sin, potentially ruinous" (Knapp 2003: 34), means that shame and guilt colour sexual longings and experiences, making the course of the Christian good girl more complex.

Disembodied Sexuality

"Disappearing in Sex"

Furthermore, while physical self-harm, such as cutting, may have provided Maya a means of negotiating experiences of guilt and shame, others' strategy for dealing with the conflict between Christian and sexual identities involved disengaging oneself from sexual acts that were taking place. Jessica employed this strategy in order to deal with her identities as a sexual being and a Christian. She told me about her experience:

> At that time, I had quite a serious relationship. We went out from the time I graduated high school to the age of 23. He was involved in the church, and so was I. I think the church was the one good thing, the one consistent thing, although just considering that we were sexually active, that was kind of hard to be involved in church knowing that I wasn't making a wise choice in terms of being sexually active.... I think about it and have to unlearn some of that shame and some of that kind of disappearing in sex because that might have been some odd attempt on my part to act as if it wasn't happening or I wasn't actually having sex when I darn well was, but if I allow this to happen to me [and] I am much more passive in the process, [then] I am not as much of a bad girl. (age 34, Baptist, attends church)

Her embodiment of shame meant she "disappeared" when she was having sex. She shut her sexual experiences off because she believed that she was being bad. Jessica became "passive," meaning she was not fully engaged in receiving and giving sexual pleasure. For Jessica, disappearing meant that she was detached and disconnected from her sexual desire and experiences, and therefore not fully

participating in what her church deems only appropriate for marriage. If she was not giving her entire sexual self to the encounter, she could preserve parts of her self for her (future) husband when she married. Jessica's physical disconnection from her body speaks of the power of an ideal sexual self that many women are to aim for as Christians. For Jessica, disappearing helps her to remain a good girl or "not as much of a bad girl." Her passivity keeps in place conventional modes of femininity. At the same time, she gives enough sexually to hold her male partner, but always with the concern for her reputation (Holland et al. 1998: 109).

Jessica's experience — outlined above — can be described through the concept of "disembodied sexuality" (Holland et al. 1998: 108–09). Disembodied sexuality in the experiences of young women involves the "sense of detachment from their sensuality and alienation from their material bodies… that produces a passive body and therefore a modest femininity" (109). Jessica's disembodied sexuality — "disappearing in sex" and reasoning that "if I allow this to happen to me [and] I am much more passive in the process, I am not as much of a bad girl" — enables her to negotiate her conflicting Christian and sexual identities. The embodiment of shame and guilt that is a result of an embodied Christian femininity can result in women, like Jessica, experiencing a disembodied sexuality. Holland et al. indicate in their research that many young non-Christian women live out this experience of disembodied sexuality. These experiences of a disembodied sexuality are tied to the pressures of a socially constructed femininity that both allures and remains in control in order to be seen as decent (Holland et al. 1998: 109). Likewise, the women in this book also lived these dynamics out, but often with the added pressure of their religious commitments. The demands of a social, personal and Christian obligation can cause many women to believe that it is not okay to masturbate or to want or enjoy sexual activity, resulting in a disembodied sexuality during sexual experiences, whether alone or with another.

"He Touched Me and I Didn't Know What to Do."

I now turn to Anita's sexual experiences to further explain the interaction between one's religiosity and sexuality. Like Jessica, she also describes a disembodied sexuality during sexual events, something that helped her to negotiate her conflicting identities as a Christian and growing sexual woman. From my conversation with Anita, I highlight two statements that summarized her struggle. Anita's first statement describes sexual disembodiment:

> Well, for instance, when a guy I dated that I really liked, he touched me, and I didn't know what to do…. Christianity was all over how sex was for me, how it defined my sexual experiences…, even masturbation I felt ashamed of. (age 28, Baptist, left church)

Anita conveys that she was not inside the sexual experience or sensations of her material body, but rather detached because of Christian expectations about

appropriate sexual behaviour. She demonstrates the conflict of desiring to be sexual, but is not able to because it is overshadowed by her Christian identity. Linked to her religious identity is a very traditional idea of being feminine, which often prescribes asexuality — a woman is not a sexual being (Averett et al. 2008: 336). Often communicated by both parents and church communities, this idea of asexuality translates into messages that can encourage ideas of abstinence only, and can reconstitute double standards where it is acceptable for young men to be sexual but not young women (Averett et al. 2008: 336). Such ideas leave women struggling with a sense of asexuality and a possible sexual immaturity that results in "not knowing what to do." Journalist Catherine Von Ruhland (2004: 14), who wrote about being a Christian and a virgin at the age of 40, states, "Churches need to take account of single people and their sexuality." An implication is that many Christian women are not recognized as embodied sexual beings.

The concession Anita made for her identity as a Christian woman further resulted in her emerging feelings of shame. In her second statement, she describes the opportunity to have sex with a young man that she was dating, but instead she remained "un-sexual" because of her Christian identity. It was this ongoing conflict that caused her to feel ashamed in two ways: Her shame was felt when in her church community because she was not experiencing marital sex and outside of her community because she was not sexual in the ways that secular contexts, such as those found at university, work or in films and television, often promote and normalize. She said,

> The boundaries that Christianity puts on sex, I felt very un-sexual and ashamed for not being sexual, in and outside of church…. In one opportunity to have sex, I didn't because all I could think about was, "What is [the minister] going to think if I told him?"… And this whole idea that if I am not a virgin what will my husband think?

Anita conveys the conflict she faced when wanting to say "yes" to sexual experiences that her church considered sinful. On the one hand, she desired to have sex in order to be knowledgeable in this area like her non-Christian and Christian friends, but on the other, how can she be a good Christian girl and have sex? While she upheld the Christian ideal to experience sex within marriage, she felt conflicted by not yet being married and not yet experiencing sexual intercourse. Furthermore, Anita's shame for feeling "un-sexual" and not having sex is determined by the imagined views of male others that she has internalized. She lives out what Bartky (1990: 72) describes as "the panoptical male connoisseur that resides within the consciousness of most women, standing perpetually before his gaze and under his judgement." Anita embodies how men may view and evaluate her. She projects onto herself and her sexuality how they might appraise her if she is not a virgin. Anita monitors and disciplines her sexual behaviour resulting in a conflicting sense of embodiment.

A "Great Separation"

Many women can internalize the social and cultural expectations of their churches, and subsequently may not be able to separate their sexuality from their investment in the feminine norms of their lived contexts (Tolman 2002). Grace told me about her observations of her church at home after having attended a different church while at university:

> I have noticed more at my church at home, after being in an open-minded church, I have noticed more than ever, especially being my age, that there aren't really any women my age involved in the leadership of the church [at home], except with children or the crèche and stuff. So the idea of being a good girl in the church is to be someone who helps out with that kind of thing or like do the cooking and cleaning and stuff and let the men go up and do the speaking and leading and stuff.
>
> Sonya: So, whom do the Christian women that you see in your family church imagine they are being good for?
>
> Grace: I'd want to say God, but sometimes the dominating men in the community as well.

Grace noticed the restriction of women's capabilities in her family church because of different churches and contexts. She sees that a woman's identity can become tied to certain nurturing and feminine roles, depending on her religious environment. These norms, for many women, easily cross into other social spaces, such as domesticity, family life and marriage. Consequently, women may experience expectations to be good in the living out of their sexuality, causing great separation between their personal desires and expectations to be good. Some of the women discussed feeling a sense of separation between their religiosity and sexuality when with another person. They also discussed this sense of separation in relation to masturbation. Victoria told me,

> In terms of masturbation, when I was in university, it was a completely bad thing to do: it was particularly bad to fantasize, and I would repent, do it again, then repent again, so that was a period of great separation between my [Christianity and sexuality]. (age 29, Anglican, between churches)

Victoria communicates the tension she felt between her sexual desires and religious teachings — a tension arising in part from the underlying notion of a Christian femininity that endorses good and godly conduct. Social psychologist Michelle Fine (1988: 35) has suggested that the "adolescent woman herself assumes a dual consciousness, at once taken with the excitement of actual/anticipated sexuality and consumed with anxiety and worry." Many of the women

in their interviews alluded to this dynamic. It is evident in the ways they attempted to separate their Christianity from their sexuality and in the ways their desire was felt as good and bad at the same time. Because they had been taught that masturbation, sexual exploration and intercourse outside of marriage were sinful, many women found it difficult to embody their sexuality. This is not unlike what feminist researcher Amy Mahoney (2008: 96) found in her qualitative research about Christian women and sexuality: "In the case of the women interviewed, the opposition between Christian messages of virginity and abstinence and their adolescent sexual curiosity and exploration caused dissonance."

While Grace alludes to the possible consequences of being good and Victoria discusses the sense of disconnection her Christianity caused her to feel in relation to her sexual body, some women enact a deliberate separation in order to live out both their religiosity and sexuality.

Women described making separate their sexuality from their Christianity in order to be sexually active with partners for whom they cared. Such moves were conveyed as imperative to their sexual desires and evidence of their agency. Rhonda said, "To get on with my own sexuality, I had to separate [my Christianity from my sexuality]" (age 26, Pentecostal, left church). Similarly, Maya stated, "I could never reconcile my sexuality with being a Christian. Not being married, it didn't fit." Resultantly, in challenging the dualism (abstinence versus married sexuality) Protestant churches can often impose on the sexual body, these women experienced great conflict. Such conflict is often emotional, which can therefore cause women to make agential moves.

Although these separations were not without negotiations and consequences to other areas of women's lives, the dilemma imposed by these conflicting positions presented an opening for sexual exploration and experiences. Continuing the story about Anita, who had lived with inner conflict comparable to that described by Victoria, told me about "finally" deciding to have a sexual experience with a young man whom she loved (age 28, Baptist, left church). This was an event that she felt she could experience only because she was in between church contexts, having left her missionary work to return to her home church. Despite her Christian beliefs, she followed her emotional and sexual desires. In other words, "the body cannot be seen merely as subject to external forces; the emotions which move through bodily processes must be understood as a source of agency" (Lyon and Barbalet 1994: 50). Women's experiences of shame and guilt can be affected externally by sources such as church doctrine on sexuality, and internally when women feel they have sexually transgressed their church's teachings. However, the emotions that move through women's bodies can cause women to experience their bodily selves not only as passive (e.g., disappearing in sex), but also as active within these assemblages. Clearly, the emotional discord women felt between their faith and sexual desires could act as a source of agency to help women give expression to their sexuality. For some women, it was difficult to move beyond perceiving sexuality

as transgression; for others, agential moves were a conscious and necessary step for their sexual development.

Leaving Church

When I asked women why it was not okay to have sex before marriage, they gave many reasons: it might cause "pregnancy," "because it is a gift from God," it may cause one shame and rejection or it may cause a woman to be seen as "promiscuous." These ideas are in part socially produced within their church contexts and reinforce good girl/bad girl discourses. They can also disregard women's sexual experiences as pleasurable and gratifying. More so, the guilt and shame expressed by women who have said "yes" to sexual experiences provides important information about the impact Protestant church communities can have on women's sexual selves. In this chapter, I have explored women's feelings of shame and guilt that they experienced and embodied during sexual events and that resulted in them keeping sexual activity secret. The impact of guilt and shame went even further for some women, resulting in self-harming, as well as in disembodied sexuality, where women disconnected from themselves during sexual events by disappearing in sex or not knowing what to do sexually. By negotiating their conflicting identities as sexual women and as Christians, women can live out the gendered ideal of the good Christian girl in their churches, an act that can re-enforce a patriarchal construction of women's sexuality.

Given the emotions and sexual experiences that have been discussed, for some women the pressures created by the values often perpetuated by their churches have meant they have left their communities. The inability to fully explore her sexual self without feeling a sense of shame was, for one woman, "rolled up into the same ball of wax" in her decision to leave the community. The desire to have sex without feeling sinful and the feeling of "unworthiness" because of the emphasis on sin have also been reasons for leaving: "What is it about church that makes us feel bad and awful, unimportant, not valuable, the emphasis on sin all the time? We're okay. We are worthy!" (Veronica age 48, Anglican, left church). Rosie Miles' UK study of why women leave the church found that some women leave because they were no longer comfortable trying to live within what they saw as constraints placed on them by their churches (Miles 1994 cited in Wraight 2001: 66). Shame and guilt produced in relation to transgressing a marital-confined sexuality constrains both sexual embodiment and the ability to discuss sexual experiences with other Christian women. For some women, leaving church meant finally growing into the body they had felt disengaged from: "I began to feel more comfortable in my own body after leaving the church" (Anita age 28, Baptist, left church). Leaving church, moreover, cannot be seen to result from the women no longer having a faith or not being spiritual. Rather, the reason for their leaving is to be found if one examines more closely how issues of gender and sexuality in church settings affect women attendees and their choices to stay or disaffiliate. Women in this book who have remained in their churches are content to stay; others are less content, but

stay anyway. Those who do remain are, moreover, not necessarily satisfied with the status quo. Women who have left have found experiences that resonated with how they were growing and evolving as women, spiritually and sexually.

Deciding to remain in church life or abandon it because of a marital-confined sexuality can be perceived as two distinct decisions. However, for many, such decisions are neither easy to make or easily disentangled, since there is much that churches provide for women, like a community and supportive networks. Sexual decisions for women thus become about finding ways to live out both their religious commitments and sexual longings. The next chapter shows how some Christian women managed to navigate these important aspects of their lives in ways that resulted in them negotiating and satisfying their religiosity and sexual desires.

Notes

1. Parts of this chapter will appear in the forthcoming journal article, Sharma, Sonya (2012). "Exploring acts of agency within Christian women's sexuality," *Fieldwork in Religion* 7(2) (c) Equinox Publishing.

2. While Christian men are held to this ideal, they do feel the constraints of their church's conservative stances on sexuality (see for example Bartkowski 2004, Aune and Sharma 2007, Aune 2008b). Further interrogation is needed with regard to masculinity within Christianity and religion more generally.

3. Stephen Pattison (2000: 229–74) writes about some of the contradictions that are a part of Christian theology, such as God loves people exactly how they are, but then asks them to repent and change, which might engender or promote a sense of shame. While this dynamic is important and intertwines with the women's experiences, I am more concerned with how shame is produced through social and cultural relations.

Having the Sex They Want[1]

> I do pull away from very austere relationship-type stuff. I think you need some flexibility.... I consider my sexuality more these days. (Linda, age 22, Anglican, attends church)

The tensions between longing for and resisting sexual desire, between the potential fulfilment and perceived risks of giving one's physical body to another, between acquiescence and resistance are dilemmas that many women confront. These tensions underlie the women's stories in this book. The women struggled not only with the possible social consequences of engaging in non-marital sexual activity, but also with the problem of whether to resist or honour the teachings of their Christian faith. Particularly between the ages of 18 and 25, navigating competing secular and ecclesial discourses on sexuality was a complex experience for many of these women.

What remains to be explored are the various acts of agency within Christian women's sexuality. I believe this is an important focus, as it shows women in religious communities working through issues of faith and sexuality in ways that enhance their sense of agency, even though church and (non-church) contexts can often cause women to wonder if they have made the right decision. I give attention to four areas: (a) women choosing to be both sexual and religious, (b) one woman's sexuality that led her back to church, (c) women choosing sexual abstinence until marriage and (d) sex in marriage. Before I launch into their stories, I first revisit how I am conceptualizing women's agency.

Agency

Agency is the ability to choose among discourses and practices that are available and to utilize them creatively. It is also the ability to reflect upon the implications of these choices lived within various relations of power (Sawicki 1991: 103–04). Agency is difficult to navigate, negotiate and sustain, and often encompasses both acts of accommodation and resistance. Accommodation is "the willingness to help or fit in with someone's wishes" (Soanes et al. 2001: 6). Resistance is "refusing to accept a definition of oneself and saying so. It is refusing to act as requested or required" (Martin 1987: 187). These two notions do not present a binary, but are a way of describing the complexity associated with enacting agency. Women's sexual subjectivities are shaped by various contexts, including Christian and secular cultures, which are not necessarily distinct, but blur. The sexualities of many of

the women exist between religious and secular influences. "Individuals become engendered and acquire a gender identity in the context of several co-existent discourses on gender, which may contradict and conflict with each other" (Moore 1994: 58, 59).

As religion has become less public and more private, "the process [of] religious authority shifts from the churches to individuals, giving individuals greater autonomy to construct their own religious meanings and to set their own standards of conduct," including in the area of sexuality (Petersen and Donnenwerth 1997: 1072). Women in this book who made sexual decisions that countered what their churches advocate demonstrate the effects brought about by feminism, and secularism that favours the individual with greater autonomy. At the same time, the effects of secularism and the sexualisation of culture can result in women living out a more distinct approach to sexuality, upholding their church's ideal. Apparent is that today, many "find themselves in a field of tension between stricter sexual morals and sexual liberation, between gender repression and sexual equality, between giving shape to new types of sexual patterns and falling into traditional social forms" (Johansson 2007: 102). In the stories that follow, Christian women show how they negotiate constructions of femininity and sexuality, which presented challenges for them. Their agency made possible ways in which to deal with conflicting demands of accommodating and/or resisting church and non-church teachings on sexuality, creating openings to live out both their religious commitments and sexuality.

"Waiting Until Marriage Is Not Realistic"

Countless women in western societies today express active and lively views of sexuality. As Johansson (2007: 42) remarks, "The passive and oppressed woman found in the work of Simone de Beauvoir (1983) and others seems to have been replaced by a more active and competent female subject." In this first section, I focus on a Christian woman named Susan, who told me she had decided to have sex with her fiancé. Her experience highlights her lived experience of sexuality alongside her Christian faith:

> I've only slept with Samuel, but we had sex before we were engaged. I remember saying that once I was engaged I would feel like I'd happily do it, but I knew Samuel was the right one. We had been going out for a few months, and I just thought there was no need for me to wait, so I went against the teaching I had been taught, then, but I, like, knew it was right for me and felt no guilt about doing it then. I mean everyone is different, but I always thought I would wait till I was engaged, but I think you should wait until it is the right one without rushing into anything. I don't think to wait until your wedding night is right, but then for some people it is…. I always thought that it's just not very realistic. I think people who aren't Christians think, "No drink, no sex," and it just makes it seem very square and very rigid and tight rules, and

it's putting people off the real message there, and if you get hung up on that, you're missing the point really.... I don't agree with sleeping around or one-night stands, but to wait until marriage is not realistic and not for me. (age 20, Methodist, attends church)

Susan's decision encompasses both her sexual desires and her individual perspective of her Christian faith. She does not look to the authority of her church to decide whether her decision was good, but instead acts independently to embody her sexual self: "I knew it was right for me." Susan, a contemporary Christian woman, recognizes that her church's ideal for sex is not always realistic. Her actions are negotiated within a broader cultural context in which sex as part of being in love is okay, while sexual desire removed from the relational context is not, but considered promiscuous (Gilmartin 2006). Changes in the wider culture, such as sex and co-habitation before marriage as acceptable, might be viewed as having helped to facilitate Susan's sexual agency, even though she possesses Christian values. They might have also contributed to how her parent's dealt with her having sex with her fiancé:

[My parents] get along really well with Samuel, and they didn't mind him stopping over, which is really cool. They didn't mind me stopping over at Samuel's sometimes, so I think they guessed. I think they would be much happier with us being married than living together, and I think because they knew we were getting engaged and married, I don't think they minded.... I remember my friend saying, "Oh I can't believe your Dad is letting him stop over." And some of my friends' Dads would let their boyfriends stop over, but somehow it was supposed to different with my Dad because he's a Minister. And that annoyed me a little bit, just the way she said it. I'll do the same, if I have daughter someday. I'd tell her if she's happy with the person, then it's okay.

Although Susan had sex outside of marriage, she eventually married the man she had sex with. While she problematizes her church's stance on sexuality, she also maintained the ideal that women's sexuality should be experienced in marriage by getting married. Susan expresses little conflict about her actions, even though she admits, "I went against the teaching I had been taught." Even though her non-marital sexual activity conflicted with her church's message, she does not view having sex with her fiancé as an act of resistance, nor getting married as an act of accommodation. Susan's decision is in line with how she chose to carry out her Christianity. She discovered a way in which to experience her sexuality that was congruent with her religiosity and desires. Her decision, moreover, demonstrates the underlying effects of feminism in that she is able to exercise her agency in a way that fits with her sexuality and faith.

Sexuality "Was My Growth Back into Faith and Church"

In this section, I focus on Patricia (age 28, Baptist, between churches), who also decided to have sex before marriage and attend church while she was sexually involved. Not unlike some of the women already mentioned, Patricia's faith and sexuality were challenged when she met her partner. Presented with an opportunity to explore her sexuality with someone she cared about, her relationship to her church and her sexual self changed. Out of all of the women I interviewed, she was the only one that spoke of her faith and sexuality in the following way. I include her story because I think her experience might be more common than is recognized in church communities.

> The thing, probably, that caused me to start thinking about my faith again was when I met my partner, and I think that probably happens a lot more than what people will actually acknowledge. I met him when I was 23…. For ages I couldn't figure out how you could be a [Christian] youth worker and have sex because five years prior, I already worked out that you couldn't do both, and here was this person who was unshakingly committed to his faith, belief in God and Jesus, and he was challenging all of those things that I thought were a huge part of being a Christian. I mean, just before he met me, he had made the decision to have sex and all those kind of things, and I just couldn't understand that. How can you have sex and believe in God? It was an opening up for me, really. And so for me, that was my growth back into faith and church, and in regard to traditional church, I feel like I can re-enter it with a completely different view about what it is, what it can do for me and what it can't. So, I was much happier and much more interested to go back into church that way…. The whole thing for me, the whole inner workings of the church are connected to a very sexual event or commencement in my life. My partner, he's the man I married, and that not only opened up a lot of things for me, but he also resolved a lot of issues for me as well because I had a lot of sexual experimentation [with him]. I got to know myself a whole lot more, and then I could go back into the church and go, "Okay, I am having sex, and I am not married." I didn't go blathering it around, but my personal knowledge actually enabled me to actually have a presence [in church] again, absolutely.

Patricia describes the resolution, challenge and angst that her decision to have sex entailed. Taking a break from attending church and finding a fellow-Christian who was questioning and exploring similar personal issues contributes to Patricia's sexual development. Importantly, in addressing her inner conflict about her Christianity and sexuality, she began to integrate them while in her relationship (Mahoney 2008). The result of her sexual exploration is a sense of empowerment. In her experience, empowerment is not an experience of "power

over" or "power for oneself"; rather it is "power with," a perception that grew out of her mutually gratifying relationship (Surrey 1991: 165). In other words, such a relationship allows Patricia to develop and embody her sexual self. In turn, this sexual embodiment leads her to attend church with more of a "presence," a self-identification that results from her agency. Sociologist Karin Martin (1996: 10) argues that a person must experience a link between agency and body/sexuality, since these affect how people act and feel about themselves in the world.

In bringing to church the embodied sexual woman she is growing into, Patricia does not conform to her community's marital-confined sexual expectations for its female membership. Instead, she is transformed and able to contribute to her church more dynamically *because* she is sexually embodied. Although she resists her church's conservative message, there is much that she gives and receives as a result. Amy Mahoney and feminist scholar Olivia Espin (2008: 1) contend that the integration of one's sexuality with their faith can "together, create a synergistic sexual and spiritual experience that is greater than either separately." Feminist researchers Judith Daniluk and Nicolle Browne (2008: 133) also argue that although many women's sexuality and sexual self-perceptions are informed and reinforced by dichotomizing traditional religious practices, sexuality based in spiritual meaning, love and connection can open up possibilities for empowering sexual selves and experiences. Through her exploration, self-reflexivity and agency, Patricia creates for herself such possibilities.

For Simone, her parents were initially against homosexuality. However, her relationship to her parents changed as a result of their church's discussions on ordaining homosexuals. Simone attended the United Church of Canada. She said,

> I had come out to my parents at the time the United Church started to have a real discussion across Canada about sexual orientation and accepting that we may have ministers that could be gay or lesbian. And my parents, I was amazed to see, really changed their positions completely. At first they would have said homosexuality was bad, but when I told them I was a lesbian, they decided it was a good thing because it was okay that ministers were gay and lesbian, and it all depends on if they are respectful to people, then it is fine. If they are disrespectful and abuse other people, then it is not okay. (age 38, United Church, left church)

Simone's parents' church had powerful sway in how they initially perceived homosexuality. Yet, when their church came to a place of acceptance, an opening was created in her parents, a new perspective, which led to an acceptance of their daughter that may not have happened otherwise. While Patricia's sexuality gives her a presence in church again, she was not able to discuss her sexuality openly with church members because of her community's traditional stance. In Simone's church, because sexuality has been openly discussed, she has the opportunity to be fully present. She does not have to hide who she is. Although she has chosen

to leave her church, she knows she is welcome there. Her church's faith in gender and sexual equality has the capacity to lead her back.

"I See Sex as Something that Should Be Saved for Marriage"

For many women, their church's message about sex as well as support from their Christian peers provided them with a platform from which to say "no" to liberal sexual messages and experiences that they were not ready for or preferred to experience only with their (future) husbands or partners. In this section, I focus on women who decided to wait until marriage to have sex, often making this choice because of their religious convictions. They made this decision in the face of secular peers and popular media that frequently insists women should be sexually active:

> The Bible says that sex is within marriage; therefore, that's what the Christian teaching is. At the end of the day, it is up to you, but you shouldn't feel pressured into it. (Jane, age 20, Anglican, attends church)

> I think it is quite admirable to save sex for marriage because there is pressure from outside and obviously the media. I think it takes a lot of courage to actually go against it and say that you don't want to have sex. (Harriet, age 19, Anglican, attends church)

> God made us, sex is a beautiful thing, and you only get the most beauty from it when you use it properly in the relationship of marriage. (Anna, age 20, Interdenominational, attends church)

These women describe the virtues of remaining abstinent and the alternative it provides to the pressures to be sexual that they observe around them. The women quoted above are very much on board with what their churches espouse. Remaining abstinent can provide women with personal space in which to figure out their sexuality. The periods between 18 and 25 can be a significant time of questioning and exploration with regard to religion and sexuality. Anna, who is mentioned above, was someone I saw months later after our interview. She told me she was in a relationship and that some of her views on sexuality had changed. As mentioned in Chapter 2, this was also the case for Victoria, who found this time important before deciding to come out as lesbian. Although it can be argued that single evangelical Christians from ages 18 to 25 are finding it difficult to live a celibate lifestyle (Evans 2001 cited in Aune 2002: 19, 20), there can be benefits to remaining chaste.

Certainly, one option that Protestant Christianity offers women is a form of femininity, a social structure that provides a counter position to the sexual permissiveness epitomized in modern culture. Choosing abstinence carves out an alternative expression of sexuality and femininity for Christian women. "For a woman who belongs to a conservative religion, maintaining an ascribed feminine role can be a powerful act of agency and resistance to a secularizing world" (Day

2008: 265). In a recent article published in *Observer Woman* (January 13, 2008: 32), it was reported that many young, successful women had discovered Christianity for themselves and lived a chaste sexuality because they preferred to have sex in a safe, committed relationship. Unlike the "hyper-sexualized culture" around them, chastity gave them the confidence to say "no." Women choosing to uphold their churches' ideal may be a response to secularism's impact on sexuality. Some women described their decisions: "I guess [Christianity has] influenced [me] in a lot of ways as I see my friends, you know, going out with boyfriends, sleeping around or whatever" (Anna, age 20, Interdenominational, attends church), while Angela said, "I have never have been able to do the one-night stand thing" (age 23, Anglican, between churches). Abstinence can be a personal sexual ethic and practice that women choose to live by until marriage or even until a committed relationship that feels right to them.

Agency encompasses awareness and boldness, which the women demonstrate in their acceptance of Christian values and counter-secular views on sexuality. Some of the older women, who were situated in different histories during the ages of 18–25, discussed what waiting until marriage meant to them:

> Eighteen was hell because we desperately wanted sex. Obviously, we did the snogging bit, and all the cuddly bits, and all the touchy bits, but we didn't have sex. It was hard… you see, I didn't have any problems. I mean the night we went on our honeymoon, it was absolutely fantastic. I wanted to do it all night. We had a wonderful sex life, and I don't think people talk about sex enough…; it just came natural to me! Two and a half years of courting. We were pretty desperate. (Rose, age 65, Baptist, attends church)

> Being a Christian and sex goes hand in hand. My faith influences how I operate in that department…. How you use your body, it goes back to the body being the temple of God…. Your body is a temple of God; you treat it with respect, so of course being a Christian influences this…. God created sex. It is for procreation and for enjoyment in marriage. (Miriam, age 43, Baptist, attends church)

Although they grew up during different times and contexts, the desire for sexual fulfilment in marriage is ageless. Both of these women had sexual experiences for the first time in marriage. It is within this relationship that these women convey sex as good, satisfying and enjoyable. Many of the younger women held on to this belief. Christian women can rely on their faith and sense of agency to navigate competing influences that say they should be sexual. Aware of the patriarchal structures that often frame sexuality within organized religion, the women felt supported by their churches in their choices to practice sexual abstinence.

"A Bible and a Vibrator": Sex in Marriage

In talking to women about sexuality and Christianity, some had followed their church's teachings to have sex only within marriage. Because their decision was in line with how they wanted to live as Christian women, it yielded feelings of self-worth and happiness. Debra Taylor, Archibald Hart and Catherine Hart Weber, who conducted The National Survey on Christian Female Sexuality, found that many Christian women experience high levels of sexual satisfaction because of happy marriages, frequent lovemaking sessions and commonly reaching orgasm (Richard 2000). The researchers also attributed these findings to a desire by Christian women to please their husbands who commonly wanted recurrent sex, often seeing his needs as more important to their own sexual fulfilment (Richard 2000). Being married, having a husband and feeling loved can lead to self-confidence. Rose, who grew up during the 1950s and 1960s, told me that if she had not married, she would have felt less worthy (age 65, Baptist, attends church): "My husband was the best thing that happened to me. He made me feel worthwhile. He loves me for me. If I hadn't married him, I would have been a mouse." She went on to tell me about seeing a woman in her church who was not married, and described her as timid. She said this woman would be different if a man wanted her. This viewpoint arises from Rose's personal history and social and religious background, whereby women can embody standards of femininity that are conventional, using them to evaluate theirs and others' feminine performances (Wolkomir 2004). Hence, a woman's sense of self-worth is still often tied to feelings of competence that are linked to a man's valuation of her.

For some women, sex with their husbands was validating and self-affirming. For others, sex in marriage was a different process. For many, marriage became a space where they made attempts to "let go" of conventional religious beliefs and values they felt had restricted their early sexual experiences. They wanted to be free of feeling "sinful" and "ashamed," and of being a "bad girl." Thus, the relationship of marriage was where they could finally be the sexual women they longed to be. Yet even this required some working through, as the ever-present "disciplines of conventional femininity can inhibit women's agency in ensuring satisfying sexual encounters" (Holland et al. 1998: 129). Rhonda said that even though she had premarital sex, she did not feel truly free to express her sexuality until she got married:

> Rhonda: The thing is to let go of what was implanted so early on. All of these things are really intrinsically placed, and to let go of that is a long process, to feel like it is not sinful, to be doing it. It is not sinful to have sexual desire. That it's not sinful to act on it was the hardest bit to let go.
>
> Sonya: When would you say you let go of that?

Rhonda: I don't think I felt truly free until we got married.

Sonya: What age were you when you got married?

Rhonda: Twenty-three. [Having sex] was truly sanctioned then. (age 26, Pentecostal, left church)

Even though "having sex was truly sanctioned [within marriage]," marriage did not make having sex more spontaneous or pleasurable for some of the women. Such acts were often fraught with conflicting emotions, as many Christian women have been discouraged to say "yes" to sexual pleasure (Ogden 2007). This seeps into marital relationships where sex can be misleadingly promised by many churches to be good and satisfying. As Rhonda explains, she was finally able to engage in sex without constraint when she was married, but it was not without working through residual teachings of sex as sinful.

Another woman, Jessica, who is married and continues to attend church with her husband and family, was also aware of the impact her church's teachings still had on her marital sexual experiences. At various points in her life, good girl/bad girl discourses as they related to her religiosity defined her sexuality. Since being married, these discourses are less present, but still linger, making old constructs difficult to relinquish. Here, I focus on two excerpts from Jessica's story to demonstrate the sexual "journey" she had been on. She grew up going to church, had non-marital sex during her teens and twenties, and then got married. She continues to attend church with her husband and family. In her first excerpt, she said,

> Even in my marriage, you know what I used to do after sex? I used to cry. A couple of times I've had a cry, which is hard. It's so sad that the way that I am is, I think, from thinking I was being a Christian, trying to be a good girl, to get in God's good books, and that's not what He had intended for me at all. So now, I understand Jesus more and know that He wants me to live out loud in my sex life… Occasionally I have a cry after sex, if he and I have what I think is bad sex, where it is more for him than for me. I have a cry where I know that cry is old, it's coming from an old place. Yeah, that feels really hard for me; it feels very kind of not good girl for me to come out of my shell during sex. That'd be a journey. It feels really hard for me to kind of go, "Can you do this?" "Can you touch me here?" It's quite vulnerable, "What will you think of me?" There's even some kind of approval-seeking behaviours with my own husband. It's got to go.

Sexual psychologist Gina Ogden describes "the good-girl script" many women live with. Good girls are not supposed to love sex or know about it. Good girls are all about dressing right, being polite and pleasing others. Both in and outside of religious communities, the pervasive message is still "Good girls *don't*" (2008: 33). Even in marriage, as Jessica describes, the good girl is still alive and well, even in

the marital bedroom, where sex has sometimes been to please her husband and not herself. When sex becomes about pleasing him or God, she goes through the motions to manage her sexual disconnection from herself. Such experiences ultimately mean a disengagement from her husband and ultimately herself (Miller and Stiver 1997). What Jessica would prefer is for her sexual desire to emerge with her husband's; she wants to "live out loud in her sex life." She believes this is what Jesus would want for her — a sex life that is abundant and her fully present within it. In this statement, she departs from a God who condemns the bad girl to a God who wants her to experience *good sex*. She renegotiates her femininity that manages sexual desires to one that vocalizes and makes direct sexual requests, asking her husband for the sexual pleasure that would please her and that she would like.

Ogden encourages women to experience the "Oh God!" script. On the one hand, these two words can connote negativity in a religious sense, yet on the other, they convey spiritual pleasure and sexual ecstasy. Ogden explains that sex is as much a spiritual experience as it is physical. The next excerpt that comes from Jessica's story is an experience that attempts to bring these two aspects together. She talks about a gift she received from her husband, a gift that highlights a new way to explore her sexuality, solo or with him, a gift, which aims to bring her Christianity and sexuality together.

> For my birthday, my husband bought me a Bible and a vibrator. [Laughs] Like no clue, no hint, no kind of "Would you like this?" No discussion, although we have had discussions where we kind of need to, you know, try something new, anyways, we laughed so hard. It's such a curious item. It's been so interesting for me to make sense of this vibrator. It is like, "Oh my goodness, what do I do with this? What do we do with this? How do we use it? Is it okay?" I mean it came with a book of questions, and they don't all have answers, and it's really been interesting for me to kind of have this sex toy in my life and go, "Is this okay? Is this bad girl? Is this good girl? Can we use it? Can I use it? Can I use it alone? Is that right? Is that wrong?" What a funny gift that was. I think we might otherwise think, "Oh my goodness, a Bible and a vibrator!" Those things don't go together. I mean this thing is so funky. It's, like, blue, you know, the blue of an iMac computer? It's that kind of bright blue!

Even though Jessica is married, she has had to reconcile her past sexual experiences within her marriage and with the sexual self she longs to be with her husband. Jessica highlights the workings of a conventional femininity that she trips over in attempting to achieve sex as "the ultimate act of intimacy" without feeling the constraints of the good Christian girl. For many women, "the dividing line between compliance and subversion is thin," and both "giving into, as well as resisting, dominant social constructions" can be difficult (Thapan 1997: 11). "Living out loud" for Jessica equates to living without inhibitions, to sharing in

an equal exchange of sexual pleasure with her husband. Many churches might encourage their married couples to have this approach to sexuality within their marriages, but women (and men) are often negotiating their desires amid conventional constructions of sexuality, which can limit their sexual fulfilment. Nonetheless, Jessica expressing the kind of sex she would like is an agential move toward sexual equality with her husband, which can inspire other women and men in similar situations.

Christian Women's Sexuality Is Varied and Complex

Christian women's sexuality is multiple and complex. Victoria said, "Sometimes I think that I have lots of different sexual selves. I have a lesbian self with my girlfriend and myself, a heterosexual past self, a could-be-heterosexual-in-the-future self, and I have a fantasy self and a masturbatory self" (age 29, Anglican, between churches). Possessing multiple expressions of sexuality was common for most of the women. Although many talked about attempting to achieve an ideal, singular, sexual self that is lived out in heterosexual marriage to one partner for life, after talking with several women, it became clear that the ideal to save or have sex only within heterosexual marriage was merely an *ideal*. This, therefore, problematizes the construction of sexuality that many churches espouse. And yet, as the previous chapter has shown, the shame and guilt that many women have embodied in relation to this ideal speaks to the power that this construction still has on many women's lives.

A marital-confined sexuality is, furthermore, not always fruitful to a woman's sexual formation because it can leave her with the inability to move forward in relationships, not only sexually, but also in the very expression of her self. Feminist psychologist Jean Baker Miller "identified sexual authenticity — that is the ability to bring one's own feelings of sexual desire and sexual pleasure meaningfully into intimate relationships — as a key feature of women's psychological health" (Miller 1976 cited in Tolman 2002: 20). Deborah Tolman (2002: 20) argues that, "From a psychological point of view, developing a strong sense of self and engaging in authentic, meaningful, and joyful intimate relationships requires an acknowledgement and acceptance of one's bodily feelings." For many women, their sexuality is central to their self-development, as is their church community that they identify with and actively participate in.

Religion and spirituality cannot be overlooked when examining sexuality, for they continue to have a profound affect on women's sexual lives. Psychoanalyst Carl Jung often found that a person's concerns about sexuality were religious ones and vice versa (Nelson 1978). Today, we observe tensions between "'the erotics of abstinence' to confronting 'the realities of owning one's sexuality'" — as read and seen in the book and film *Twilight* (Flanagan 2008; Grossman 2008; Siering 2009). Religion and sexuality and how they are worked through remain very present today and highlight the complexities of living in a pluralist society (Roper 2001). Whether it is choosing sexual abstinence, becoming sexually active for the

first time or expressing sexual desire in numerous ways, conversations about faith and sexuality and their tensions are a reality. Many of the women I interviewed wanted to explore these tensions brought about by situations in their own lives. Although their agency was difficult to navigate or to enact, they were consistently engaged in determining how to best live out their sexual desires and religiosity. And even though this raised challenges for them, numerous women found ways to live out both.

Note

1. Parts of this chapter will appear in the forthcoming journal article, Sonya Sharma, 2012, "Exploring Acts of Agency within Christian Women's Sexuality," *Fieldwork in Religion* 7(2) (c) Equinox Publishing.

"Watch the Women"

> Let's move away from black and white, good girl, bad girl and start to be a bit more progressive, a little bit more postmodern in our teaching of sex in the church. (Jessica, age 34, Baptist, attends church)

Many Protestant churches still teach and encourage a marital-confined sexuality, which can play a key role in the construction of Christian women's sexuality. The women I interviewed described finding their own way in the world from the age of 18 through university, relationships, employment and/or travelling. They were making decisions in regard to their sexuality and were also finding church communities where Christian beliefs and values were often crucial to giving them a structure by which to live. These communities were sites of friendships that both encouraged and reinforced Christian teachings. At the same time, many women struggled with the constraints that their churches espoused with regard to traditional gender roles and sexuality. In today's world, particularly for young women, marriage is no longer necessarily a marker of adulthood, nor is finishing school, finding a full-time job or having a child (Arnett 2007). Although these events can happen during one's late adolescence and early to mid-20s, these markers do not necessarily denote adult status, even though many people still perceive these events as signs of adulthood. They do, however, signify certain kinds of responsibility, which people are taking on later in life (Arnett 2007). As adult status is defined in more varied ways and getting married and having children are happening later in people's lives, this is something that churches could be more mindful of when advocating their conventional message for sexuality. It does not necessarily suit all ages or fit within formerly considered life stages (Erikson 1968; Levinson 1978).

Navigating life transitions and social contexts also vary according to markers of social difference (Jones 2002; Hopkins 2006; Henderson et al. 2006). Gender, class and race influenced the women's experiences of church. For instance, some revealed how class can be "an enabling or constraining influence" on how they experienced church life, often expressed through the right dress and appearance (McCloud 2007: 7). Race and racism also complicated women's religious lives, and discourses of respectability emerged in the women's accounts about sexuality. Because of respectability, saying "yes" or "no" to sexual desire and exploration was not simple, but intersected with Christian values, race and class. The women in this book confronted social norms within their churches that impacted them, but

because of the friendships and support they found there, these could remain in the background. For others, expectations to conform caused them to leave church to find other places of worship and/or spiritual groups that would accommodate them and their sexual decisions.

Many women chose to follow their churches' teachings, but there were those who while involved in church resisted them, both of which decisions had costs. For example, for some chastity resulted in a sense of asexuality, and for others, the espousal of chastity played a part in "sex going underground." Sexuality, often a taboo topic or perceived as something "bad," left many of the women consumed with shame and guilt for sexual transgressions. Churches that say very little on matters of sexuality except "no" or "don't until marriage" caused some of the women great fear of judgment within their Christian communities, sexual experiences wrought with unpleasant emotions, and for some, a lack of vocabulary about sexuality. Because of this, many women policed their own and their peers' sexual behaviours to uphold a patriarchal sex agenda. Women's self-surveillance and the surveillance of others not only alienated them from their sexual experiences, but also from each other. Most women expressed a desire to be able to talk to their female Christian friends about issues of sex, but often did not for fear of losing their sense of belonging within the group. Women can thus be complicit in their own sexual oppression. Cultures of accountability in which one discovers oneself in a fishbowl while dating can be very difficult to endure and can cause some women to disaffiliate from their churches rather than drawing them closer. Ironically, it is also why many women felt compelled to stay. Practices of community accountability in church life provided a structure that worked to guard against secular cultures and media that encourage women to live out their sexuality in ways they may not want to experience. Their church's main message regarding sexuality provided them with a reference point. Church also gave them a place where they were supported by a strong network of women in their roles as wives and mothers.

This book has shown how the women's religiosity and sexual desires were complicated by conflicting discourses of femininity and sexuality espoused in their churches and non-church cultures. Women's bodies became the sites where these discourses, and the tensions between them, were embodied, lived and negotiated. Women's acts of agency, in order to embody their sexuality, both accommodated and resisted dominant constructions of sexuality found within church and non-church contexts (Thapan 1997). Their agential acts therefore emphasized the heterogeneity of Christian women's sexual experiences, challenging the ideal of a marital-confined sexuality, as well as more liberal secular messages. Although heterosexual women's experiences are largely the foci, the lesbian women I spoke with demonstrated resilience in their faith despite their churches' marginalization of them. They, along with a few heterosexual women, were finding ways to renegotiate their church's theology and spaces so they could continue to live out their religiosity and sexuality in ways that suited them. Women are thus actively

negotiating, engaging and contesting religious rules and boundaries in relation to their sexuality. Although women continue to face the dichotomy presented between their religion and sexuality, this dualism is too simplistic to explain the diversity of women's faith and sexual experiences. Assisted by the processes of secularism and feminism, and the cultural mores of the sexual revolution, opportunities have opened up for women to make agential moves to live out their sexuality and faith traditions simultaneously.

On Feminism and Religion

Throughout this book a feminist thread weaves through women's stories. While some did not explicitly call themselves feminists, their actions in relation to their churches echo feminist moves. For example, women's various attitudes and behaviours with regard to sexual experiences outside of marriage or engaging in a same-sex relationship whilst maintaining religious commitments challenged patriarchal structures found within their churches. What is more, Christian women have not been strangers to feminism. Looking back, Christian feminists like Elizabeth Cady Stanton, who wrote *The Women's Bible* in 1898, felt that traditional Christianity had largely discounted women's contributions to the faith. First-wave feminists who possessed a Christian background made tireless efforts that paved the way for second-wave feminist theologians, who articulated the marginalization of women within patriarchal Christianity. Rosemary Radford Ruether and Mary Daly educated many women on the androcentricity of traditional Christianity and how it has shaped and impacted women's sexuality.

Women's work, scholarly and grassroots, has been pivotal to women's changing relationship with traditional religion. Sociologist of religion Callum Brown has argued that the feminist movement and women's subsequent abandonment of religion has been central to understanding patterns of secularism. Yet feminism was not a completely secularizing experience for women from religion and/or spirituality. Out of feminism there has been a proliferation of distinct groups, from Wiccans, Ecofeminists, Goddess Feminists to Neo-Pagan groups (Anderson and Young 2004). Also, many women continue to attend church. Mainstream feminism, however, has given little coverage of women's religiosity and its sustained influence. Political scientist and feminist Leela Fernandes (2003: 9) states that, "feminist theorists and organizations tend to relegate spirituality [or religiosity] to the local 'cultural' idiom of grassroots women (usually in 'other' places and for 'other' women), acknowledging it in the name of an uneasy cultural relativist tendency of 'respecting cultural difference.'" It is also typically the case that within public life, religion is sidelined. In universities, for example, where secularism has taken hold, religion will most often be taught as a "cultural object," something external to oneself, rather than as a valuable perspective that one has an inner relationship with (Wuthnow 2008). Like Fernandes suggests, faith, spirituality or religion becomes something that others do, practised elsewhere. Many secular feminists have been

wary of religion because of its colonizing history and patriarchal practices (Klassen 2003). While this may be true, many women grow up in actively religious homes that affect the gendered and sexual discourses that they hear and live, even after having left their religious traditions. This study has shown that religion cannot be discounted nor be dismissed from examination. It continues to intersect with women's lived experiences of gender, race, class and sexuality.

Subsequently, women who are both feminists and religious can confront tensions when they hold both stances. Alison Webster (1995: xi), who has written about Christianity and sexuality, argues that if a Christian woman is a lesbian, "she may not feel that this primary aspect of her identity is adequately addressed" in her church. And while her lesbian identity is more readily accepted in feminist circles, she may find there that any interest she retains in religion has to be "suspended." One might argue that feminism pushes women towards movement and change, while traditional religion, at its extreme, prevents this. Elucidating the similarities between fundamentalist Christians and feminists, two heterogeneous groups that often offer a critique of the other, Heidi Epstein contends that feminists are not without their own fundamentalist tendencies; both groups can live out their own orthodoxies. The intersection of feminism and religion thus complicates gendered constructions and cultural expectations for women.

Many scholars and feminists believed that secularism would have resulted in the emancipation of women and men from the oppression of religion (Sharma and Young 2007). However, feminists and sociologists of religion Marta Trzebiatowska and Dawn Llewellyn observe that women involved in Christian spirituality outside of churches, often seen as working with a feminist legacy, could, in fact, represent a changing face of Christianity rather than its demise. As such, women who have remained religious and/or spiritual are not rejecting modernity (or feminism *tout court*), but are undertaking a complex series of negotiations within a pluralist culture (Brereton and Bendroth 2001). Feminism today is as relevant as it was in the 1970s, albeit more complex. Christianity is also transforming, affected by secularism, globalization and migration. As such, women can be both religious and feminist, and these encompass manifold approaches and positions. Christian (and) feminist women today are an array of voices, living out a variety of approaches to sexuality and religion.

Feminism Informing Christian Practice

Although feminism has helped to generate opportunities for women, there is still much more to do for women to be considered equal within their churches. It is often assumed that because women have made advances in work and education, gender equity has been achieved. However, feminist thought and practice is still alive, needed and able to contribute to Christian contexts in order that women may be recognized more fully in Christian history and theology, the running of churches and everyday practices in congregational life. I briefly focus on these three areas.

Christian History and Theology
Feminist theologians have helped to transform Christian thought and interpretation. They argue that a patriarchal character has mainly defined traditional Christian theology and Christology. Theologians such as Daphne Hampson (1985: 349) therefore argue that feminism has much to offer Christianity. She contends that "feminism is a movement of the greatest importance for religion in the West, and that not simply because it throws into relief the partiality of the religion which we have inherited, but because it proposes new values and norms" by which different understandings of God and the Bible can come. Rosemary Radford Ruether further contends that by rereading the scriptures through a feminist lens, one can apply a more pluralistic approach that expands the images of God to include female ones. Feminist theologian Elisabeth Fiorenza brings credence to feminist interpretations of the Bible with her influential book *In Memory of Her*. She offers a reconstruction of Christian origins that establishes women's part in the richness of biblical history.

African-American women have also transformed their religious traditions (Walker 1983), contributing to other ways of perceiving Jesus Christ. Mary Grey (2001: 68) argues that when African-American women call Jesus "Lord," it is a subversive act because it is different from the way that the White slave owner was "Lord." The significance of Christ is not his maleness, but his humanity (Grant 1989). In claiming the humanity of Christ, Black women become subjects in their own theological discourse rather than being objectified in the discourse of others (Grant 1989). Latina feminist theologians, such as Maria Pilar Aquino and Elsa Tamez, have also reread and reinterpreted biblical passages that create paths to liberation for women from oppressive circumstances based on their gender, race and class. Feminism can offer Christianity re-conceptualizations of women's place in a religion that has a long history of patriarchy and oppression.

The Running of Churches
Feminists have played a role in advancing gender equity within secular work environments. These achievments have and could be of great benefit to women's positions in churches. A recent study in the U.S. on congregational life found that the numbers of women hired for clergy roles between 1994-2008 increased by 12 percent among mainline Protestant denominations, compared with very little movement among conservative denominations (Woolever 2010). Bäckström et al. (2011: 7) argue, as women are "noticeably present" in the day-to-day delivery of religion, they are "correspondingly absent" at the senior levels. Ordained women often face discrimination for jobs because of their gender, being single or having a family. Women who are not ordained but in leadership roles also face prejudices and the sense of having to prove their competence. Abigail, who was a church leader for young people, said,

> Probably the area that it has been most difficult to deal with is being female in this faith culture, for me especially over the last few years.

This job, it is either your age or gender or both stacked against you, and in one place, I had to prove myself because I was female. I find it quite damaging in some ways. I mean, coming from an arts background and working in museums, there are quite a few women in leadership, and so to come from that and come into this archaic culture, it's kind of..., I mean I always knew it was there, but I never realized to what extent until I came into this job, and sometimes you think it is me being oversensitive, but it's not.

Churches within Protestantism can do more in addressing women's work opportunities and situations within religious contexts. It is usual to hear among Christian communities that women and men are different and therefore have different roles that carry equal weight. In practice, women's roles have typically been caring and helping ones. In practice, notions of equality need to be heeded so that women are recognized for all that they can do, including leadership and preaching. In many churches, women are doing this, but several still confront social and gender constraints. Sarah Page's (2011a, 2011b) research on clergy mothers in England shows that while women are being ordained as priests, pregnancy and child-rearing are often barriers to them being considered for positions or advancing in the ministry. Because women face these obstacles (within churches and outside of them), their sense of worth and achievement can be undermined. In response, some women clergy have written their own work policies to address the demands of parenting (i.e., a child's illness, school pick-up) that may coincide or conflict with their parish duties. Many women in ministry, past and present, are vocalizing their concerns to shift these barriers. For example, St. Hilda's Community that supports women priests; WATCH (Women and the Church), a group that is campaigning for gender-inclusive language and women bishops in the Church of England; WIMM — ECUSA Women's Organizations (Women in Mission and Ministry — Episcopal Church U.S.A.) that is working for gender and social justice in church and non-church contexts; or WICC (Women's Inter-Church Council of Canada) that focuses on social justice, women's issues, ecumenism and women's spirituality. Feminist practices, such as inclusive language, forming collectives, (re)writing policies, protesting and speaking out, can, moreover, inform Christian ministry by helping to create an environment that recognizes women's abilities and contributions to church life.

Everyday Practices in Congregational Life
In order for women's work roles to be (re)considered, everyday practices within Christian communities need to transform. Demonstrated in the women's stories, gender and sexual repression is embodied as well as institutional (Banyard 2010). Transforming church cultures means carrying out a variety of individual and collective everyday practices to end oppression. Even though many Christian women and men are intellectually and philosophically against inequality, sexism and oppression, they find this difficult to enact openly because it could put their

church relationships and friendships at risk. Maya, who had left church, said,

> A couple of times I was incensed at things that were said in sermons. I never gave myself a voice, and it wasn't just that I was going against the flow of a particular congregation; you're going against the flow of the whole institution.... It's safer to shut-up. Why stir the pot?

Moves for gender equity are happening, but because many members do not want to be labelled or alienated in their churches, this results in a lack of deliberate and transparent feminist practices that emphasize equality. Feminist authors Catherine Redfern and Kristin Aune call for a re-claiming of the f-word. Yet, "reclaiming the f-word" or claiming to be "feminist" at all is not an easy task, especially among Christian women who, in order to have a voice in their communities, consistently negotiate relations of power that can be distrusting, even disparaging of feminism. Consequently, many Christian women do not identify as feminists nor actively resist the structures and practices that subordinate them. In many communities and organizations, including churches, the "absence of extreme restrictions leads many women to ignore the areas in which they are exploited or discriminated against; it may even lead them to imagine that no women are oppressed" (hooks 1984: 5). On the one hand, as we have seen in previous chapters, women are negotiating and carving out spaces within their churches for their voices to be heard and roles recognized. On the other, although victories are won and women are able to preach, changing a system of power that seems resolute and unbending can cause many women to vote with their feet, leaving their churches for communities and experiences that are more receptive, just and impartial.

Women are not alone in confronting conventional ideals in relation to gender and sexuality; men do too. Many Christian men face their church's dominant constructions that insist on hegemonic masculinity and a disciplined sexuality (Aune and Sharma 2007). Men are also simultaneously depicted as sexually uncontrollable, even in their churches. Some women I talked to concurred, believing that more Christian women would be "virgins" compared to the Christian men that they knew. Transformations to religious conceptualizations and practices of gender and sexuality could benefit men as much as women. A crucial question Kat Banyard (2010: 206), feminist activist and author, asks for the progression of gender equality within society is "what impact does the practice have on gender relations as a whole? Does it help end the subordination of women — does it further perpetuate it?" Churches might pay heed to this important question when espousing their long-time teachings on sexuality. This question that encapsulates feminist practice could aid both Christian women *and* men. Asking them both to live out their religiosity and sexuality in ways that inform gender equality could more deeply inform their relationship to the sacred and to one another, therefore creating church communities built on openness and equitability, not reticence and hierarchy.

On Being a Good Girl

For these changes to take effect, however, the notion of the good girl has to desist. Discourses of good girl/bad girl are pervasive in women's experiences of sexuality and religion. Attempting to be a good girl is not helpful to women's sexuality, but can repress them in becoming sexually developed women, even in their marriages. Notions of the good girl can, for some Christian women, mean that good sex is about pleasing their male partners and/or policing the boundaries for appropriate sexual behaviour that is in line with religious teachings.

Good girl/bad girl discourses, however, not only permeate women's sexuality, but other areas of their lives, such as work, education and home life. English author Allison Pearson, who wrote the novel *I Don't Know How She Does It*, chronicled the "modern female malady: the crazed pursuit of the perfect life" (*The Guardian* April 29, 2010: 5). Trying to be all things to all people, and do it well, caused her to become depressed. Many women share her predicament — being good or being perfect has meant the demise of their mental health and well-being. Psychologist Dorothy Rowe states, "Most girls are still brought up to be very good, and a good person is somebody who always feels that they can do better. We're brought up on the principle that if a job's worth doing, it's worth doing well" (quoted in *The Guardian* April 29, 2010: 5). Christian and non-Christian women of today confront this dilemma "of being good" and "doing it perfectly" at children's school drop-offs, coffee-rooms at work, churches on Sunday, and on television and in magazines. Women are bombarded with societal messages that tell them they can or have to achieve a good education, excel in their careers, be an exceptional mother, entertain with panache and keep an impeccable home, all the while maintaining a svelte physique and a fashionable wardrobe.

With the establishment and proliferation of self-help literature and media, including Christian mediums, there is no problem that cannot be solved. There is always a way to improve oneself. This has meant that women, in addition to being good, are expected to feel good, to be happy. Feminist theorist Sara Ahmed, in her book, *The Promise of Happiness*, critiques the latest surge of happiness books and studies, arguing that happiness is an "unconditional good" for many women, resulting in feminism being blamed for women's unhappiness because it attunes them to the social restraints found within their marriages, churches, work, educational and community settings. She contends that feminism has been blamed for making women "unhappy" because it has opened them to what is possible outside of the constraints and ideologies of domesticity. Feminism's consciousness-raising has raised women's "consciousness of unhappiness" (Ahmed 2010: 70). Although religious and non-religious women of today have "choices" because of feminism, these choices do not necessarily guarantee gender equity, personal freedoms or "happiness" (Everingham et al. 2007). Discourses of the good girl and being "happy" continue to pervade church and non-church settings complicating women's goals and ambitions. With regard to church life, women find support for

their domestic roles. At the same time, their churches may repel them because of traditional stances and expectations that may compound or conflict with personal aspirations. Ahmed (2010: 55) explains that a happy woman "aligns her happiness with the happiness of others." Consequently, women's happiness is often negotiated at the junctures of their faith, relationships, responsibilities and individual goals, and may be further compromised by an expectation, feeling or a desire to be good.

In addition to being good and happy, women, religious and non-religious, experience social pressures that endorse being "good in bed." On the shift of sexual mores within western society, psychologist and sex therapist David Schnarch (1997: 127) says, "We've gone beyond making it okay to want sex. Now, you're *supposed* to want it." With this mandate, girls and women are also seduced into thinking they are supposed to *give* it. New technologies and media have contributed to pornographic images becoming accessible and common ways to express sexuality (Attwood 2009). Ariel Levy (Levy 2005 in Taylor and Newton 2006: 28) argues that women are now "co-opted to internalise pornography as the new female sexual norm." Some argue that in addition to normalizing sexual acts and expectations, this gives women new sexual freedoms — the sexualization of culture benefits not only the boys and the men. At the same time, others argue that conventional attitudes to women's sexuality underscores these changes whereby girls and women are expected to give sex, resist it or be the ones held responsible (Attwood 2009).

Likewise, popular Christian literature has attempted to stay relevant, publishing books and manuals for sexual intimacy. Yet, these are aimed at married couples and newlyweds, reproducing discourses that espouse a marital-confined sexuality. Additionally, popular television and radio talk shows are promoting their own sexual discourses. *Dr. Ruth's Guide to Good Sex* is one example, or *Talk Sex with Sue Johanson*, or Dr. Laura Berman, who has appeared on *The Oprah Winfrey Show* telling people how they can improve their sex lives and become "better in bed." These shows have also helped to normalize sex, making it more acceptable to discuss at home between couples and with children. They have helped to give people a language for their sexuality and have generally emphasized sexuality as essential to health and well-being. However, depending on the show, these popular discourses can re-constitute heteronormativity and can marginalize other sexualities and sexual expressions, like celibacy or transsexuality.

Several Protestant churches attempt to counter modern changes with their distinct message for sexuality. However, to stay relevant and to adapt to modernity, they are also left in a predicament of how to do this without compromising their core beliefs and values. Consequently, many churches have remained rigid in their stances, imposing traditional ideals that have been detrimental to women's (and men's) sexuality. Women thus find themselves in the middle of social and sexual discourses that require them to be and achieve numerous aims, which can be unrealistic and may not fit with who they know themselves to be or want to be. How can Protestant churches address sexuality differently so that people can engage

with discourses that affirm their religiosity and the goodness of their sexuality? Heeding feminists, theologians and sociologists who have studied this area, I discuss the differences between a sexual theology and a theology of sexuality that some of them have proposed as an alternative to Christianity's traditional position.

On Good Sex

When a woman embodies her Christianity and sexuality, whether she is single, married, straight, lesbian or otherwise identified, she can contribute a powerful "presence" to church life. When a woman's sexual subjectivity is lived and recognized in a mutual, caring relationship, it can positively affect her relationship to her church. There were only a few women that talked about this. For most, it was difficult to achieve a union between their Christianity and sexuality. The few women who were able to do this represent what scholars term a *sexual theology* (see for example, James B. Nelson 1992; Rosemary Radford Ruether 2000; Andrew K.T. Yip 2003). Sociologist Andrew K.T. Yip (2003: 63) explains that a "sexual theology emphasizes the lived experiences of sexuality as the starting point to illuminate our understanding of scriptures and tradition" while a "*theology of sexuality* uses the scriptures and tradition literally to inform our understanding of human sexuality." Those who advocate a sexual theology do not dichotomize spirituality from sexuality, but view them as working together in the human capacity for sensuality, relationship and commitment (2010: 40). Importantly, Yip (2010: 41) and others believe that such a stance "seeks to expand heterosexist theological frameworks such as the institution of marriage" so as to be more inclusive of a range of sexualities and identities.

Theology of Sexuality

Many churches have positioned themselves within a theology of sexuality. To demonstrate the affects of this position, I return to Barbara's story. Barbara (age 33, Baptist, attends church) talked about dating her husband for up to five years before they were married in their mid-twenties. She expressed her sadness about the length of time she felt guilty about sexual experiences. Having no real guidance on levels of intimacy provided by her Christian community was difficult for her. She stated that, "There were no rules saying mutual masturbation is okay, lying together naked, whatever you do, whatever state, there are no clear cut rules. It's like no sex to sex, and there is a huge range in between that." She reflected back on this time and said, "My sexuality, it was a very strong part of me. I felt very sexual, an awakening of being a sexual being, and the feeling was amazing, but the church added that sense of control over it." For Barbara, sex was more than penis-vagina intercourse. For her, it involved spirituality, emotionality, physicality and the relationship itself. Barbara wanted to move beyond religious definitions of sex and live what she felt most deeply. Like many women in this book, she wanted to transcend religious dogma that causes shame and guilt and confrontations with the "good girl." She wanted to

experience ecstasy, union and sacredness. Theologian Marvin Ellison (1994 : 236) argues that conservative Christian messages like "celibacy in singleness, fidelity in marriage" can be woefully inadequate when addressing sexuality. "It denies the rich diversity of sexual experiences and relationships and establishes uncritically the exclusive claim of heterosexual marriage to moral propriety and sexual maturity" (Ellison 1994: 236). Psychologist Judith Daniluk (2003: 12) argues that women's sexuality has come to mean much more than "procreation and forbearance," but also love, connection, intimacy, ecstasy, pleasure and comfort. A theology of sexuality is more concerned with the facts and circumstances of sexual relationships (i.e., genital acts and with whom) rather than on the substance, such as the quality of honesty, care and respect (Ellison 1994). We see this in the story of Barbara, whose sexuality was stifled by definitions of sexual acts and the circumstances of not being married, even though her own reality was one of desire to be in physical connection and intimacy with a man she loved.

Sexual Theology

A sexual theology perceives sexuality as intrinsic to our relationship with God and that sexual experiences are an expression of God and God's self-disclosure to us (Nelson 1978: 16). Rosemary Radford Ruether (2000: 218) sets out a similar alternative, calling for a new *ars erotica* (knowledge of sex or sensual pleasure). She outlines the integration of eros with philia (friendship) upon which an ethic of genuine mutuality, trust and care in all sexual relationships can lead to sexual maturation and well-being. She argues that saving sex for heterosexual marriage does not always mean sexual development, comfort, pleasure or contentment. Ruether describes "hallowing covenant relations," which can be an alternative to traditional marriage, thereby honouring relationships that churches might otherwise consider wrong or problematic such as younger, same-sex or cohabiting couples. She outlines such commitments for those "who seek to integrate sex with the covenant of friendship and mutual support of each other's development" at various stages of their lives (214). The differences, as explicated by these theologians and sociologists, between a theology of sexuality and a sexual theology highlight the significant gap that exists between typical Protestant church teachings on sexuality and how most people live.

This book has mainly focused on how women have interacted with a theology of sexuality that their churches have encouraged. Yet, some women experienced a sexual theology that transformed their relationship to their Christianity and sexuality. As discussed previously, an evening church service within the Methodist tradition and a group of Christian friends enabled Abigail to explore and talk about sexual issues. This was the only time something like this was mentioned by the women interviewed. She described the respect that members of the group had for one another's complex and varied sexual experiences, each navigating these and their faith in a safe space. Key to Abigail's experience was the development of

a sense of worth about her sexuality. In a church context, people important to her conveyed that they recognized and acknowledged her experiences. Feminist writer and activist, Audre Lorde has explained that "the erotic as power" goes beyond the merely sexual to women's deepest expressions of their selves. The mutual acknowledgment and validation Abigail received expanded not only her experience as an embodied sexual woman, but also her expression of herself.

Some of the women in this book challenged their church's fear of the sexual body, while others succumbed to it. Rather than discuss sexuality, churches are often silent on "the goodness of sexuality or the pleasure of a sexual relationship" (Young 2000: 23). This is mirrored in women's relationships to their own sexual body and in their surveillance of one another. Instead of encouraging openness and discussion about the diversity of sexual experiences, churches have restricted their message to a marital-confined sexuality. Rather than generating a dialogue about sexuality as "a part of a continuum of intimacy and relationship," they "diminish sexuality as good" (Young 2000: 23). Abigail's experience, however, is an example that gets beyond many Protestant churches' typical stance and Ogden's description of women's triple bind (Chapter 1). Abigail does not remain silent about her sexual experiences, but risks discussing them openly, thereby claiming her sexuality as good and wholesome in an unlikely space. Similar to Abigail's experience, Patricia's mutually giving, caring and respectful sexual relationship with her partner gave her more of a "presence" in her church, resulting in a different relationship with her congregation. However, her sexual embodiment and its fruits are something that she brought to her church on her own. Her church benefited from Patricia's (non-marital) sexual subjectivity, something her church most likely would not have encouraged had it known. Ellison argues that good sex enhances self-worth and the desire to connect more justly with others.

In many ways, churches have a history of being involved in people's sexual lives (Foucault 1978). However, because of changing times and shifting social patterns, churches must consider being involved differently. In other words, they already attempt to regulate sexuality from a particular approach, usually through a theology of sexuality. But by incorporating a sexual theology, churches could move closer to gender and sexual equity. The recent controversy over same-sex unions and the ordination of women bishops have given a glimpse into the challenges associated with change in established churches. For some churches, in their struggle to retain social power that continues to lessen, they have redoubled their efforts to control sexuality in modern times (Woodhead 2007b). In spite of this, Patricia's, Abigail's and other women's experiences suggest that many churches may unwittingly benefit from more "sexually experienced" women (and men) who, by having a more rounded sense of their selves, are then able to contribute more to their church communities than they would otherwise. Theologian Carter Heyward (1990: 261) contends that if one is to envision a "sex-positive rather than a sex-negative ethic" — sex as an expression of love,

goodness and commitment — then the Christian understanding of marriage as the arena in which sexual expression is "morally legitimate and good" may need to be re-examined. There is a need for today's churches to change their role from "parental" to one of a "concerned and caring friend," thus fostering a greater sense of equality among members. For churches to consider such a position toward sexuality and Christianity would transform the relationship many people have to their churches and sexual selves. Ellison (1994: 238) further contends that churches "must choose between perpetuating a patriarchal ethic of sexual control and gender oppression or pledge its commitment to an ethic of gender justice, of mutuality between women and men and of respect for sexual diversity and lived experience's of sexuality." I strongly agree that many Protestant churches in order to progress need to transform in this area. It is certainly the case that many women and men would prefer a Christianity that encourages positive approaches to sex versus those that demand them to avoid it because it is perceived as sinful, ungodly and not good (Freitas 2008). Many women would appreciate teachings in their churches that leave them feeling less emotionally bereft about sexual experiences and confident and satisfied instead. Several women experience gratification, God's love and church support in relation to their sexual decisions. Yet there are also those women — heterosexual and lesbian — that with their love for God and their churches, would like their sexuality, whether through chastity, a non-marital sexual relationship, civil partnership or marriage, to be an acknowledged expression of this love, not hidden, kept secret or repressed.

Concluding Thoughts

The women in this book and their relationship to their churches demonstrate that as they engage in rich and varied sexual activities (physical or not), their attitudes towards sexuality can constitute and contribute to a change in the attitudes of the wider Protestant church community. When women leave their churches because of issues related to gender and sexuality, they take with them their potential to transform their communities. The possible risk here is that the status quo is maintained within their churches and the gap between conventional and liberal values becomes wider. On the other hand, women who do decide to stay and contribute to transformation mean their churches have the capacity to change from within, making them more relevant to today's world. Numerous women continue to attend their churches because they provide for many needs. Rather than simply disaffiliate or become complacent, women "often employ strategies of resistance from within" (Young 2004). For example, becoming "educated interpreters of the texts and traditions," even when "official roles" have been closed to them, and/ or through "the academy or parallel ritual communities" presenting ideas and alternatives until their faith tradition begins to take them seriously (Young 2004). It is through these moves that women "are beginning to push religious traditions to rethink their stable and essentialized views of sex and gender, a difficult task

that is hardly begun yet, but one in which women stand to gain much more than lose" (Young 2004).[1]

For decades Christianity has been the dominant religious tradition in the West, a powerful force in western societies' constructions and views of sexuality (Young 2004). Although there are many diverse and progressive Christian perspectives on sexuality, many churches within Protestantism have changed little in their theorizing of sexuality. And while it might be perceived that secularists are unaffected by religion, notions of femininity and sexuality are still unreservedly grounded in particular interpretations of the Christian tradition (Young 2004). Moreover, sexuality is largely regarded "in terms of its problems, not its potential" (Leech 1997: 31). I argue that women's experiences of religiosity and sexuality offer another lens through which to understand some of the effects of secularism and Christianity on women's lives. Magnifying the complexity of their sexual experiences, the women thereby reflect back to their church and non-church contexts the interaction of feminism, religion and secularity, complicating conventional and liberal sexual discourses. Penny Marler suggests that we "watch the women." Women are the pulse of church life, and it is here, through their sexuality and thoughts about church community, that women show that although there is much that they embrace within these contexts, there is much that they resist too.

Note

1.　Pamela Dickey Young (2004) has also argued that another task that is needed but has hardly begun is to begin theorizing maleness and masculinity in religious systems

Appendix

Research Methods

Qualitative methods based on a feminist theoretical approach were employed for this study. As a feminist, I challenge essentialist notions of sexuality and femininity often espoused in many church communities. The orientation my study took was contemporary standpoint feminism, which focuses on the relationality and differences between women, as well as the power structures that women are both complicit in and oppressed by. A feminist standpoint provided me with "theory, language and politics for making sense of gendered lives" (Ramazanoglu and Holland 2002: 4). Feminist politics creates feminist research in that it can create conditions to look beyond arrangements of inequality, and can aide in the accounting for the social differences among women (Collins 1990). Moreover, a feminist approach allowed for an embodied, socially located, historical starting point for the generation of feminist knowledge (Harding 1991). This was significant to examining the systemic oppressions in societies that devalue women's knowledge and lived experiences (Narayan 1989). Women's sexuality has often been affected by their church involvement, which further magnifies the effect that social and cultural discourses like heterosexuality and conventional femininity can have on women's lives. Women's experiences of church life became a resource for feminist knowledge, revealing the inter-workings of gendered constructs.

As stated in the first chapter, data collection was carried out from 2004-05. In interviewing women about their experiences of church life and sexuality, my aim was not to compare their denominational affiliations or their experiences by age, even though their social, historical and geographical contexts differed. Central to my study was to understand how their religious communities' teachings on sexuality impacted their sexual lives during the ages of 18 to 25, a time when women are becoming more independent and negotiating their way through various social contexts (Arnett 2004; Lefkowitz 2005). Women older than these age periods were interviewed and offered an additional dimension. Many of the women talked about the age periods of 18 to 25 and more recent experiences of sexuality and church life. They helped me to see that their religious teachings and the social discourses (e.g., good girl/bad girl) often associated continued to have an affect, even into marriage. Of key interest was how women lived and negotiated their sexuality within ecclesial and secular contexts (e.g., higher education, employment, travel) that often convey more liberal sexual messages.

The Women Participants

This research took place in England and was carried out for my doctoral thesis (Sharma 2007). Ethical approval was granted by a small interdisciplinary committee

based at Lancaster University, Lancaster, UK. I interviewed thirty-six women for this study. They were of various ages, ranging from 18–65 and living in Britain or Canada at the time of the interviews. The criterion for the women's involvement in the study was that they had or were attending a Protestant church during the age periods of 18–25. I was interested to hear from women about how their sexual identities were affected by their church's teachings during these ages, but many talked about this time as well as current experiences of sexuality and church life. By including an array of women from different Protestant denominations and of different ages and contexts, I was able to consider how their church involvement continued to affect their sexual development after this transitional period. The women gathered for the study were mainly White, middle class and heterosexual, with three identifying as lesbian. Although efforts were made, the small number of lesbian women is due to those who made themselves available for the study. As discussed, I included myself in the group (see the first chapter for this discussion).[1] The women's church affiliations varied: Anglican (12), Baptist (9), Interdenominational (7), Methodist (4) and other (4). The churches termed as "other" were Alliance, Free Evangelical, Pentecostal and United Church of Canada. As stated, the women, by being from a range of Protestant denominations, allowed me to draw wider conclusions about the commonalities and complexities of women's sexuality and religiosity. In the next few paragraphs, I focus on the different approaches to gender and sexuality to give a sense of the complexity of the Protestant church context.

In the Anglican Church of Canada and the Church of England, for example, there are an array of differences in their "interpretation of the Bible and applying its teaching to contemporary situations," such as "the ordination of women and the remarriage of divorced people" (Crawford 1990: 258). However, with regard to sexual relationships, marriage between a man and a woman is still upheld (Lambeth 1998). This, however, does not mean that all churches within Anglicanism adhere to this, but may take more liberal positions, as observed in the moves by some churches to bless same-sex unions. Among the women, some attended "low" Anglican churches in Britain, which usually take more evangelical approaches to worship and emphasize the Bible as the predominant source of authority in matters of faith.[2] Women who attended such churches said that a conventional stance on sexuality was the most typically espoused. A contrasting example of a church within Protestant Christianity is the United Church of Canada. This church is known for its liberal stance toward gender, sexual orientation and marriage. The congregation selects its clergy rather than a bishop or other authoritative body. One woman in the study attended this church, but left at a time when the church was confronting social and institutional changes. Since then, the United Church has evolved to incorporate stances toward gender and sexuality that are inclusive by performing marriages for same-sex couples and ordaining woman and transgendered ministers (Airhart 2006; Turnball 2011).

There were women who attended the Methodist church in Britain that also has women in leadership roles. Women who were affiliated to a Methodist church experienced teachings that affirmed sexual relations only within marriage. Yet, this is being challenged. Young people at a recent conference for the Methodist Church of Great Britain (2010) have called on their church to examine the issue of cohabitation and to address issues of sexuality that are more relevant to young people today. In recent research conducted in Britain with Methodists in their 20s and 30s, a large number of women and men had one or more sexual partners while single, and many had co-habited, even though this relationship did not develop into marriage (Hutchings 2002). Some of the women interviewed who were Methodists resisted their church's traditional teaching on sexuality.[3]

Baptists mainly believe that sexual relations are "a gift from God" and to be enjoyed between a man and a woman in "the context of the covenant of marriage" (Buschart 2010). However, similar to other Protestant traditions, a diversity of views has grown. There is no overarching viewpoint that determines how issues of gender and sexuality are addressed in the Baptist church because of the autonomy and independence Baptists have within their tradition (Brackney 2006; Buschart 2010). There are several debates on baptism, conversion, theology and social issues such as abortion, gender, race and the economy (Leonard 2005). Even though there are numerous perspectives within the Baptist tradition on gender and sexuality, some of the women who did attend Baptist churches in Britain and Canada struggled with the conventional stance their churches encouraged.

There were also women who attended Interdenominational churches in Britain and Canada, which can be characterized as "new paradigm churches" (Miller 1997). At these churches, which may take place in a non-traditional church building, there is typically an acceptance of the divinity of Jesus Christ, contemporary worship, Bible-centred teaching and an emphasis on conversion, and family commitment and church community involvement (Miller 1997). Women who attended these churches typically confronted teachings that advocated the expression of sexuality only within the confines of marriage (Miller 1997).[4]

In addition to the churches the women attended, they were engaged in a wider contemporary Christian culture, which has grown to complement Sunday services within Canada and Britain. This includes, for example, weekly Bible studies, popular Christian music, magazines and literature, youth organizations, ministries and seasonal outdoor festivals. The presence of Christian media has not detracted from churchgoing, but tends to supplement people's church involvement (Ruether 2000).[5] This has resulted in the mainstreaming of Christianity, which can often be perceived as promoting particular values related to sexuality, marriage and family (Ruether 2000). Although this research focused on women, I am very aware of the ways in which church teachings also affect men (Aune and Sharma 2007).

Data Collection and Analysis

The women were recruited through word-of-mouth, or "snowball" sampling, meaning that two respondents were located who fulfilled my criteria for my study and who helped me to locate others through their social networks (Warren 2002: 87). A limitation of this method, however, is that these findings are not deemed representative given the volunteer nature of the sample. Women, moreover, were made aware of the focus of the study during recruitment. I collected data through semi-structured interviews that lasted for 1–1.5 hours and that were audio taped with the women's consent. Semi-structured interviews meant that I had a general structure of questions, but with enough leeway within the structure of these questions to allow the women to expand or clarify their answers. Choosing semi-structured interviews allowed me to gather a) factual information about the women, b) information about their perspectives and c) to explore in some depth their experiences (Drever 1995: 1). Interviews as the main form of data collection allowed me to actively listen and to hear in detail the stories of the women. It also gave the women an opportunity to express their voices on issues that they may have not been able to easily discuss within their churches or amongst their Christian peers.

Interview Questions

Interviews were semi-structured, questioning and probing the following areas:

- History of going to church and denominational affiliation(s): How long have you attended church? What church do you go to?
- Why they went to church or not, and how they perceived their church communities: Why do you go to church? How are you involved in your church? What do you notice about the church culture that you are part of?
- The importance of church to their personal development between 18 and 25 and more recently: How important has church been to your personal development during 18-25? And more recently?
- What their churches taught about sexuality and their responses to this teaching: What has your church taught you about sex? How has your sexuality been shaped by this teaching? What message would you give your fellow Christian women about sex? In your own words, why do you think your church gives the message that it does about sex?
- Perceptions of the roles of women in their churches: What is it about women in your church who you may look up to as role models?
- How they experienced their voice and contribution to church life: In the context of church, what do you notice about women's voices? How about your own voice?

Other types of research instruments could have been designed and applied, such as questionnaires, but this may have risked not capturing women's voices and experiences. All the women were made aware that the interview questions

would address issues of sexuality, but I did not ask women for intimate details. If they offered to share such information, I checked with them to make sure they felt comfortable with what they said. The women answered questions about their church history and involvement, and its influence on their sexuality. In order to maintain confidentiality, I assured all the women that I would use pseudonyms to identify them so they would remain anonymous. Interviews took place in the women's homes and/or in an office setting. After each interview, women were asked their preferred form of further contact and whether they would like to receive a copy of their transcript and/or a summary of the findings.

To analyze this data, I transcribed and examined these interviews, and reflected on the field notes I had made during the interviewing process. My transcripts were manually coded in order to identify preliminary themes. From here, I moved to deeper layers of feminist-based interpretation. Throughout the process, I became absorbed in the stories of the women, generating layers of insight and analysis into their narratives and their descriptions of their worlds (Crabtree and Miller 1999). Overall, a feminist theoretical approach enabled me to gather women's lived experiences as a resource in order to examine how Protestant Christianity affected their sexuality.

Notes

1. Nicola Slee (2004), who has researched women's faith development, also includes herself in the research she carried out for similar reasons as I have said above.
2. In contrast, "high" Anglican churches are more formal in their approaches to theology and liturgy, with rituals and practices usually associated with Catholicism (Cross and Livingstone 1997). See Hayes (2004) for a history of Anglicans in Canada and Chadwick and Ward (2000) for a history of Anglicanism in Britain.
3. For more on Methodism, see Andrews (1996) and Kent (2002). Also, see Troeltsch (1931) on variations of post-Reformation Protestantism.
4. For considerations of the variations and workings of congregational life in western contexts see Guest et al. 2004.
5. These forms of Christian media are evident on American and Canadian radio, television and in print media. Britain also has a Christian cable station *Revelation TV* (*The Guardian* March 2, 2007), which has been on the air in recent years, as well as Christian radio and various print media.

References

Abrahams, Naomi. 1996. "Negotiating Power, Identity, Family and Community: Women's Community Participation." *Gender and Society* 10, 6: 768–96.

Ahmed, Sara. 2010. *The Promise of Happiness*. London: Duke University Press.

Airhart, Phyllis D. 2006. "Women in the United Church of Canada." In Rosemary Skinner Keller, Rosemary Radford Ruether, and Marie Cantlon (eds.), *Encyclopaedia of Women and Religion in North America, Volume 1*. Bloomington, Indiana: University of Indiana Press.

Ammerman, Nancy Tatom. 1987. *Bible Believers: Fundamentalist in the Modern World*. London: Rutgers University Press.

Anderson, Leona M., and Pamela Dickey Young (eds.). 2004. *Women and Religious Traditions*. Toronto: Oxford University Press Canada.

Andrews, Dee. 1996. *The Methodists and Revolutionary America: The Shaping of an Evangelical Culture*. Oxford, UK: Princeton University Press.

Aquino, Maria Pilar. 1993. *Our Cry for Life: Feminist Theology from Latin America*. Maryknoll, NY: Orbis Books.

Arnett, Jeffrey J. 2007. "The Long and Leisurely Route: Coming of Age in Europe Today." *Current History: A Journal of Contemporary World Affairs* 106, 698: 130–36.

---. 2004. *Emerging Adulthood: The Winding Road from Late Teens through the Twenties*. New York: Oxford University Press.

Arthur, L.B. (ed.). 1999. *Religion, Dress and the Body*. Oxford, UK: Berg.

Asthana, A., J. Doward and P. Harris. 2004. "Celibacy: The New Sex, Drugs and Rock n' Roll." *The Observer*, June 27.

Attwood, Feona (ed.). 2009. *Mainstreaming Sex: The Sexualization of Western Culture*. London: I.B. Taurus.

Aune, Kristin. 2008a. "Singleness and Secularization: British Evangelical Women and Church (Dis)Affiliation." In Kristin Aune, Sonya Sharma, and Giselle Vincett (eds.), *Women and Religion in the West: Challenging Secularization*. Aldershot, UK: Ashgate.

---. 2008b. "Making Men Men: Masculinity and British Evangelical Identity." In Mark Smith (ed.), *British Evangelical Identities: Past and Present*, Carlisle: Paternoster Press.

---. 2002. *Single Women: Challenge to the Church?* Carlisle: Paternoster Press.

Aune, Kristin, and Sonya Sharma. 2007. "Sexuality and Contemporary Evangelical Christianity." In C. Beckett, O. Heathcote and M. Macey (eds.), *Negotiating Boundaries? Identities, Sexualities, Diversities*. Cambridge: Cambridge Scholars Press.

Averett, Paige, Mark Benson and Kourtney Vaillancourt. 2008. "Young Women's Struggle for Sexual Agency: The Role of Parental Messages." *Journal of Gender Studies* 17, 4: 331–44.

Bäckström, Anders, Grace Davie, Ninna Edgardh and Per Pettersson (eds.). 2011. *Welfare and Religion in 21st Century Europe: Volume 1, Configuring the Connections*. Farnham, UK: Ashgate.

Banyard, Kat. 2010. *The Equality Illusion: The Truth about Women and Men Today*. London: Faber.

Barkham, P. 2007. "The Show Is Like a Coffee Morning in Slow Motion." *The Guardian*: March 2.

Bartkowski, John P. 2004. *The Promise Keepers: Servants, Soldiers and Godly Men*. Piscataway, NJ: Rutgers University Press.

Bartky, Sandra L. 1990. *Femininity and Domination: Studies in the Phenomenology of Oppression.* London: Routledge.

Beaman, Lori G. 1999. *Shared Beliefs Different Lives: Women's Identities in Evangelical Context.* St Louis, MI: Chalice Press.

Bellah, Robert. 1967. "Civil Religion in America." *Journal of the American Academy of Arts and Sciences* Winter 96, 1: 1–21.

Bendroth, Margaret L. 1993. *Fundamentalism and Gender: 1875 to the Present.* New Haven, CT: Yale University Press.

Bentham, Jeremy. ([1787] 1995). *The Panopticon Writings.* Ed. Miran Bozovic. London: Verso. 29-95.

Berger, John. 1972. *Ways of Seeing.* London: BBC Books.

Bergman, Brian. 2002. "Returning to Religion." *MacLean's* 115, 13: 48.

Beyer, Peter. 2006. "Religious Vitality in Canada: The Complementarity of Religious Market and Secularization Perspectives." In L.G. Beaman (ed.), *Religion and Canadian Society: Traditions, Transitions and Innovations.* Toronto: Canadian Scholars' Press.

Bibby, Reginald. 2002. *Restless Gods: The Renaissance of Religion in Canada.* Toronto: Stoddart Publishing.

---. 2000. "Canada's Mythical Religious Mosaic: Some Census Findings." *Journal for the Scientific Study of Religion* 39, 2: 235–39.

Bordo, Susan. 1995. *Unbearable Weight: Feminism, Western Culture and the Body.* London: University of California Press.

Bourdieu, Pierre. 1973. "Cultural Reproduction and Social Reproduction." In R. Brown (ed.), *Knowledge, Education and Social Change.* London: Tavistock.

Brackney, William H. 2006. *Baptists in North America: An Historical Perspective.* Oxford, UK: Blackwell Publishing.

Bradshaw, James. 1988. *Healing the Shame that Binds You.* Florida: Health Communications Inc.

Brah, Avtar, and Ann Phoenix. 2004. "Ain't I A Woman? Revisiting Intersectionality." *Journal of International Women's Studies* 5, 3: 75–86.

Bramadat, Paul A. 2000. *The Church and the World's Turf: An Evangelical Christian Group at a Secular University.* New York: Oxford University Press.

Brasher, Brenda E. 1998. *Godly Women: Fundamentalism and Female Power.* London: Rutgers University Press.

Braun, Virginia, and Nicola Gavey. 1999. "'Bad Girls' And 'Good Girls'? Sexuality and Cervical Cancer." *Women's Studies International Forum* 22, 2: 203-13.

Brereton, Virginia L., and Margaret L. Bendroth. 2001. "Secularization and Gender: An Historical Approach to Women and Religion in the Twentieth Century." *Method and Theory in the Study of Religion* 13, 2: 209–23.

Brown, Callum G. 2001. *The Death of Christian Britain.* London: Routledge.

Bruce, Steve. 2002. *God Is Dead: Secularization in the West.* Oxford: Blackwell.

Burgess, Richard. 2009. "African Pentecostal Spirituality and Civic Engagement: The Case of the Redeemed Christian Church of God in Britain." *Journal of Beliefs & Values* 30, 3: 255–73.

Buschart, W. David. 2010. *Baptist Gender and Sexuality.* At <patheos.com/Library/Baptist/Ethics-Morality-Community/Gender-and-Sexuality.html> March 21.

Butler, Judith. 1993. *Bodies that Matter: On the Discursive Limits of "Sex."* New York: Routledge.

---. 1990. *Gender Trouble: Feminism and the Subversion of Identity*. New York: Routledge.

Canadian Census. 2001. Statistics Canada. Ottawa, Ontario.

Carpenter, Laura M. 2005. *Virginity Lost: An Intimate Portrait of First Sexual Experiences*. New York: New York University Press.

Casanova, J. 1994. *Public Religions in the Modern World*. Chicago: University of Chicago Press.

Chadwick, Henry, and Allison Ward. 2000. *Not Angels, but Anglicans: A History of Christianity in the British Isles*. Norwich: Canterbury Press.

Clark, Warren. 2000. "Patterns of Religious Attendance." *Canadian Social Trends* Winter: 23–27.

---.1998. "Religious Observance, Marriage and Family." *Canadian Social Trends* Autumn: 2–7.

Cline, Sally. 1994. *Women, Celibacy and Passion*. London: Optima.

Cochrane, Kira. 2010. "Why Do So Many Women Have Depression?" *The Guardian*, April 29.

Collins, Patricia Hill. 2000. *Black Feminist Thought: Knowledge, Consciousness, and the Politics of Empowerment* second edition. New York: Routledge.

---.1990. *Black Feminist Thought: Knowledge, Consciousness and the Politics of Empowerment*. Boston: Unwin Hyman.

Connell, Robert W. 1987. *Gender and Power: Society, the Person and Sexual Politics*. Cambridge, UK: Polity.

Cott, Nancy. 1987. *The Grounding of Modern Feminism*. New Haven, CT: Yale University Press.

Cox, Harvey. 2009. *The Future of Faith*. New York: HarperCollins.

Crabtree, B.F., and W.L. Miller (eds.). 1999. *Doing Qualitative Research* second edition. London: Sage.

Crawford, Janet. 1990. "Attitudes to Female Sexuality/Anglican Church in New Zealand." In Jeanne Becher (ed.), *Women and Religion and Sexuality: Studies on the Impact of Religious Teachings on Women*. Philadelphia: Trinity Press International.

Crawford, J., S. Kippax, J. Onyx, U. Gault and P. Benton. 1992. *Emotion and Gender: Constructing Meaning from Memory*. London: Sage.

Crenshaw, Kimberlé. 1989. "Demarginalizing the Intersection of Race and Sex: A Black Feminist Critique of Antidiscrimination Doctrine, Feminist Theory, and Antiracist Politics." *University of Chicago Legal Forum* 14: 538–54.

Cross, F.L, and E.A. Livingstone. 1997. *The Oxford Dictionary of the Christian Church*. Oxford, UK: Oxford University Press.

Daly, Mary. [1968] 1985. *The Church and The Second Sex*. Boston: Beacon Press.

Daniluk, Judith C. [1998] 2003. *Women's Sexuality Across the Lifespan: Challenging Myths, Creating Meanings*. New York: Guilford Publications.

Daniluk, Judith C., and Nicolle Browne. 2008. "Traditional Religious Doctrine and Women's Sexuality: Reconciling the Contradictions." *Women & Therapy* 31, 1: 129–42.

Davie, Grace. 2011. "Understanding Religion in Modern Europe: The Questions to Ask." Presentation at the Bruce Marshall Faith and Globalization Seminar, Durham University, Durham, UK, March 10.

---. 2006. "Religion in Europe in the 21st Century: The Factors to Take into Account." *European Journal of Sociology* 47, 2: 271–96.

---. 1994. *Religion in Britain since 1945: Believing without Belonging*. Oxford: Blackwell.

Davis, Kathy. 2008. "Intersectionality as Buzzword: A Sociology of Science Perspective on What Makes a Feminist Theory Successful." *Feminist Theory* 9, 1: 67–85.

Day, Abby. 2008. "Wilfully Disempowered: A Gendered Response to a 'Fallen World.'" *European Journal of Women's Studies* 15, 3: 261–76.

Day, Elizabeth. 2008. "Is Virginity the Last Taboo?" *Observer Woman*, January 13.

de Beauvoir, Simone. [1949] 1983. *The Second Sex* (translated and edited by H.M. Parshley). Harmondsworth, Middlesex: Penguin Books.

Deliovsky, Katerina. 2005. "Compulsory 'White' Heterosexuality: The Politics of Racial and Sexual Loyalty." *Socialist Studies: The Journal of the Society for Socialist Studies* 1, 2: 74–92.

Dillow, L., and L. Pintus. 2002. *Gift-Wrapped by God, Secret Answers to the Question "Why Wait?"* Colorado Springs, CO: Water Brook Press.

Drever, E. 1995. *Using Semi-Structured Interviews in Small-Scale Research: A Teacher's Guide.* Edinburgh: SCRE Publications.

Dryden, Windy. 1994. *Overcoming Guilt.* London: Sheldon Press.

Eckholm, Erik. 2011. "Unmarried Pastor, Seeking a Job, Sees Bias." *New York Times*, March 22.

Eden, Dawn. 2007. *The Thrill of the Chaste: Finding Fulfillment While Keeping Your Clothes On.* London: W Publishing.

Edwards, Lisa M., Richard J. Fehring, Keyona M. Jarrett, and Kristin A. Haglund. 2008. "The Influence of Religiosity, Gender, and Language Preference Acculturation on Sexual Activity among Latino/a Adolescents." *Hispanic Journal of Behavioral Sciences* 30, 4: 447–62.

Elliot, Elizabeth. 1984. *Passion and Purity: Learning to Bring Your Love Life Under Christ's Control.* Grand Rapids, MI: Baker/Revell.

Ellison, Marvin. 1994. "Common Decency: A New Christian Sexual Ethics." In J.B. Nelson, and S.P. Longfellow (eds.), *Sexuality and the Sacred: Sources of Theological Reflection.* London: Mowbray.

Epstein, Heidi. 2007. "Chastening Tale: Figuring Woman across the Christian Fundamentalist/Feminist Divide." In Arvind Sharma, and Katherine K. Young (eds.), *Fundamentalism and Women in World Religions.* New York: Continuum.

Erikson, Erik H. 1968. *Identity: Youth and Crisis.* London: Faber and Faber.

Espiritu, Yen Le. 2001. "'We Don't Sleep around like White Girls Do': Family, Culture, and Gender in Filipina American Lives." *Signs* 26, 2: 415–40.

Evans, Claire. 2001. "A Theological Response to the Issue of Singleness with 18–35 Year Olds in the Western Church Today." Undergraduate thesis. London: London Bible College.

Everingham, Christine, Deborah Stevenson, and Penny Warner-Smith. 2007. "'Things Are Getting Better all the Time?' Challenging the Narrative of Women's Progress from a Generational Perspective." *Sociology* 41, 3: 419–37.

Fausto-Sterling, Anne. 2000. *Sexing the Body: Gender Politics and the Construction of Sexuality.* New York: Basic Books.

Fernandes, Leela. 2003. *Transforming Feminist Practice: Non-Violence, Social Justice and the Possibilities of a Spiritualized Feminism.* San Francisco: Aunt Lute Books.

Fine, Michelle. 1988. "Sexuality, Schooling, and Adolescent Females: The Missing Discourse of Desire." *Harvard Educational Review* 58: 29–53.

Fiorenza, E. Schüssler. 1992. *In Memory of Her: A Feminist Theological Reconstruction of Christian Origins.* New York: Crossroad.

Flanagan, Caitlin. 2008. "What Girls Want: A Series of Vampire Novels Illuminates the Complexities of Female Adolescent Desire." *The Atlantic* December: 108–20.

Foucault, Michel. 1999. *Religion and Culture.* Jeremy R. Carrette, ed. New York: Routledge.

---. 1978. *The History of Sexuality: Volume I: An Introduction* (translated from the French by Robert Hurley). Harmondsworth: Penguin Books.

---. [1977] 1991. *Discipline and Punish: The Birth of the Prison.* London: Penguin Books.

---. 1974. *The Archaeology of Knowledge.* London: Tavistock.

Frankenberg, Ruth. 1993. *White Women Race Matters: The Construction of Whiteness.* London: Routledge

Freitas, Donna. 2008. *Sex and the Soul: Juggling Sexuality, Spirituality, Romance, and Religion on America's College Campuses.* New York: Oxford University Press.

Gentleman, Amelia. 2010. "Marriage: The New Minority Pursuit." *The Guardian,* March 4.

Giddens, Anthony. 1992. *The Transformation of Intimacy: Sexuality, Love and Eroticism in Modern Societies.* Cambridge, UK: Polity.

Gilkes, Cheryl Townsend. 1985. "'Together and in Harness': Women's Traditions in the Sanctified Church." *Signs* 10, 4: 678–99.

Gilligan, Carol. 1982. *In a Different Voice: Psychological Theory and Women's Development.* London: Harvard University Press.

Gilmartin, S.K. 2006. "Changes in College Women's Attitudes toward Sexual Intimacy." *Journal of Research on Adolescence* 16, 3: 429–54.

Gökarıksel, B. 2009. "Beyond the Officially Sacred: Religion, Secularism, and the Body in the Production of Subjectivity." *Social & Cultural Geography* 10, 6: 657–74.

Gonzalez, D. 2007. "A Church's Challenge: Holding On to Its Young." *New York Times,* January 16.

Grant, J. 1989. *White Women's Christ and Black Women's Jesus.* Atlanta, GA: Scholars Press.

Gresh, Danna. 2000. *And the Bride Wore White: Seven Secrets to Sexual Purity.* Chicago, IL: Moody Press.

Grey, Mary. 2001. *Introducing Feminist Images of God.* Sheffield, UK: Sheffield Academic Press.

Griffith, R. Marie. 2004. *Born Again Bodies: Flesh and Spirit in American Christianity.* Berkeley and London: University of California Press.

---. 1997. *God's Daughters: Evangelical Women and the Power of Submission.* Berkeley and London: University of California Press.

Grossman, L. 2008. "Stephenie Meyer: A New J.K. Rowling?" *Time Magazine.* <time.com/time/magazine/article/0,9171,1734838-2,00.html> April 24.

Guest, Mathew, Karin Tusting, and Linda Woodhead (eds.). 2004. *Congregational Studies in the UK: Christianity in a Post-Christian Context.* Aldershot, UK: Ashgate.

Hall, S. 2006. "Teenagers in No Rush to Have Sex, Biggest Survey Shows." *The Guardian,* August 15.

Hampson, Daphne. 1985. "The Challenge of Feminism to Christianity." *Theology* 88: 341–50.

Harding, Susan. 1991. *Whose Science? Whose Knowledge? Thinking from Women's Lives.* Milton Keynes: Open University Press.

Hayes, Alan L. 2004. *Anglicans in Canada: Controversies and Identity in Historical Perspective.* Champaign, IL: University of Illinois Press.

Heelas, Paul, and Linda Woodhead. 2005. *The Spiritual Revolution: Why Religion is Giving Way to Spirituality.* Oxford, UK: Blackwell.

Helm Jr., H.W., J.M. Berecz and E.A. Nelson. 2001. "Religious Fundamentalism and Gender Differences: Religious Fundamentalism and its Relationship to Guilt and Shame." *Pastoral Psychology* 5, 1: 25–37.

Henderson, Sheila J., Rachel Thomson and Janet Holland. 2006. *Inventing Adulthoods: A Biographical Approach to Youth Transitions*. California: Sage.

Heyer-Grey, Zoe A. 2001. "Gender and Religious Work." In N. Nason-Clark, and M.J. Neitz (eds.), *Feminist Narratives in the Sociology of Religion*. New York: AltaMira Press.

Heyward, Carter. 1990. "Sexual Ethics and the Church: A Response." In Jeanne Becher (ed.), *Women and Religion and Sexuality: Studies on the Impact of Religious Teachings on Women*. Philadelphia: Trinity Press International.

Higginbotham, Evelyn Brooks. 1993. *Righteous Discontent: The Women's Movement in the Black Baptist Church, 1880–1920*. Cambridge, MA: Harvard University Press.

Hill, Amelia. 2010. "House Prices Force Couples to Delay Marriages and Families, Survey Shows." *The Guardian*, March 14.

Holder, D.W., R.H. Durant, T.L. Harris, J.H. Daniel, D. Obeidallah and E. Goodman. 2000. "The Association between Adolescent Spirituality and Voluntary Sexual Activity." *Journal of Adolescent Health* 26, 295–302.

Holland, Janet, Caroline Ramazanoglu, Sue Sharpe and Rachel Thomson. 2000. "Deconstructing Virginity: Young People's Accounts of First Sex." *Sexual and Relationship Therapy* 15, 3: 222–32.

---. 1998. *The Male in the Head: Young People, Heterosexuality and Power*. London: Tufnell Press.

---. 1994. "Power and Desire: The Embodiment of Female Sexuality." *Feminist Review*. 46 (Spring).

Holy Bible: New International Version [1982] 1984. (Second edition). Michigan: Zondervan Corporation.

hooks, bell. 1990. *Yearning: Race, Gender, and Cultural Politics*. Boston, MA: South End Press.

---. 1984. *Feminist Theory: From Margin to Center*. Boston, MA: South End Press.

Hopkins, Peter E. 2006. "Youth Transitions and Going to University: The Perceptions of Students Attending a Geography Summer School Access Programme." *Area* 38, 3: 240–47.

Hunt, Stephen. 2005. "'Basic Christianity': Gender Issues in the Alpha Initiative." Presentation at British Sociological Association, Sociology of Religion Study Group Annual Conference, Lancaster University, Lancaster, UK, April 12.

Hutchings, Roger. 2002. *The Methodist Church 20s30s Initiative: A Report of Structured Conversations with People in the Age-Group*. At <methodist.org.uk/static/conf2005/20s30sconversations.rtf>.

Inglehart, Ronald, and Pippa Norris. 2004. *Sacred and Secular: Religion and Politics Worldwide*. New York: Cambridge University Press.

Jackson, Stevi. 1996. "Heterosexuality and Feminist Theory." In D. Richardson (ed.), *Theorising Heterosexuality*. Buckingham, UK: Open University Press.

Johansson, Thomas. 2007. *The Transformation of Sexuality: Gender and Identity in Contemporary Youth Culture*. Aldershot, UK: Ashgate.

Johnson, J.M. 2002. "In-Depth Interviewing." In J.F. Gubrium, and J.A. Holstein (eds.), *Handbook of Interview Research: Context & Method*. London: Sage.

Jones, Gill. 2002. *The Youth Divide: Diverging Paths to Adulthood*. New Earswick, UK: Joseph Rowntree Foundation.

Jordan, Judith V. 1997 "A Relational Perspective for Understanding Women's Development." In J.V. Jordan (ed.), *Women's Growth in Diversity*. New York: Guilford Press.

Joshi, Khyati. 2006a. "The Racialization of Hinduism, Islam, and Sikhism in the United States." *Equity and Excellence in Education* 39, 3: 211–26.

---. 2006b. *New Roots in America's Sacred Ground: Religion, Race, and Ethnicity in Indian America*. Piscataway, NJ: Rutgers University Press.

Kelly, Liz. 1988. *Surviving Sexual Violence*. Cambridge, UK: Polity.

Kent, John. 2002. *Wesley and the Wesleyans: Religion in Eighteenth-Century Britain*. Cambridge: Cambridge University Press.

Klassen, Pamela. 2003. "Confront the Gap: Why Religion Needs to Be Given More Attention in Women's Studies." *Thirdspace* 3, 1. At <thirdspace.ca/articles/klassen.htm>.

Knapp, Caroline. 2003. *Appetites: Why Women Want*. New York: Counterpoint.

Lambeth Conference. 1998. *Resolution I.10: Human Sexuality*. At <lambethconference. org/resolutions/1998/1998-1-10.cfm>.

Leech, K. 1997. *The Sky Is Red: Discerning the Signs of the Times*. London: Darton, Longman & Todd.

Lees, Sue. 1997. *Ruling Passions: Sexual Violence, Reputation and the Law*. Buckingham, UK: Open University Press.

---. 1993. *Sugar and Spice: Sexuality and Adolescent Girls*. New York: Penguin Books.

---. 1989. "Learning to Love: Sexual Reputation, Morality and the Social Control of Girls." In M. Cain (ed.), *Growing Up Good: Policing the Behaviour of Girls in Europe*. London: Sage.

Lefkowitz, Eva S. 2005. "'Things Have Gotten Better': Developmental Changes Among Emerging Adults after the Transition to University." *Journal of Adolescent Research* 20, 1: 40–63.

Lefkowitz, Eva S., M.M. Gillen, C.L. Shearer and T.L. Boone. 2004. "Religiosity, Sexual Behavior, and Sexual Attitudes during Emerging Adulthood." *Journal of Sex Research* 41, 150–59.

Leonard, Bill J. 2005. *Baptists in America*. New York: Columbia University Press.

Levinson, Daniel J. 1978. *Seasons of a Man's Life*. New York: Alfred A. Knopf.

Levy, Ariel. 2005. *Female Chauvinist Pigs: Women and the Rise of Raunch Culture*. London: Simon and Schuster UK.

Lewis, Helen B. 1971. *Shame and Guilt in Neurosis*. New York: International Universities Press.

Lewis, Reina. 2011. "Mediating Modesty: Fashioning Faithful Bodies." Symposium as part of the AHRC/ESRC Religion and Society Programme, London College of Fashion, UK, June 15.

Lorde, Audre. 1984. *Sister Outsider: Essays and Speeches*. Trumansburg, NY: Crossing Press.

Lupton, Deborah. 1998. *The Emotional Self*. London: Sage.

Lyon, M.L., and J.M. Barbalet. 1994. "Society's Body: Emotion and the 'Somatization' of Social Theory." In T.J. Csordas (ed.), *Embodiment and Experience: The Existential Ground of Culture and Self*. New York: Cambridge University Press.

Mahoney, A. 2008. "Is It Possible for Christian Women to Be Sexual?" *Women & Therapy* 31, 1: 89–106.

Mahoney, A., and O.M. Espin. 2008. "Introduction." *Women & Therapy* 31, 1: 1–4.

Mann, Chris. 1996. "Girls' Own Story: The Search for a Sexual Identity in Times of Family Change." In J. Holland and L. Adkins (eds.), *Sex, Sensibility and the Gendered Body*. London: MacMillan.

Marler, Penny. 2008. "Religious Change in the West: Watch the Women." In Kristin Aune, Sonya Sharma, and Giselle Vincett (eds.), *Women and Religion in the West: Challenging Secularization*. Aldershot, UK: Ashgate.

Martin, Bernice. 2001. "The Pentecostal Gender Paradox: A Cautionary Tale for the Sociology of Religion." In R.K. Fenn (ed.), *The Blackwell Companion to the Sociology of Religion*. Oxford, UK: Blackwell.

Martin, David. 2005. "Secularisation and the Future of Christianity." *Journal of Contemporary Religion* 20, 2: 145–60.

Martin, Emily. 1987. *The Woman in the Body: A Cultural Analysis of Reproduction*. Milton Keynes: Open University Press.

Martin, Karin A. 1996. *Puberty, Sexuality, and the Self: Girls and Boys at Adolescence*. London: Routledge.

Maynard, Mary, and June Purvis (eds.) 1994. *Researching Women's Lives from a Feminist Perspective*. London: Taylor and Francis.

McCloud, Sean. 2007. *Divine Hierarchies: Class in American Religion and Religious Studies*. Chapel Hill, NC: University of North Carolina Press.

McRobbie, Angela. 2007. "Top Girls?" *Cultural Studies* 21, 4: 718–37.

---. 2004. "The Rise and Rise of Porn Chic." *Times Higher Education Supplement*, January 2.

The Methodist Church of Great Britain. 2010. "Methodist Youth Push for Advice on Cohabitation at Methodist Conference." At <methodist.org.uk/index. cfm?fuseaction=opentogod.newsDetail&newsid=455>.

Meyer, Stephenie. 2008. *Twilight*. New York: Little Brown and Company.

Miller, Donald E. 1997. *Reinventing American Protestantism: Christianity in the New Millennium*. Los Angeles: University of California Press.

Miller, Donald E., and Tetsunao Yamamori. 2007. *Global Pentecostalism: The New Face of Christian Social Engagement*. Berkeley, CA: University of California Press.

Miller, Jean Baker. 1991. "The Development of Women's Sense of Self." In J.V. Jordan, A.G. Kaplan, J. Baker Miller, I. Stiver, and J. Surrey (eds.), *Women's Growth in Connection: Writings from the Stone Center*. London: Guildford Press.

---. 1976. *Toward a New Psychology of Women*. London: Allen Lane/Penguin Books.

Miller, Jean Baker, and Irene Stiver. 1997. *The Healing Connection: How Women Form Relationships in Therapy in Life*. Boston: Beacon Press.

Mitchell, K. 2001. "Transnationalism, Neo-liberalism, and the Rise of the Shadow State." *Economy and Society* 30, 2: 165–89.

Moore, Henrietta L. 1994. *A Passion for Difference: Essays on Anthropology and Gender*. Cambridge, UK: Polity.

Narayan, U. 1989. "The Project of Feminist Epistemology." In A. Jaggar, and S. Bordo (eds.), *Gender/Body/Knowledge: Feminist Reconstructions of Being and Knowing*. London: Rutgers University Press.

Nelson, James B. 1992. *Body Theology*. Louisville, KY: Westminster John Knox Press.

---. 1978. *Embodiment: An Approach to Sexuality and Christian Theology*. Minneapolis: Augsburg Publishing House.

Ogden, Gina. 2008. *The Return of Desire: A Guide to Rediscovering Your Sexual Passion*. Boston: Trumpeter Books.

---. 2007. *Women Who Love Sex: Ordinary Women Describe Their Paths to Pleasure, Intimacy, and Ecstasy*. Boston: Trumpeter Books.

Orsi, Robert. 2003. "Is the Study of Lived Religion Irrelevant to the World We Live In?

Special Presidential Plenary Address, Society for the Scientific Study of Religion, Salt Lake City, November 2, 2002. *Journal for the Scientific Study of Religion* 42, 2: 169–74.

Ozorak, Elizabeth W. 1996. "The Power, But Not the Glory: How Women Empower Themselves Through Religion." *Journal for the Scientific Study of Religion* 35, 1: 17–29.

Page, Sarah. 2011a. "Clergy Mothers in the Church of England." Presentation at the Café des Femmes, Durham University, Durham, UK, March 3.

---. 2011b. "Negotiating Sacred Roles: A Sociological Exploration of Priests who Are Mothers." *Feminist Review* 97: 92–109.

Pattison, Stephen. 2000. *Shame: Theory, Therapy, Theology*. Cambridge: Cambridge University Press.

Pearson, Allison. 2002. *I Don't Know How She Does It*. London: Chatto & Windus.

Percy, Martyn. 1996. *Words, Wonders and Power: Understanding Contemporary Christian Fundamentalism and Revivalism*. London: SPCK.

Perel, Esther. 2007. *Mating in Captivity: Sex, Lies, and Domestic Bliss*. London: Hodder and Stoughton.

Petersen, L.R., and G.V. Donnenwerth. 1997. "Secularization and the Influence of Religion on Beliefs about Premarital Sex." *Social Forces* 75, 3: 1071–89.

Plaskow, Judith, and Carol Christ (eds.). 1989. *Weaving the Visions: New Patterns in Feminist Spirituality*. New York: Harper San Francisco.

Porter, Fran. 2002. *Changing Women, Changing Worlds: Evangelical Women in Church, Community and Politics*. Belfast, NI: Blackstaff Press.

Quach, T. 2008. "Femininity and Sexual Agency among Young Unmarried Women in Hanoi." *Culture, Health & Sexuality* June, 10 (Supplement): S151–61.

Ramazanoglu, Caroline, and Janet Holland. 2002. *Feminist Methodology: Challenges and Choices*. London: Sage.

Ransom, Lily S. 2000. "Navigating Sex, Sexuality, and Christian Values." *Sexuality and Culture* 4, 3: 65–79.

Rayburn, C.A., and L.J. Richmond. 2002. "Women, Whither Goest Thou? To Chart New Courses in Religiousness and Spirituality and to Define Ourselves!" In L.H Collins, M.R. Dunlop and J.C. Chrisler (eds.), *Charting a New Course for Feminist Psychology*. London: Praeger.

Redfern, Catherine, and Kristin Aune. 2010. *Reclaiming the F-Word: The New Feminist Movement*. London: Zed Books.

Regnerus, Mark D. 2007. *Forbidden Fruit: Sex and Religion in the Lives of American Teenagers*. New York: Oxford University Press.

Reimer-Kirkham, Sheryl, and Sonya Sharma. Forthcoming. "Intersectional Analyses of Culture, Religion, Ethics, and Nursing." In M.D.M. Fowler, E. Johnston Taylor, B. Pesut, S. Reimer-Kirkham, and R. Sawatzky (eds.), *Religion, Religious Ethics, and Nursing*. New York: Springer.

---. 2011. "Adding Religion to Gender, Race, and Class: Seeking New Insights on Intersectionality in Health Care Contexts." In O. Hankivsky (ed.), *Health Inequities in Canada: Intersectional Frameworks and Practices*. Vancouver, BC: University of British Columbia Press.

Rich, Adrienne. 1980. "Compulsory Heterosexuality and Lesbian Experience." *Signs: Journal of Women in Culture and Society* 5, 4: 1–32.

Richard, D. 2000. "Christian Women Have More Fun, Study Finds." *Contemporary Sexuality* 34, June: 1, 4.

Richardson, Diane. 1996. "Heterosexuality and Social Theory." In Diane Richardson (ed.), *Theorising Heterosexuality*. Buckingham, UK: Open University Press.

Robb, A. 2007. "The Innocence Project." *'O' Oprah Magazine* March.

Robbins, Mandy. 2001. "Clergywomen in the Church of England and the Gender Inclusive Language Debate." *Review of Religious Research* 42, 4: 405–14.

Roberts, Sam. 2010. "Study Finds Cohabiting Doesn't Make a Union Last." *New York Times*, March 3.

Roper, A. 2001. "A Young Person's Perspective on Authority and Sexuality." In J.A. Selling (ed.), *Embracing Sexuality: Authority and Experience in the Catholic Church*. Aldershot, UK: Ashgate.

Rowe, Dorothy. 1987. *Beyond Fear*. London: Fontana Paperbacks.

Ruether, R. Radford. 2000. *Christianity and the Making of the Modern Family: Ruling Ideologies, Diverse Realities*. Boston, MA: Beacon Press.

---. 1990. "Is Feminism the End of Christianity? A Critique of Daphne Hampson's Theology and Feminism." *Scottish Journal of Theology* 43: 390–400.

---. 1983. *Sexism and God-Talk: Toward a Feminist Theology*. London: SCM Press.

Said, Edward. W. 1987. *Orientalism*. New York: Vintage Books.

Sawicki, Jana. 1991. *Disciplining Foucault: Feminism, Power, and the Body*. New York: Routledge.

Schaefer, Nancy, A. 2010. "'Changing the Lure': Billy Graham Evangelistic Association's 'Rock the River' Musical Tour." Presentation at the British Sociological Association, Sociology of Religion Study Group Annual Conference, University of Edinburgh, Edinburgh, UK, April 6–8.

Schnarch, David. 1997. *Passionate Marriage: Love, Sex, and Intimacy in Emotionally Committed Relationships*. New York: Henry Holt and Co.

Sharma, Arvind, and Katherine K. Young (eds.). 2007. *Fundamentalism and Women in World Religions*. New York: Continuum.

Sharma, Sonya. 2008a. "Young Women, Sexuality and Protestant Church Community: Oppression or Empowerment?" *European Journal of Women's Studies* 15, 4: 345–59.

---. 2008b. "When Young Women Say 'Yes': Exploring the Sexual Selves of Young Canadian Women in Protestant Churches." In Kristin Aune, Sonya Sharma, and Giselle Vincett (eds.), *Women and Religion in the West: Challenging Secularization*. Aldershot, UK: Ashgate.

---. 2007. "The Impact of Protestant Church Involvement on Young Women's Sexual Identities." Unpublished doctoral thesis. Lancaster, UK: Lancaster University.

Siering, C.D. 2009. "Taking a Bite out of Twilight." *Ms. Magazine* XIX, 2 (Spring).

Simpson, J.H. 2006. "The Politics of the Body in Canada and the United States." In L.G. Beaman (ed.), *Religion and Canadian Society: Traditions, Transitions and Innovations*. Toronto: Canadian Scholars' Press.

Skeggs, Beverley. 2004. *Class, Self, Culture*. London: Routledge.

---. 1997. *Formations of Class and Gender: Becoming Respectable*. London: Sage.

Slapšak, Svetlana. 2004. "The Three Medeas." Presentation given at NOISE Summer School, Ljubljana, Slovenia, September 4–9.

Slee, Nicola. 2004. *Women's Faith Development: Patterns and Processes*. Aldershot, UK: Ashgate.

---. 2000. "Some Patterns and Processes of Women's Faith Development." *Journal of Beliefs and Values: Studies in Religion and Education* 21, 1: 5–16.

Smith, Christian, and Patricia Snell. 2009. *Souls in Transition: The Religious and Spiritual Lives of Emerging Adults*. New York: Oxford University Press.

Soanes, C., A. Spooner and S. Hawker. 2001. *Oxford Paperback Dictionary, Thesaurus, and Wordpower Guide*. Oxford: Oxford University Press.

Stanton, E. Cady. [1898] 1985. *The Woman's Bible* (Abridged edition). Edinburgh: Polygon.

Statistics Canada. 2005. "Early Sexual Intercourse, Condom Use and Sexually Transmitted Diseases." *The Daily*. At <statcan.ca/Daily/English/050503/d050503a.htm> May 3.

Storkey, Elaine. 1988. "Sex and Sexuality in the Church." In M. Furlong (ed.), *Mirror to the Church: Reflections on Sexism*. London: SPCK.

Stuckey, Johanna H. 1998. *Feminist Spirituality*. Toronto: York Centre for Feminist Research.

Surrey, Janet. 1991. "The 'Self-In-Relation': A Theory of Women's Development." In J.V. Jordan, A.G. Kaplan, J. Baker Miller, I. Stiver and J. Surrey (eds.), *Women's Growth in Connection: Writings from the Stone Center*. London: Guilford Press.

Tamez, Elsa (ed.). 1989. *Through Her Eyes: Women's Theology from Latin America*. Oregon: Wipf and Stock Publishers.

Taylor, C., and D. Newton. 2006. "Sex Now." *The Guardian Weekend*, April 15.

Taylor, Jenny. 2008. *A Wild Constraint: The Case for Chastity*. London: Continuum.

---. 2004. "A Wild Constraint." *Third Way* 27, 6: 12–13.

Taylor, K. 2007. *Not Tonight, Mr Right: Why Good Men Come to Girls Who Wait*. London: Penguin Books.

Thapan, Meenakshi. 1997. "Introduction: Gender and Embodiment in Everyday Life." In M. Thapan (ed.), *Embodiment: Essays on Gender and Identity*. Mumbai: Oxford University Press.

Tolman, Deborah L. 2002. *Dilemmas of Desire: Teenage Girls Talk about Sexuality*. Cambridge, MA: Harvard University Press.

---. 1991. "Adolescent Girls, Women and Sexuality: Discerning Dilemmas of Desire." In C. Gilligan, A.G. Rogers and D.L. Tolman (eds.), *Women, Girls and Psychotherapy: Reframing Resistance*. New York: Haworth Press.

Tolman, Deborah L., and L.M. Diamond. 2002. "Desegregating Sexuality Research: Cultural and Biological Perspectives on Gender and Desire." *Annual Review of Sexuality Research*: 33–74.

Tolman, Deborah L., and T.E. Higgins. 1996. "How Being a Good Girl can Be Bad for Girls." In N. Bauer Maglin and D. Perry (eds.), *Bad Girls, Good Girls*. New Brunswick, NJ: Rutgers University Press.

Troeltsch, Ernst. [1931] 1992. *The Social Teaching of the Christian Churches*. Louisville, Kentucky: Westminster John Knox Press.

Trzebiatowska, Marta, and Dawn Llewellyn. 2010. "The Changing Feminist Face of Christianity." Presentation at the British Sociological Association, Sociology of Religion Study Group Annual Conference, University of Edinburgh, Edinburgh, UK, April 6–8.

Turnball, Larke. 2011. "Interview: Rev. Cindy Bourgeois." At: <ucobserver.org/faith/2011/03/cindy_bourgeois/>.

Vakulenko, A. 2007. "'Islamic Headscarves' and the European Convention on Human Rights: An Intersectional Perspective." *Social & Legal Studies* 16, 2: 183–99.

Valdivia, A.N. 2000. *A Latina in the Land of Hollywood and Other Essays on Media Culture*. Tuscon, AZ: University of Arizona Press.

Valenti, Jessica. 2009. *The Purity Myth: How America's Obsession with Virginity is Hurting*

Young Women. Berkeley: Seal Press.

Vincett, Giselle, Sonya Sharma and Kristin Aune. 2008. "Women, Religion and Secularization in the West: One Size Does Not Fit All." In Kristin Aune, Sonya Sharma, and Giselle Vincett (eds.), *Women and Religion in the West: Challenging Secularization*. Aldershot, UK: Ashgate.

Viswanath, Kalpana. 1997. "Shame and Control: Sexuality and Power in Feminist Discourse in India." In M. Thapan (ed.), *Embodiment: Essays on Gender and Identity*. Mumbai: Oxford University Press.

Von Ruhland, Catherine. 2004. "An Unchosen Chastity." *Third Way* 27, 5: 12–15.

Walby, Sylvia. 1990. *Theorizing Patriarchy*. Oxford, UK: Blackwell.

Walker, Alice. 1983. *In Search of Our Mother's Gardens: Womanist Prose*. Orlando, FL: Harcourt Brace.

Walter, Tony, and Grace Davie. 1998. "The Religiosity of Women in the Modern West." *British Journal of Sociology* 49, 4: 640–60.

Warner, Rob. 2010. *Secularization and Its Discontents*. London: Continuum.

Warren, C.A.B. 2002. "Qualitative Interviewing." In J.F. Gubrium, and J.A. Holstein (eds.), *Handbook of Interview Research: Context & Method*. London: Sage.

Wastell, C. 1996. "Feminist Developmental Theory: Implications for Counseling." *Journal of Counseling and Development* 74, 6: 575–78.

WATCH (Women and the Church). 2011. At <womenandthechurch.org/index.htm>.

Watling, Tony. 2005. "'Experiencing' *Alpha*: Finding and Embodying the Spirit and Being Transformed-Empowerment and Control in a ('Charismatic') Christian Worldview." *Journal of Contemporary Religion* 20, 1: 91–108.

Webster, Alison R. 1996. "Revolutionising Christian Sexual Ethics: A Feminist Perspective." In A. Thatcher and E. Stuart (eds.), *Christian Perspectives on Sexuality and Gender*. Leominster, UK: Gracewing Fowler Wright Books.

---. 1995. *Found Wanting: Women, Christianity and Sexuality*. London: Cassell.

Welland, Trevor. 2001. "'Assaults upon the Self': Control and Surveillance in a Theological College." *Journal of Contemporary Religion* 16, 1: 71–84.

White, E. Frances. 2001. *Dark Continent of Our Bodies: Black Feminism and the Politics of Respectability*. Philadelphia, PA: Temple University Press.

WICC (Women's Inter Church Council of Canada). 2011. At <wicc.org>.

Wilkins, Amy C. 2008. *Wannabes, Goths and Christians: The Boundaries of Sex, Style and Status*. Chicago, IL, University of Chicago Press.

Wilkinson, Michael (ed.). 2009. *Canadian Pentecostalism: Transition and Transformation*. Montreal, QC: McGill-Queen's University Press.

Williams, Zoe. 2007. "The Outdated Idea of Chastity as a Feminine Virtue Is Making a Most Unwelcome Comeback." *The Guardian*, January 24.

WIMM (Women in Mission and Ministry). 2011. At <episcopalchurch.org/congr/women>.

Winner, Lauren F. 2005a. *Real Sex: The Naked Truth about Chastity*. Grand Rapids, MI: Brazos Press.

---. 2005b. "Sex in the Body of Christ: Chastity as a Spiritual Discipline for the Whole Church." *Christianity Today* 49, 5: 28.

Winter, M.T., A. Lummis and A. Stokes. 1994. *Defecting in Place: Women Claiming Responsibility for Their Own Spiritual Lives*. New York: Crossroads.

Wolkomir, Michelle. 2004. "'Giving it up to God' Negotiating Femininity in Support Groups for Wives of Ex-Gay Christian Men." *Gender and Society* 18, 6: 735–55.

Woodhead, Linda. 2008. "'Because I'm Worth It": Religion and Women's Changing Lives in the West." In Kristin Aune, Sonya Sharma and Giselle Vincett (eds.), *Women and Religion in the West: Challenging Secularization*. Aldershot, UK: Ashgate.

---. 2007a. "Why So Many Women in Holistic Spirituality? A Puzzle Revisted." In K. Flanagan and P.C. Jupp (eds.), *A Sociology of Spirituality*. Aldershot, UK: Ashgate.

---. 2007b. "Sex and Secularization." In Gerard Loughlin (ed.), *Queer Theology: Rethinking the Western Body*. Oxford, UK: Blackwell.

---. 2004. *Introduction to Christianity*. Cambridge, UK: Cambridge University Press.

---. 2003. "Feminism and the Sociology of Religion: From Gender-Blindness to Gendered Difference." In R.K. Fenn (ed.) *The Blackwell Companion to Sociology of Religion*. Oxford: Blackwell.

Woolever, Cynthia. 2010. "U.S. Congregational Life Survey: A National Study of Worshipers, Congregations, and Their Leaders." Presentation at the Society for the Scientific Study of Religion and the Religious Research Association Annual Meeting, Baltimore, MD, October 29–31.

Wraight, Heather. 2001. *Eve's Glue: The Role Women Play in Holding the Church Together*. Carlisle and London: Paternoster Lifestyle and Christian Research.

Wuthnow, Robert. 2008. "Can Faith Be More than a Side Show in the Contemporary Academy?" In D. Jacobsen, and R. Hustedt Jacobsen (eds.), *The American University in a Postsecular Age*. New York: Oxford University Press.

Yip, Andrew K.T. 2010. "Coming Home from the Wilderness: An Overview of Recent Scholarly Research on LGBTQI Religiosity/Spirituality in the West." In Kath Browne, Sally R. Munt, Andrew K.T. Yip (eds.), *Queer Spiritual Spaces: Sexuality and Sacred Places*. Farnham, UK Ashgate.

---. 2003. "Sexuality and the Church." *Sexualities* 6, 1: 60–64.

---. 2000. "Leaving the Church to Keep My Faith: The Lived Experiences of Non-Heterosexual Christians." In L.J. Francis and Y.J. Katz (eds.), *Joining and Leaving Religion: Research Perspectives*. Leominster, UK: Gracewing.

Yip, Andrew K.T., Michael Keenan and Sarah-Jane Page. 2011. *Religion, Youth and Sexuality: Selected Key Findings from a Multi-Faith Exploration Report*. Nottingham, UK, University of Nottingham.

Young, Iris M. 1990. *Throwing Like a Girl and Other Essays in Feminist Philosophy and Social Theory*. Indianapolis, IN: Indiana University Press.

Young, Pamela Dickey. 2004. "Religion." In Philomena Essed, David Theo Goldberg and Audrey Kobayashi (eds.), *A Companion to Gender Studies (Blackwell Companions in Cultural Studies)*. Oxford, UK: Blackwell Publishing. At <blackwellreference.com/subscriber/tocnode?id=g9780631221098_chunk_g978063122109839> March 21.

---. 2000. *Re-Creating the Church: Communities of Eros*. Harrisburg, PA: Trinity Press International.

Yuval-Davis, Nila. 2006. "Intersectionality and Feminist Politics." *European Journal of Women's Studies* 13, 3: 193–209.

NEW in the Basic Series
from Fernwood Publishing

Men & Women and Tools
Bridging the Divide

Marcia Braundy

9781552664483 $17.95 128pp Rights: World

September 2011

FERNWOOD BASICS

MEN & WOMEN AND TOOLS
Bridging the Divide
MARCIA BRAUNDY

Although there have been many equity initiatives to encourage women to train and work in the trades, Canadian women still represent less than 3 percent of tradesworkers. Why does this disparity continue to exist? In *Men & Women and Tools*, Marcia Braundy — herself a tradesperson — explores this issue by focusing on male resistance to the inclusion of women in technical work. Early in her research, Braundy conducted an interview with several male and female tradespeople. Finding this interview rich with deeply ingrained notions of masculinity and female roles, Braundy constructs a short play from their words. Deconstructing the play line by line, this book weaves together scholarly research and lived experience to explore the historical and cultural origins of the ideas expressed.

"We know that class is gendered, and that often upper class professionals and blue collar working men set the highest barriers to women's entry. In her careful and erudite book, Marcia Braundy brings together the tools of the trade and the hands that hold them. By exploring men's resistance to equality, this book explodes the myths on which that resistance is based."
— Michael Kimmel, author of *The Gendered Society*, Stony Brook University

MARCIA BRAUNDY is a multidisciplinary academic/feminist who keeps her hand in as a construction carpenter, multimedia project manager, educator, author and social change activist.

visit www.fernwoodpublishing.ca for the complete list of the Basics Series

ALSO NEW IN 2011

Gendered Intersections
An Introduction to Women's and Gender Studies, 2nd Edition

C. Lesley Biggs, Susan Gingell & Pamela Downe, eds.

pb 9781552664131 $54.95 hb 9781552664292 $74.95 424pp Rights: World October, 2011

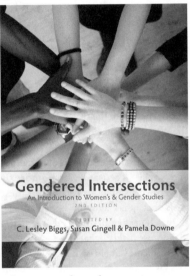

Following the structure of the successful first edition of *Gendered Intersections*, this second edition examines the intersections across and between gender, race, culture, class, ability, sexuality, age and geographical location from the diverse perspectives of academics, artists and activists. Using a variety of mediums — academic research, poetry, statistics, visual essays, fiction, emails and music — this collection offers a unique exploration of gender through issues such as Aboriginal self-governance, poverty, work, spirituality, globalization and community activism. This new edition brings a greater focus on politics, and gender and the law. It also includes access to a Gendered Intersections website, which contains several performances by poets and a Gendered Intersections Quiz, which highlights the historical and contemporary contributions of women and non-hegemonic men on Canadian Society.

Praise for the first edition
"*Gendered Intersections'* diverse selections provide an excellent and encompassing overview in the field of Women's and Gender Studies in Canada today. The thought-provoking readings encourage students to use a gendered perspective to engage in a critical analysis of current issues and topics. I find this an excellent text to get students thinking about the gendered world in which live."
— *Wendee Kubik, Women's Studies, University of Regina*

C. LESLEY BIGGS is an associate professor in the history department at the University of Saskatchewan. SUSAN GINGELL is a professor in the Department of English at the University of Saskatchewan. PAMELA DOWNE is an associate professor and head of the Department of Archeology and Anthropology at the University of Saskatchewan.

visit www.fernwoodpublishing.ca for the complete list of new titles

ABOUT CANADA SERIES

About Canada explores key issues for Canadians. Accessibly written, affordable and in a distinctive format, these books provide basic — but critical and passionate — coverage of central aspects of our society.

About Canada: Queer Rights

Peter Knegt

pb 9781552664377 / $17.95
hb 9781552664568 / $34.95
128pp Rights: World September, 2011

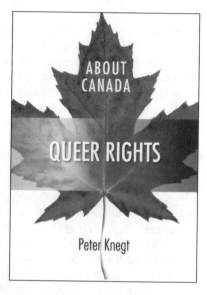

Is Canada a "queer utopia"? Canada was the fourth country in the world — and the first in the Western Hemisphere — to legalize same-sex marriage. Queer people in Canada enjoy many of the same legal rights as heterosexuals, and social acceptance of homosexuality has grown exponentially. But are these the goals that queer activists hoped to achieve? Is this legal regulation and normalization of homosexuality what the lesbian and gay liberation movement of the early 1970s fought for? Using the origins of this movement as a starting point, *About Canada: Queer Rights* examines the history of the struggle for queer rights in Canada to create a better understanding of the present. What Peter Knegt finds is that Canada's queer people are as diverse and multicultural as Canada itself — they are not easily generalized and have most certainly not achieved equality.

PETER KNEGT holds an MA in media studies from Concordia University. He has written for the *Undergraduate Journal of Sexual Diversity Studies, Xtra!, Exclaim, InToronto, Variety* and *Playback*, and is the associate editor of *indieWIRE*.

About Canada: Media

Peter Steven
pb 9781552664476 / $17.95
hb 9781552664599 / $34.95
176pp Rights: World September, 2011

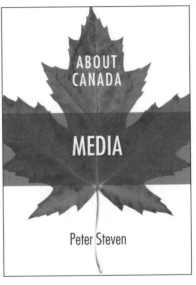

Canada enjoys a long-held reputation for producing high-quality media, from National Film Board documentaries to the CBC to children's programming. But in recent years, funding cuts, commercial media concentration and a sour political environment have been steadily eroding this reputation. In *About Canada: Media*, Peter Steven examines developments in film, television, the internet and newspapers and finds that the quality of our news and entertainment media is steadily declining, as well as becoming increasingly restricted and less diverse. Although Canada is not alone in this crisis of quality, we are particularly vulnerable living in the shadow of the United States. However, despite this decline and the shadow of our southern neighbour, Canada still produces distinctive and popular work, which receives critical international acclaim. *About Canada: Media* explores all things CanCon and argues that the Canadian people must reclaim the media from elite interests in order to ensure its democratic and quality future.

PETER STEVEN holds a PhD in radio/TV/film from Northwestern University, Chicago and is a professor of film studies at Sheridan College.